ART

CLIVE BELL was born in 1881 into an affluent, middle-class family which, by his own admission, had no interest in the arts. It was during his time at Trinity College, Cambridge (where he met Leonard Woolf, Thoby Stephen, and Lytton Strachey) that he developed his interest in painting, which became a passion when he took up temporary residence in Paris in 1903. His marriage to Vanessa Stephen placed him at the centre of the Bloomsbury group and widened still further his interest in the fine arts. His meeting with Roger Fry on a train in 1910 was crucial to the evolution of English art, for together with Fry, he was involved in setting up the first Post-Impressionist exhibition in that same year and the second exhibition in 1912. It was Fry who was first approached by Chatto and Windus to write an account of the modern tradition in art, but the older man was too busy with his new Omega Workshop to take on the commission. So he passed the project over to Bell, who had already published a large number of reviews of modern exhibitions. *Art* was the result and it placed Bell in the forefront of the modern movement. He subsequently published a number of works, most notably *Civilization* in 1928, but none created the impact and controversy of *Art*. He died in 1964.

J. B. BULLEN read English at Pembroke College, Cambridge, and was Andrew Bradley Junior Research Fellow at Balliol College, Oxford. He now teaches at the University of Reading. His publications include an edition of Roger Fry's *Vision and Design* (OUP, 1981), a study of Thomas Hardy, *The Expressive Eye* (OUP, 1986), the forthcoming *Post-Impressionists in England,* and many articles on the relationship between literature and the fine arts in the nineteenth and twentieth centuries.

ART

CLIVE BELL

Edited by
J. B. BULLEN

OXFORD UNIVERSITY PRESS

1987

Oxford University Press, Walton Street, Oxford OX2 6DP

Oxford New York Toronto
Delhi Bombay Calcutta Madras Karachi
Petaling Jaya Singapore Hong Kong Tokyo
Nairobi Dar es Salaam Cape Town
Melbourne Auckland

and associated companies in
Beirut Berlin Ibadan Nicosia

Oxford is a trade mark of Oxford University Press

British Library Cataloguing in Publication Data

Bell, Clive
Art
1. Art
I. Title II. Bullen, J. B.
700 N7425
ISBN 0-19-282049-4

Printed In Great Britain by
The Guernsey Press Co. Ltd.
Guernsey, Channel Islands

ACKNOWLEDGEMENTS

I AM most grateful for the advice and opinions of Dr Nicola Bradbury and Dr David Gervais of the Department of English, University of Reading, the late Professor Alan Wardman of the Department of Classics, and Dr Christopher de Hamel of Sotheby's; and grateful also to the students of Reading University who, I hope, will find this edition of *Art* useful.

A NOTE ON THE TEXT

THE text of this edition is based on the edition of 1949. This was substantially the same as the 1914 edition with one or two minor alterations which Bell explains in his Preface to the later edition.

All footnotes in the text are Bell's.

Bell's spellings 'Raffael' (for Raphael) and 'Lionardo' (for Leonardo) have been retained.

PREFACE

In this little book I have tried to develop
a complete theory of visual art. I have put
forward an hypothesis by reference to which
the respectability, though not the validity,
of all aesthetic judgments can be tested,
in the light of which the history of art from
palaeolithic days to the present becomes
intelligible, by adopting which we give intel-
lectual backing to an almost universal and
immemorial conviction. Everyone in his
heart believes that there is a real distinction
between works of art and all other objects;
this belief my hypothesis justifies. We all
feel that art is immensely important; my
hypothesis affords reason for thinking it so.
In fact, the great merit of this hypothesis
of mine is that it seems to explain what
we know to be true. Anyone who is
curious to discover why we call a Persian
carpet or a fresco by Piero della Francesca
a work of art, and a portrait-bust of Hadrian

or a popular problem-picture rubbish, will here find satisfaction. He will find, too, that to the familiar counters of criticism— *e.g.* "good drawing," "magnificent design," "mechanical," "unfelt," "ill-organised," "sensitive," — is given, what such terms sometimes lack, a definite meaning. In a word, my hypothesis works; that is unusual: to some it has seemed not only workable but true; that is miraculous almost.

In fifty or sixty thousand words, though one may develop a theory adequately, one cannot pretend to develop it exhaustively. My book is a simplification. I have tried to make a generalisation about the nature of art that shall be at once true, coherent, and comprehensible. I have sought a theory which should explain the whole of my aesthetic experience and suggest a solution of every problem, but I have not attempted to answer in detail all the questions that proposed themselves, or to follow any one of them along its slenderest ramifications. The science of aesthetics is a complex business and so is the history of art; my hope has been to write about them something simple and true. For instance, though I have indicated very clearly, and even repetitiously, what I take to be essential in

PREFACE

a work of art, I have not discussed as fully
as I might have done the relation of the
essential to the unessential. There is a
great deal more to be said about the mind
of the artist and the nature of the artistic
problem. It remains for someone who is
an artist, a psychologist, and an expert in
human limitations to tell us how far the
unessential is a necessary means to the
essential—to tell us whether it is easy or
difficult or impossible for the artist to
destroy every rung in the ladder by which
he has climbed to the stars.

My first chapter epitomises discussions
and conversations and long strands of cloudy
speculation which, condensed to solid argu-
ment, would still fill two or three stout
volumes : some day, perhaps, I shall write
one of them if my critics are rash enough
to provoke me. As for my third chapter—
a sketch of the history of fourteen hundred
years—that it is a simplification goes with-
out saying. Here I have used a series of
historical generalisations to illustrate my
theory ; and here, again, I believe in my
theory, and am persuaded that anyone who
will consider the history of art in its light
will find that history more intelligible than
of old. At the same time I willingly admit

that in fact the contrasts are less violent, the hills less precipitous, than they must be made to appear in a chart of this sort. Doubtless it would be well if this chapter also were expanded into half a dozen readable volumes, but that it cannot be until the learned authorities have learnt to write or some writer has learnt to be patient.

Those conversations and discussions that have tempered and burnished the theories advanced in my first chapter have been carried on for the most part with Mr. Roger Fry, to whom, therefore, I owe a debt that defies exact computation. In the first place, I can thank him, as joint-editor of *The Burlington Magazine*, for permission to reprint some part of an essay contributed by me to that periodical.[1] That obligation discharged, I come to a more complicated reckoning. The first time I met Mr. Fry, in a railway carriage plying between Cambridge and London, we fell into talk about contemporary art and its relation to all other art; it seems to me sometimes that we have been talking about the same thing ever since, but my friends assure me that it is not quite so bad as that. Mr. Fry, I remember, had recently become familiar with the modern French masters—Cézanne, Gauguin, Matisse :[2] I en-

joyed the advantage of a longer acquaintance. Already, however, Mr. Fry had published his *Essay in Aesthetics*,[3] which, to my thinking, was the most helpful contribution to the science that had been made since the days of Kant. We talked a good deal about that essay, and then we discussed the possibility of a " Post-Impressionist " Exhibition at the Grafton Galleries. We did not call it " Post-Impressionist "; the word was invented later by Mr. Fry,[4] which makes me think it a little hard that the more advanced critics should so often upbraid him for not knowing what " Post-Impressionism " means.

For some years Mr. Fry and I have been arguing, more or less amicably, about the principles of aesthetics. We still disagree profoundly. I like to think that I have not moved an inch from my original position, but I must confess that the cautious doubts and reservations that have insinuated themselves into this Preface are all indirect consequences of my friend's criticism. And it is not only of general ideas and fundamental things that we have talked; Mr. Fry and I have wrangled for hours about particular works of art. In such cases the extent to which one may have affected the judgment of the other cannot possibly be appraised,

nor need it be : neither of us, I think, covets the doubtful honours of proselytism. Surely whoever appreciates a fine work of art may be allowed the exquisite pleasure of suppos- ing that he has made a discovery? Never- theless, since all artistic theories are based on aesthetic judgments, it is clear that should one affect the judgments of another, he may affect, indirectly, some of his theories ; and it is certain that some of my historical generalisations have been modified, and even demolished, by Mr. Fry. His task was not arduous : he had merely to confront me with some work over which he was sure that I should go into ecstasies, and then to prove by the most odious and irrefragable evidence that it belonged to a period which I had concluded, on the highest *a priori* grounds, to be utterly barren. I can only hope that Mr. Fry's scholarship has been as profit- able to me as it has been painful : I have travelled with him through France, Italy, and the near East, suffering acutely, not always, I am glad to remember, in silence ; for the man who stabs a generalisation with a fact forfeits all claim on good-fellowship and the usages of polite society.

I have to thank my friend Mr. Vernon Rendall for permission to make what use I

PREFACE

chose of the articles I have contributed from time to time to *The Athenaeum* : if I have made any use of what belongs by law to the proprietors of other papers I herewith offer the customary dues. My readers will be as grateful as I to M. Vignier, M. Druet, and Mr. Kevorkian, of the Persian Art Gallery, since it is they who have made it certain that the purchaser will get something he likes for his money. To Mr. Eric Maclagan of South Kensington, and Mr. Joyce of the British Museum, I owe a more private and particular debt. My wife has been good enough to read both the MS. and proof of this book; she has corrected some errors, and called attention to the more glaring offences against Christian charity. You must not attempt, therefore, to excuse the author on the ground of inadvertence or haste.

<div align="right">CLIVE BELL</div>

November 1913

PREFACE TO THE 1949 EDITION

To bring *Art* up to date, that is to make what I thought and felt in 1911 and 1912 square with what I think and feel to-day, would be to write a new book. That I shall not do : for one thing because I am lazy; for another because, if *Art* has any value for future generations it will be as a record of what people like myself were thinking and feeling in the years before the first War. So let exaggerations, childish simplifications and injustices stand.

Some errors have been rectified in this or earlier editions; of these the most surprising—one that survived for years in numerous editions produced in this country and America—was the printing of " Gaugin" for Gauguin. It is surely to the credit of reviewers of my generation, many of whom were not much in love with my ideas, that not one thought fit to reproach me with this misprint—except Professor Tonks[1] who was not

a reviewer. Whether it was magnanimity that prevented them espying a gross tautology in my statement of the aesthetic hypothesis I cannot be sure: this stain, I may say, was obliterated long ago. To the best of my belief I have never been taken to task for a sentence (it is still there) which ranks Seurat slightingly with Signac and Cross.[2] For this judgment my only excuse was that I had seen very little of the master's work, and that, of course, is no excuse for anyone who has taken it on himself to favour the public with his views. On the other hand, I would like to make some apology for a denigratory note which, in another book, *Landmarks in Nineteenth Century Painting*, I let fly at Degas.[3] Degas was a great, a very great, artist; but I had been exasperated by a fashion, at one time prevalent amongst English people who knew very little of French painting, of belauding the Beach Scene in the Tate at the expense of better pictures. *La Plage* is far from being one of Degas' masterpieces;[4] but it is brilliant, and brilliant in a way that can be easily appreciated. I was indignant, and, as generally happens when one is in that exalted state, said something silly.

These are particular blemishes; the more

general faults of this book are not altogether
unbecoming to youth. The tone is too con-
fident and too pugnacious. A whiff of pro-
paganda emanates from pages where propa-
ganda is out of place; but you must remember
that " the battle of Post-Impressionism " had
just been joined. The best that even
Sickert would say for Cézanne, in 1911,
was that he was " un grand raté,"[5] while
Sargent called him a " botcher,"[6] and the
director of the Tate Gallery refused to hang
his pictures. Van Gogh was denounced
every day almost as an incompetent and
vulgar madman;[7] M. Jacques-Emile Blanche
informed us that, when cleaning his palette,
he often produced something better than a
Gauguin;[8] and when Roger Fry showed a
Matisse to the Art-Workers Guild the cry
went up " drink or drugs ? "[9] To lose one's
temper with " Art-Workers " or a Slade pro-
fessor may be silly, but do not forget that
honoured artists and critics—to say nothing
of novelists, poets, judges, bishops, poli-
ticians and biologists—joined in the cry.
Hark to Sickert: " Matisse has all the worst
art-school tricks " . . . " Picasso, like all
Whistler's followers, has annexed Whistler's
empty background without annexing the one
quality by which Whistler made his empty

background interesting."[10] Perhaps we did well to be angry. Nevertheless, anyone who reads this book will see that, being angry, I speak absurdly and impertinently of the giants of the High Renaissance, that I under-rate the eighteenth century, and that I think it necessary, for ridiculous doctrinaire reasons, to qualify my admiration for the Impressionists. The tone of the book, as I said, is too confident besides being aggressive. The generalisations are too sweeping; the history of fourteen hundred years, which is told in seventy-five pages, is told, not as it should be told if it is to be told so briefly, in black and white, but in violently contrasted colours: also some of the colours are false. Besides all this, there is a deal of optimism which has been made to look funny by the events of the last thirty-five years; but then events were not under the author's control. And yet, re-reading *Art*, and taking into account all, but I think no more than all, the extenuating circumstances that may be urged in its defence, I cannot but feel a little envious of the adventurous young man who wrote it.

CLIVE BELL

CHARLESTON, *October* 1948

CONTENTS

xix

ART

V. THE FUTURE

INTRODUCTION

CLIVE BELL'S *Art* is a quintessentially Bloomsbury text. It is witty, stylish, assertive, acerbic, and self-confident. It challenges contemporary conventions of taste, yet it is fully conversant with the terms of the culture which it attacks. It speaks not to the ignorant but to the informed; and Bell assumes that if the reader does not share his opinions, he or she will at least be familiar with the monuments of high culture to which he refers. Though Bell drew heavily on the writings, conversations, and lectures of Roger Fry his tone is quite different from that of the older man and he possesses none of Fry's scholarly diffidence and critical reserve. His bravura, his swagger, and his outspokenness are faintly reminiscent of Whistler's *Ten o'Clock Lecture* for which Bell had a sneaking admiration. What Bell said of Whistler—'There is dignity in his impudence' (p. 189)—is equally applicable to Bell himself—an 'impudence' which was admired,

though not shared, by Fry. 'Mr Bell,' said Fry, 'walks into the holy of holies of culture in knickerbockers with a big walking-stick in his hand, and just knocks one head off after another with a dextrous back-hander that leaves us gasping.'[1]

Though the theory which Bell offers is panchronistic and treats all works of visual art at all times and in all places equally, the controversial doctrine of 'significant form' which he argues in these books is deeply rooted in the local and particular circumstances in which *Art* was written. First and foremost *Art* was a manifesto of Bloomsbury aesthetics at a time when the manifesto was a highly popular means of promulgating artistic theories.[2] It appeared in March 1914, during a period of intense aesthetic activity in Britain—a period which had been ushered in by the first Post-Impressionist exhibition in the late months of 1910. This show had led to radical reassessments of the status of art in England; it provoked considerable changes in British painting and was rapidly followed up by exhi-

[1] Roger Fry, 'A New Theory of Art', *Nation*, 7 Mar. 1914, p. 938.
[2] Manifestos had been popularized by the Futurists whose first exhibition at the Sackville Gallery in 1912 had been accompanied by much documentary material. The fashion extended to the Neo-Realists and the Vorticists.

INTRODUCTION

bitions of other advanced movements from
the Continent, culminating in the second
Post-Impressionist exhibition in 1912. Per-
haps the most important effect of these exhibi-
tions was to make the discussion of art enor-
mously public. Newspapers, journals, and
periodicals which, in former years, had given
scant attention to matters concerned with art
suddenly became obsessed with modernism.
The first Post-Impressionist exhibition was a
succès de scandale; initially it provided highly
coloured journalistic copy, but before long
discussion of the new styles in art became a
matter of considerable seriousness. It was fol-
lowed rapidly by the influx of Fauvism,
Futurism, and Cubism from the Continent,
which together with the development of a
native movement—Vorticism—became topics
widely discussed in the current literature.

Much of the debate about modern art in
these years centred on the term 'Post-
Impressionism' which Clive Bell, though he is
aware of its limitations, uses frequently
throughout *Art*.[3] 'Impressionism', it will be
remembered, was a translation from the
French; it was widely used in French criticism
and was recognized by those whose style it
described. In contrast 'Post-Impressionism'

[3] *Art*, p. 46.

was an English invention, devised to form the title of Roger Fry's exhibition 'Manet and the Post-Impressionists' at the Grafton Galleries in 1910. At first it embraced the work of Cézanne, Van Gogh, Gauguin (all of whom were dead by 1910), and the Fauves, Matisse, Derain, and Vlaminck together with a number of French painters who were working towards the end of the nineteenth century and the beginning of the twentieth century. By the time of the second Post-Impressionist exhibition in October 1912 it had significantly changed its frame of reference and now encompassed the recent work of Braque and Picasso as well as the painting of English artists such as Duncan Grant, Vanessa Bell, Wyndham Lewis, and Eric Gill. What had happened was that between 1910 and 1912 'Post-Impressionism' had become a cult term which was used to describe many manifestations of the avant-garde. In 1911 the work of Eric Gill and Epstein was described as 'Post-Impressionist sculpture';[4] a review of D. H. Lawrence's first novel *The White Peacock* in the same year claimed that it was 'paulo-post-Impressionism in fiction';[5] *The Times* described Nijinski's performance in

[4] *Athenæum*, 28 Jan. 1911, pp. 104–5.
[5] Ibid., 25 Feb. 1911, p. 217.

INTRODUCTION

Stravinsky's *Rite of Spring* in 1913 as 'Post-Impressionist';[6] and in 1914 Horace Holly published a collection entitled *Post-Impressionist Poems*.[7]

It soon became clear to writers and artists who were already familiar with Continental art, like Frank Rutter and Walter Sickert, that Post-Impressionism had become such a loose and baggy monster that it was losing all credibility as an art-historical term. This fact was pointed up by the arrival, in 1912, first of Futurism then of Cubism, neither of which seemed to fit easily into the established category. In spite of disagreements, however, it was used once again in 1912 in the title of Roger Fry's second Post-Impressionist exhibition. Many of Bell's contemporaries, including Virginia Woolf, felt that they were living in a new age—a new 'Post-Impressionist age' as she called it[8]—in which many values, attitudes, and opinions were being re-examined and reassessed. Nowhere was the stress of this

[6] *The Times*, 5 July 1913, p. 11.

[7] Horace Holly, *Creation: Post Impressionist Poems* (London: A. C. Fifield, 1914). Richard Aldington thought that the title was 'a good idea' but 'the poems aren't much good' (*Egoist*, 1 June 1914, p. 210).

[8] Virginia Woolf to Vanessa Bell, 21 July 1911, in *The Flight of the Mind: The Letters of Virginia Woolf 1888–1912*, ed. Nigel Nicolson (London: Hogarth Press, 1975), p. 476.

ART

process greater than in the theory and practice of the arts and throughout *Art* Clive Bell is conscious of offering a view of art which is substantially different from those which preceded it.

In many important respects the second Post-Impressionist exhibition can be seen as forming the basis of Clive Bell's *Art*. The catalogue was prepared jointly by Roger Fry, Clive Bell, and Boris Anrep, and it was in his introduction to the English section that Bell first publicly propounded his idea of 'significant form'. How, then, does a Post-Impressionist regard a simple household object such as a coal-scuttle? he asked, replying: 'He regards it as an end in itself, as a significant form related on terms of equality with other significant forms.'[9] In this same catalogue Bell and Fry expressed views on contemporary art which were later to have repercussions for English criticism. On the one hand they both professed enthusiasm for Matisse's decorative designs, but on the other they were considerably less sure about the status of Picasso's Cubist paintings. Perhaps most important, however, both men dismissed Futurist work as

[9] 'The English Group', from the catalogue for the second Post-Impressionist exhibition (London: Ballantyne, 1912), p. 11.

INTRODUCTION

unworthy of inclusion in a modernist show.[10]

It was not long after the second Post-Impressionist exhibition that the publishers Chatto and Windus invited Fry to write a monograph on modern art. Fry, however, was setting up the Omega Workshops and was too busy to undertake the commission, so he passed it on to Clive Bell. Bell immediately busied himself with the task and the volume was published in 1914. Meanwhile Fry's workshop was under way. Its aim was to introduce the ideas of Post-Impressionism into the home through furniture and pottery decoration and textiles and fabric design. Fry wanted to give work to young artists who might otherwise be unemployed and one of those artists was Wyndham Lewis. Lewis had shown his pictures with great success in 1912 both at the Allied Artists' exhibition where they had been openly praised by both Fry and Bell,[11] and again at the second Post-Impressionist exhibition. But unlike Fry and Bell, Lewis's allegiances lay less with the Post-Impressionism of Matisse than with the

[10] Fry wrote that they had succeeded 'in developing a whole system of aesthetics out of a misapprehension of some of Picasso's recondite and difficult works' (ibid, p. 7)—a view from which Lewis strongly dissented.

[11] Roger Fry, *Nation*, 20 July 1912, p. 538, and Bell, *Athenæum*, 27 July 1912, p. 98.

Futurist celebration of mechanical energy and the geometric art of Cubism. He made no secret of this fact, nor did he disguise his personal antagonism to Fry—a combination of factors which led to a rupture within the Omega movement and the secession late in 1913 of Lewis and a number of other artists.

In the preface to the 1949 reprint of *Art* Bell looked back to this period, and what he remembered about 'the battle of Post-Impressionism' was the struggle with British philistinism (p. xvii). There is no doubt that in 1910 this struggle was uppermost, but what Bell had forgotten was that by 1913 when he was writing *Art* the enemy within was more formidable than the enemy without, and opposition to the Bloomsbury ethos was more solid amongst the new avant-garde than it was amongst the academicians and the critical establishment.

What happened in 1913 was that a division had taken place in the ranks of both modern criticism and artistic practice—between those who followed Matisse and those who were influenced by Picasso, between Fauvism and Futurism. Lewis fell into the latter category and was vocally assisted first by T. E. Hulme and later by Ezra Pound. Like the Italian Futurists this English group was highly ico-

INTRODUCTION

noclastic and determined to create modern art
for a modern world—turning their backs, if
necessary, on the art of the past. For them
'revolution' and 'anarchism' were terms of
approbation, and though they did not wish,
like Marinetti, to see Venice and its burden of
ancient monuments perish beneath the waves
of the Adriatic, they felt that if modern art was
to have any integrity it should see itself as
separate and distinct from all that had come
before. Consequently they set themselves up
as the enemies of Post-Impressionism as
defined by Fry and Bell, and when Lewis
described the paintings of the 'Cubist Room',
in an important exhibition held in Brighton at
the end of 1913 he made it very clear that his
aesthetic principles and those of his colleagues
were deeply opposed to the principles laid
down by Fry, Bell, and the other members of
Bloomsbury.[12]

The fact is that from the outset Post-
Impressionism had been the province of
Bloomsbury and in one important respect
Clive Bell's *Art* is a vindication of a view of art
which, during 1913, had come more and more

[12] Lewis wrote: 'To be done with tags, post impression-
ism [sic] is an insipid and pointless name invented by a
journalist, which has been naturally ousted by the better
word "Futurism" in public debate on modern art' ('The
Cubist Room', *Egoist*, 1 Jan. 1914, p. 8).

persistently under attack. That view had been promulgated mainly by Roger Fry, Desmond MacCarthy, and Clive Bell, each of whom had argued from a historicist position stressing both the newness of French art and the continuity between the painting of Cézanne and Gauguin and the primitive artists of Byzantium. Where Lewis and the Futurists argued that art was for the here-and-now and should embody all the importunate and immediate realities of modern life—the train, the machine, and the automobile—Fry and Bell stressed the permanent and timeless aspects of art and those things which separated aesthetic experience from the pressures of practical life—the distinction, in other words, between art and life. For Lewis the new 'geometrical art' as he called it drew its vitality from its opposition to the culture which preceded it; for Bell, Post-Impressionism was a revivification and a revitalization of a creative spirit which had slowly dwindled in western art as it became more and more embroiled in illusionism or the mechanical reproduction of natural forms.

For this reason a large part of *Art* is historical; it views the history of art from 'paleolithic days to the present' (as Bell modestly sets out his aims) through the spectacles of Post-

Impressionism. Bell openly admitted that his view of 'significant form' came to him in the presence of the works of Cézanne, and either consciously or unconsciously he tries, tests, and measures great works of the past by what he considered the supreme achievement of Cézanne.

Though Bell and Fry shared an enthusiasm for the work of Cézanne they were very different in terms of background, temperament, and, of course, age—all of which feed into their art criticism. Bell was born in 1881 and Fry was sixteen years his senior. Fry came from a long line of Quakers while Bell was one of the *nouveau-riche*. The family was moneyed and philistine and Bell was brought up in a large, ugly neo-Gothic mansion, Cleeve House, where 'animals dominated the conversation, yielding only occasionally to lawn tennis, hockey and the weather'.[13] Bell combined considerable sensibility with the attitudes of the country squire, and it is significant that the most bitter invective in *Art*, in the chapter entitled 'Society and Art', is reserved for moneyed philistines who reduce art to the level of polite drawing-room conversation. His time at Marlborough, about which he felt

[13] Quentin Bell, *Virginia Woolf: a Biography* (London: Hogarth Press, 1972), i. 113.

nothing but bitterness, was the first stage in his education as a rich young gentleman, but Cambridge reversed that process, introducing him to the life of the mind, to intense idealism, and indirectly, to art. He went up to Trinity College in 1899 where he rapidly fell in with Thoby Stephen, Leonard Woolf, and Lytton Strachey. At Trinity he was strongly influenced by the philosopher G. E. Moore to whose *Principia Ethica* he frequently refers in the argument of his book.[14] After leaving Cambridge there was an interval of big-game shooting in British Columbia followed by a period of research. In 1904 Bell

[14] *Art*, pp. 87–8, 107–8, 110. The influence of Moore on Bloomsbury is a vexed question. J. K. Johnstone in *The Bloomsbury Group* (London: Secker and Warburg, 1954) suggests that *Principia Ethica* was the Group's bible. William G. Bywater convincingly argues, however, that Bell adopts Moore's method but not his logic. He writes: 'Moore characterizes those propositions of which we have intuitive knowledge as incapable of proof; that is, they are self-evident. Self-evident propositions are not, and cannot be inferred from some other propositions. No logical reason—reasons, why these propositions themselves must be true or false—can be given in support of any claims about their truth value. . . . The proposition asserting that a painting possesses significant form is self-evident because the critic can offer no proof. His claim is not supported by logical reasons. The critic's task is to get people to hold to the belief—actually, have the experience—that some painting possesses significant form.' (William G. Bywater, *Clive Bell's Eye* (Detroit: Wayne State University, 1975), p. 33).

went to Paris to work on the Congress of Verona, but he became more interested in the Louvre than in the archives, and it was while he was in Paris that he experienced the work of the Post-Impressionists. He made the acquaintance of the painter Roderic O'Conor and on visits to his studio saw photographs of the work of Cézanne and drawings which Gauguin had given O'Conor. Marriage to Vanessa Stephen in 1907 intensified his interest in modern art but this did not bear real fruit until (as he mentions in *Art*) he met Roger Fry in a train travelling from Cambridge to London in January 1910.[15] By this time Fry was a well-known connoisseur of Italian Art, had been European adviser to the Metropolitan Museum of Art in New York, and had recently become editor of the *Burlington Magazine*. In the last two years, however, he had taken an interest in modern French art and when he met Bell he had recently published his own translation of a long article by Maurice Denis on Cézanne in the *Burlington Magazine*.[16] The Bells (both Vanessa and Clive) brought youthful enthusiasm into Fry's life—particularly enthusiasm

[15] *Art*, p. x.
[16] Maurice Denis, 'Cézanne—I and II', *Burlington Magazine*, 16 (Jan. 1910), pp. 207–19 and 275–80.

for modern art; Fry brought knowledge, experience, and influence and this powerful combination led to the explosive exhibition 'Manet and the Post-Impressionists' which Fry organized at the Grafton Galleries in November 1910.

Bell's principal intellectual debt, as he freely acknowledges in *Art*, was to Fry,[17] and especially to an important article which Fry published in 1909 entitled 'An Essay in Aesthetics'.[18] The burden of this paper is the view that the emotions and feelings experienced in life are distinct and separate from those experienced before a work of art, and Fry stresses again and again the autonomy and the importance of the imaginative, aesthetic life of the man as opposed to the practical, quotidian aspects of his mental activity. In *Art* Bell echoes, almost word for word, Fry's remarks about the fundamental difference in our response to beauty in objects of nature and to beauty in works of art. Fry wrote,

It may be objected, that many things in nature, such as flowers, possess [the] two qualities of order and variety in a high degree, and these objects do

[17] *Art*, pp. x–xii.
[18] Roger Fry, 'An Essay in Aesthetics', *New Quarterly*, 2 (Apr. 1909), pp. 171–90: reprinted in *Vision and Design*, ed. J. B. Bullen (Oxford: Oxford University Press, 1981), pp. 12–27.

undoubtedly stimulate and satisfy that clear disinterested contemplation which is characteristic of the aesthetic attitude. But in our reaction to a work of art there is something more—there is a consciousness of purpose, the consciousness of a peculiar relation of sympathy with the man who made this thing in order to arouse precisely the sensations we experience. And when we come to the higher works of art, where sensations are so arranged that they arouse in us deep emotions, this feeling of a special tie with the man who expressed them becomes very strong. . . . And this recognition of purpose is, I believe, an essential part of the aesthetic judgement proper.[19]

For his part Bell asks: 'Does anyone feel the same kind of emotion for a butterfly or a flower that he feels for a cathedral or a picture? Surely, it is not what I call an aesthetic emotion that most of us feel, generally, for natural beauty' (p. 13). As Bell admits, this theory (*pace* Moore) is based upon sensibility and 'personal experience of a peculiar emotion' (p. 6), and both he and Fry identify the intuitive, subjective response to art works under the term 'aesthetic emotion'. They ponder the question 'what are the special properties of a work of art which generate an aesthetic response in man?' and both decide that it is form,

[19] *Vision and Design*, p. 21.

not content, which is aesthetically moving. Fry tentatively divides these formal properties into rhythm, gesture, mass, organization of space, light and shade, and arrangements of colour. Bell is much bolder and puts forward a theory which he anticipates will invite 'pretty sharp criticism' (p. 234). He asks,

What quality is shared by all objects that provoke our aesthetic emotions? What quality is common to Sta. Sophia and the windows at Chartres, Mexican sculpture, a Persian bowl, Chinese carpets, Giotto's frescoes at Padua and the masterpieces of Poussin, Piero della Francesca, and Cézanne? Only one answer seems possible—significant form. (p. 8)

The circularity of this argument has often been pointed out. A work of art is by definition a work with power to evoke aesthetic emotion; aesthetic emotion is by definition the appreciation of significant form in a work of art; and significant form is by definition that feature of works of art which evokes aesthetic emotion. But Bell's ideas have received articulate support from a number of quarters. William G. Bywater defends Bell's position by pointing out how he is essentially 'audience oriented rather than artist oriented' and how he 'is not interested in establishing canons for

INTRODUCTION

propriety in the creation of works of art, rather he is a guide, or a signpost—a fallible one—who helps his audience see things they might otherwise overlook'.[20] He goes on to show how much more flexible is Bell's approach to works of art than is generally realized and how, by reference to 'ultimate reality', he subverts his own strict formalism and the sharp division between art and life by postulating what he calls a 'metaphysical hypothesis'. Bywater writes:

... it seems to me that Bell offers us the exciting opportunity of bringing what is most personal in us into contact with a painting. Upon making this effort, quite possibly we will experience a peculiar emotion, and see a work of art emerge before our eyes. None of this is conclusive, of course. What I want to suggest is that we are not being confronted with a sterile formalism which casts aside all appeal to the human within the aesthetic situation. Bell uses the notion of aesthetic emotion in a double thrust which brings audience and art into close relationship. This is the foundation of his humanistic formalism.[21]

It is not possible here to give a detailed account of the debate about the philosophical merits of Bell's theory, and those interested

[20] Bywater, p. 18.
[21] Ibid. p. 79.

should consult the books and articles men-
tioned in the section 'Select Bibliography',
but in historical terms the daring assertiveness
of Bell's views had the merit of cutting
through, at one stroke, some of the late-
Victorian notions that the greatness of a work
of art is related to its ability to vividly encap-
sulate moral issues, tell stories and anecdotes,
or be life-like.[22] Such a theory also opened the
way for non-specialists to enjoy the art works
of ancient or exotic cultures. Bell was writing
at a time when the arts of Byzantium, China,
South America, and Africa were coming into
vogue but their art objects could not be fitted
into a western aesthetic which derived from
the Renaissance.

Needless to say, as Bell anticipated, there
was some 'pretty sharp', albeit good-natured,
criticism of his theory and one of those critics
was Fry. Fry's reservations about the notion
of significant form was that it did not face the
problems of representation in art. However
rarefied our responses to works of art, he
argued, we cannot eliminate from our minds
the fact that (if they are not abstract works)
they represent something and are not simply

[22] These issues are well illustrated in the discussions on
painting between Lily Briscoe and Mr Bankes in Virginia
Woolf's novel *To the Lighthouse* (1927).

arrangements of form and colour.[23] The two men also differed strongly in their attitude to the metaphysical implications of Bell's theory.[24] Speaking of 'aesthetic emotion' in 1920, Fry was referring to Bell when he said: 'Those who experience it feel it to have a peculiar quality of "reality" which makes it matter of infinite importance in their lives. Any attempt I might make to explain this would probably land me in the depths of mysticism. On the edge of that gulf I stop.'[25] Fry knew, of course that Clive Bell had no such inhibitions and had joyfully thrown himself into the gulf in *Art*. There is nothing of Fry's hesitancy in his bold assertion that what makes 'significant form' significant is that from it 'we catch a sense of ultimate reality' and the apprehension of this 'ultimate reality' is, at bottom, a mystical, spiritual, and religious experience.[26] For Bell the recognition of significant form is much more than an act of perception or imagination—it is a mystery in which 'we become

[23] Later in his career Bell, too, came to feel that his ideas had been simplistic, and it is one of the features of *Art* that it contains very little detailed analysis of individual works which would have obliged him to confront the representational issue.

[24] See *Art*, p. xi.

[25] Roger Fry, 'Retrospect', *Vision and Design*, p. 212.

[26] See *Art*, p. 54.

aware of ... essential reality, of the God in everything, of the universal in the particular, of the all-pervading rhythm' (p. 69). Fry had put forward a similar idea in a considerably more circumspect way in 'An Essay on Aesthetics'. Art and religion, he argued, draw close together at some points 'for religion is also an affair of the imaginative life'. Bell takes up this parallel in *Art* but he presses the similarities much harder than Fry had dared to do. Both art and religion, he says, generate a kind of spiritual 'ecstasy' (p. 81); they are 'twin manifestations of the spirit' (p. 82) and are 'means to similar states of mind' (p. 93). For Bell artists are the self-sacrificing priests in a cult, a new clerisy (with all its echoes of Matthew Arnold), since 'religion is art; [and] art is a religion ... and it is towards art that modern minds turn, not only for the most perfect expression of transcendent emotion, but for an inspiration by which to live' (p. 277).[27]

[27] In 'The Study of Poetry' (1880) Arnold had written: 'More and more mankind will discover that we have to turn to poetry to interpret life for us, to console us, to sustain us. Without poetry, our science will appear incomplete; and most of what now passes with us for religion and philosophy will be replaced by poetry' (*The Complete Prose Works of Matthew Arnold*, ed. R. H. Super (Ann Arbor: University of Michigan Press), ix. 161).

It is this strain of Bloomsbury ideology which prompted an amusing painting by Henry Tonks entitled *The Unknown God. Roger Fry Preaching the New Faith and Clive Bell ringing the Bell* (*c.*1912) and several cartoons by Max Beerbohm[28] and brought down D. H. Lawrence's invective on the mystical worship of art in his essay 'Introduction to These Paintings'.[29]

In spite of its appearance of novelty and its fresh and candid response to works of art there is, however, something very familiar about the evangelical fervour of Bell's tone in *Art*. The combination of art-theory and social theory,

[28] Beerbohm's 'We needs must love the highest when we see it' (1913: King's College, Cambridge) showed Roger Fry appreciating a toy soldier in an art gallery, and his 'Significant Form' (n.d.: private collection) was accompanied by the following caption:

Mr. Clive Bell: 'I always think that when one feels one's been carrying a theory too far, *then's* the time to carry it a little further.'

Mr. Roger Fry: 'A *little*? Good heavens, man! Are you growing old?'

[29] D. H. Lawrence spoke of how 'these evangelical gentlemen at once ran up their chapels, in a Romanesque or Byzantine shape, as was natural for a primitive and a methodist, and started to cry forth their doctrines in the decadent wilderness. They discovered once more that the aesthetic experience was an ecstasy, an ecstasy granted only to the chosen few, the elect, among whom said critics were, of course, the arch-elect' (*Phoenix: the Posthumous Papers of D. H. Lawrence*, ed. Edward McDonald (London: Heinemann, 1936, reprinted 1967), p. 567.

the connections between aesthetic experience
and religious experience, are strongly reminis-
cent of one aspect of the work of Ruskin, who
receives guarded praise from Bell at one point
in the book.[30] As an aesthetic 'eminent Victor-
ian' Ruskin posed something of a problem for
Bloomsbury; gifted with a highly developed
visual sensibility, combined with outstanding
literary talent, he changed the face of English
art-criticism. He died in 1900 by which time
he had gained a reputation for being an eccen-
tric sage though he had never been central to
the British art establishment. As a young man
in the 1840s and 1850s, he had infuriated that
establishment by insisting that art possessed
the kind of moral importance normally re-
served for religious questions and managed to
secure the attention of his Victorian audience
by insisting that art was as much an affair of
the spirit as of the senses. With this end in
view he had used the early volumes of *Modern
Painters* (vol. 1, 1843; vol. ii, 1846) and *The
Stones of Venice* (1851–3) to rewrite the his-
tory of art from the point of view of truth to
the natural world and the moral integrity of
the artist. If anyone could be said to have
walked into 'the holy of holies of culture in
knickerbockers with a big walking-stick in his

[30] *Art*, p. 205.

INTRODUCTION

hand' it was Ruskin, and much of his early effort was dedicated to the aim of showing that the revered masters of the past were actually inferior to the supreme genius of modern English painting—J. M. W. Turner.

But the similarities between Ruskin's work and Bell's *Art* are not confined to attitudes of mind and approaches to art; there are also strong and specific similarities of opinion and style. Both Ruskin and Bell, for example, conceive the history of art as a series of slopes which start in the pure white heights of primitivism and descend to the swampy flats of the nineteenth century. Primitivism meant something rather different for each writer, but they share the view that art becomes progressively effete and tired as it approaches the present. Ruskin's primitives are the early Italian painters, and though later in life he developed an admiration for the Venetian painters of the Renaissance, he preserved a reverence for pre-Renaissance artists. For Bell, 'primitive art is good . . . for as a rule it is also free from descriptive qualities. In primitive art you will find no accurate representation; you will find only significant form' (p. 22). In this category he placed Sumerian sculpture, pre-dynastic Egyptian art, archaic Greek work, 'Wei and T'ang masterpieces', and above all 'the

primitive Byzantine art of the sixth century' (p. 23). In Ruskin's writing the early Italian masters join hands with Turner in their sensitive and accurate description of natural forms, in Bell's *Art* the Byzantines of the sixth century are one with Cézanne in their creation of significant form.[31]

In Ruskin the decline of art is marked out by the descent from 'the Grand Canal to Gower Street';[32] in *Art* it is paced out by 'the long journey from Santa Sophia to St. John's Wood,' but both writers take the highly eccentric view that the Italian Renaissance was at best an interlude in art-history and at worst the source of modern social and spiritual evils— what Bell calls 'The Classical Renaissance and its Diseases'. In the middle of the nineteenth century Ruskin was reacting against the academic veneration of High Renaissance art which extended from Vasari through Reynolds to Sir Charles Eastlake; in the early days of the twentieth century Bell was reacting against the aesthetic reverence for the Renaissance in Pater and Symonds, but when Bell claims that the period from Giotto to Leonardo is a 'long . . . imperceptible fall' (p. 123) Ruskin would not

[31] Ibid., p. 130.
[32] Ruskin, *The Stones of Venice*, vol. iii, in *The Works*, ed. E. T. Cook and Alexander Wedderburn (London: George Allen, 1903–12), xi. 4.

INTRODUCTION

have disagreed with him, since Ruskin himself had argued that Leonardo was more of an engineer than an artist with 'hardly a picture left to bear his name'.[33]

In the early volumes of *Modern Painters* and in the two volumes of *The Stones of Venice* Ruskin inveighs loudly against the cold sterility, the lack of humanity, and the dead perfection of Renaissance art, and similarly Bell speaks of the Renaissance as 'a mere fever-flash' (p. 156)—a movement that was 'purely intellectual'. Bell's remarks on Correggio's 'lasciviousness' and Michelangelo's figures as 'noble animal[s] whose muscles wriggle heroically as watch-springs' (p. 164) would have received the young Ruskin's approbation and he would have sympathized entirely with Bell's view of Boccaccio as a 'full stop' in literature and his description of Petrarch's 'curse of mellifluous phrase-making' (p. 154). Like Ruskin, too, Bell is contemptuous of seventeenth-century Dutch painting. For Bell, Dutch realism is slick and superficial—'urchins with painted apples: that makes the people stare' (p. 152); for Ruskin Dutch art is merely the art of 'bricks and fogs, fat cattle and ditchwater'.[34]

[33] Ibid., pp. 70–1.
[34] Ruskin, *The Stones of Venice*, vol. i, *The Works*, ix. 45.

Rembrandt, for Bell, 'is a typical ruin of his age. For, except in a few of his later works, his sense of form and design is utterly lost in a mess of rhetoric, romance and chiaroscuro' (p. 172); while Ruskin claimed that Rembrandt's 'chiaroscuro is always forced—generally false, and wholly vulgar'.[35]

Of course it would be absurd to suggest that Ruskin and Bell agree on all issues, as it would be wrong to force the parallel between the creative genius of Ruskin and the minor critical talent of Bell. Unlike Ruskin, Bell has little admiration of Gothic architecture and no love for Titian and Veronese; nor does Bell share Ruskin's admiration for the members of the Pre-Raphaelite Brotherhood who were, in Bell's view, not artists, but archaeologists.[36] They intuited, says Bell, that early Italian art was superior to that of the High Renaissance but they emulated the outward form and possessed none of the spirit. Most prominently the two disagree about the relative merits of Claude Lorraine and Turner, some of whose pictures hang (at Turner's request) side by side in the National Gallery. For Ruskin, this direct comparison served to illustrate the superiority of Turner; Bell, however, felt that

[35] 'Academy Notes', *The Works*, xiv. 254.
[36] *Art*, p. 185.

in Turner's work there was no sign of significant form. He was 'so much excited by his observations and his sentiments that he set them all down without even trying to co-ordinate them in a work of art', adding rather harshly that 'he could not have done so in any case' (p. 174).

The name of Turner, however, points up what is perhaps the closest resemblance between the structure of *Art* and the early volumes of *Modern Painters*. Both texts are aimed at the vindication of the work of a single artist whose mission was to bring salvation to a world swamped in irrelevant artistic dogma or suffocated by academicism. For Ruskin, of course, this painter is Turner who, he says, 'is the only man who has ever given an entire transcript of the whole system of nature, and is, in this point of view, the only perfect landscape painter whom the world has ever seen'.[37] For Bell it is Cézanne who is 'a type of the perfect artist' (p. 211), the 'Christopher Columbus of a new continent of form' (p. 207), whose business was 'not to make pictures, but to work out his own salvation' (p. 211). Furthermore, both Ruskin and Bell interpret the history of art in terms of their special view of the work of their chosen artist.

[37] *Modern Painters*, vol. i, *The Works*, iii. 616.

xlvii

'What contemporary art owes to [Cézanne] it would be hard to compute,' says Bell in a passage of ecstatic outpouring. 'Without him the artists of genius and talent who to-day delight us with the significance and originality of their work might have remained port-bound for ever ...' (p. 207).

The similarities between Ruskin and Bell, odd bedfellows though they be, did not go unnoticed when Bell published *Art* in 1914,[38] but I have stressed their similarities to show that, for all its appearance of revolutionary fervour, *Art* is no subversive document. It offers shocks and surprises for the established view of the history of art and it challenges local and particular evaluations, but at bottom its tendency is conservative. For Bell the new revolution in art is not one which overthrows the past; it is one which re-establishes ancient and primitive values. In certain important ways it is a backward-looking thesis, attempting to reassess ancient art in the light of modern art. But 'modern art' for Bell means the painting of Cézanne and his French and

[38] An anonymous reviewer in the *Athenæum* said that 'Mr Bell, like Ruskin, rebels against the normal view; for him, too, there is a profound connexion between art and morals' (*Athenæum*, 21 Feb. 1914, p. 280), and D. H. Lawrence suggested that Bell was 'outdoing Ruskin' (Phoenix, p. 567).

English followers. About the art of the immediate present or the future he is less sanguine. So he is diffident about Cubism and he is openly hostile to Futurism.

In 1914 *Art* was a popular book, and it was popular because readers who had been brought up in the tradition of *Modern Painters* recognized and were familiar with its evangelical and passionate idealism. Its rhetoric is the rhetoric of Ruskin, not Marinetti, and its appeal is to humble self-sacrifice in the great aesthetic cause, not to rampant self-expression. Bell's message is one of continuity, not confrontation, and it was one which in 1914 the British wished to hear. Fry's description of Bell was apt; it was a walking-stick which he took into the holy of holies of culture, not a bomb, and when he toppled the idols from their pillars he merely shook their foundations a little—he did not destroy them. Throughout the first decade of the century the British had been persistently disturbed by the threat of social and political upheaval. At home the suffragettes had been on the march, troops had been sent in to check the power of the miners in South Wales, and anarchist activity had erupted in violent incidents in London. Above all the British had watched with anxiety the growing military might of Germany. Clive Bell came

ART

with an attractive gospel—the notion that in this state of flux and uncertainty some values were beyond change and were untouchable. So to be told that 'great art remains stable and unobscure because the feelings that it awakens are independent of time and place' (p. 37) and that 'the essential quality in art is permanent' (p. 41) was music to the ears of a nation poised on the brink of the First World War.

J. B. BULLEN

I

WHAT IS ART?

1

THE AESTHETIC HYPOTHESIS

IT is improbable that more nonsense has been written about aesthetics than about anything else : the literature of the subject is not large enough for that. It is certain, however, that about no subject with which I am acquainted has so little been said that is at all to the purpose. The explanation is discoverable. He who would elaborate a plausible theory of aesthetics must possess two qualities—artistic sensibility and a turn for clear thinking. Without sensibility a man can have no aesthetic experience, and, obviously, theories not based on broad and deep aesthetic experience are worthless. Only those for whom art is a constant source of passionate emotion can possess the data from which profitable theories may be deduced ; but to deduce profitable theories even from accurate data involves a certain amount of brain-work, and, unfortunately, robust in-

tellects and delicate sensibilities are not inseparable. As often as not, the hardest thinkers have had no aesthetic experience whatever. I have a friend blessed with an intellect as keen as a drill, who, though he takes an interest in aesthetics, has never during a life of almost forty years been guilty of an aesthetic emotion. So, having no faculty for distinguishing a work of art from a handsaw, he is apt to rear up a pyramid of irrefragable argument on the hypothesis that a handsaw is a work of art. This defect robs his perspicuous and subtle reasoning of much of its value; for it has ever been a maxim that faultless logic can win but little credit for conclusions that are based on premises notoriously false. Every cloud, however, has its silver lining, and this insensibility, though unlucky in that it makes my friend incapable of choosing a sound basis for his argument, mercifully blinds him to the absurdity of his conclusions while leaving him in full enjoyment of his masterly dialectic. People who set out from the hypothesis that Sir Edwin Landseer[1] was the finest painter that ever lived will feel no uneasiness about an aesthetic which proves that Giotto[2] was the worst. So, my friend, when he arrives very

4

logically at the conclusion that a work of art should be small or round or smooth, or that to appreciate fully a picture you should pace smartly before it or set it spinning like a top, cannot guess why I ask him whether he has lately been to Cambridge, a place he sometimes visits.

On the other hand, people who respond immediately and surely to works of art, though, in my judgment, more enviable than men of massive intellect but slight sensibility, are often quite as incapable of talking sense about aesthetics. Their heads are not always very clear. They possess the data on which any system must be based; but, generally, they want the power that draws correct inferences from true data. Having received aesthetic emotions from works of art, they are in a position to seek out the quality common to all that have moved them, but, in fact, they do nothing of the sort. I do not blame them. Why should they bother to examine their feelings when for them to feel is enough? Why should they stop to think when they are not very good at thinking? Why should they hunt for a common quality in all objects that move them in a particular way when they can linger over the many delicious and

peculiar charms of each as it comes? So, if they write criticism and call it aesthetics, if they imagine that they are talking about Art when they are talking about particular works of art or even about the technique of painting, if, loving particular works they find tedious the consideration of art in general, perhaps they have chosen the better part. If they are not curious about the nature of their emotion, nor about the quality common to all objects that provoke it, they have my sympathy, and, as what they say is often charming and suggestive, my admiration too. Only let no one suppose that what they write and talk is aesthetics; it is criticism, or just " shop."

The starting-point for all systems of aesthetics must be the personal experience of a peculiar emotion. The objects that provoke this emotion we call works of art. All sensitive people agree that there is a peculiar emotion provoked by works of art. I do not mean, of course, that all works provoke the same emotion. On the contrary, every work produces a different emotion. But all these emotions are recognisably the same in kind; so far, at any rate, the best opinion is on my side. That there is a particular kind of emotion pro-

6

voked by works of visual art, and that this emotion is provoked by every kind of visual art, by pictures, sculptures, buildings, pots, carvings, textiles, &c., &c., is not disputed, I think, by anyone capable of feeling it. This emotion is called the aesthetic emotion; and if we can discover some quality common and peculiar to all the objects that provoke it, we shall have solved what I take to be the central problem of aesthetics. We shall have discovered the essential quality in a work of art, the quality that distinguishes works of art from all other classes of objects.

For either all works of visual art have some common quality, or when we speak of "works of art" we gibber. Everyone speaks of "art," making a mental classification by which he distinguishes the class "works of art" from all other classes. What is the justification of this classification? What is the quality common and peculiar .to all members of this class? Whatever it be, no doubt it is often found in company with other qualities; but they are adventitious—it is essential. There must be some one quality without which a work of art cannot exist; possessing which, in the least degree, no work is altogether

worthless. What is this quality? What quality is shared by all objects that provoke our aesthetic emotions? What quality is common to Sta. Sophia and the windows at Chartres, Mexican sculpture, a Persian bowl, Chinese carpets, Giotto's frescoes at Padua, and the masterpieces of Poussin, Piero della Francesca, and Cézanne?[3] Only one answer seems possible—significant form. In each, lines and colours combined in a particular way, certain forms and relations of forms, stir our aesthetic emotions. These relations and combinations of lines and colours, these aesthetically moving forms, I call "Signifi cant Form"; and "Significant Form" is the one quality common to all works of visual art.

At this point it may be objected that I am making aesthetics a purely subjective business, since my only data are personal experiences of a particular emotion. It will be said that the objects that provoke this emotion vary with each individual, and that therefore a system of aesthetics can have no objective validity. It must be replied that any system of aesthetics which pretends to be based on some objective truth is so palpably ridiculous as not to be worth discussing. We have no other means of recog-

nising a work of art than our feeling for it. The objects that provoke aesthetic emotion vary with each individual. Aesthetic judgments are, as the saying goes, matters of taste; and about tastes, as everyone is proud to admit, there is no disputing. A good critic may be able to make me see in a picture that had left me cold things that I had overlooked, till at last, receiving the aesthetic emotion, I recognise it as a work of art. To be continually pointing out those parts, the sum, or rather the combination, of which unite to produce significant form, is the function of criticism. But it is useless for a critic to tell me that something is a work of art; he must make me feel it for myself. This he can do only by making me see; he must get at my emotions through my eyes. Unless he can make me see something that moves me, he cannot force my emotions. I have no right to consider anything a work of art to which I cannnot react emotionally; and I have no right to look for the essential quality in anything that I have not *felt* to be a work of art. The critic can affect my aesthetic theories only by affecting my aesthetic experience. All systems of aesthetics must be based on personal ex-

perience—that is to say, they must be subjective.

Yet, though all aesthetic theories must be based on aesthetic judgments, and ultimately all aesthetic judgments must be matters of personal taste, it would be rash to assert that no theory of aesthetics can have general validity. For, though A, B, C, D are the works that move me, and A, D, E, F the works that move you, it may well be that x is the only quality believed by either of us to be common to all the works in his list. We may all agree about aesthetics, and yet differ about particular works of art. We may differ as to the presence or absence of the quality x. My immediate object will be to show that significant form is the only quality common and peculiar to all the works of visual art that move me; and I will ask those whose aesthetic experience does not tally with mine to see whether this quality is not also, in their judgment, common to all works that move them, and whether they can discover any other quality of which the same can be said.

Also at this point a query arises, irrelevant indeed, but hardly to be suppressed:

THE AESTHETIC HYPOTHESIS

"Why are we so profoundly moved by forms related in a particular way?" The question is extremely interesting, but irrelevant to aesthetics. In pure aesthetics we have only to consider our emotion and its object: for the purposes of aesthetics we have no right, neither is there any necessity, to pry behind the object into the state of mind of him who made it. Later, I shall attempt to answer the question; for by so doing I may be able to develop my theory of the relation of art to life. I shall not, however, be under the delusion that I am rounding off my theory of aesthetics. For a discussion of aesthetics, it need be agreed only that forms arranged and combined according to certain unknown and mysterious laws do move us in a particular way, and that it is the business of an artist so to combine and arrange them that they shall move us. These moving combinations and arrangements I have called, for the sake of convenience and for a reason that will appear later, "Significant Form."

A third interruption has to be met. Are you forgetting about colour?" someone inquires. Certainly not; my term "significant form" included combinations

of lines and of colours. The distinction between form and colour is an unreal one; you cannot conceive a colourless line or a colourless space; neither can you conceive a formless relation of colours. In a black and white drawing the spaces are all white and all are bounded by black lines; in most oil paintings the spaces are multi-coloured and so are the boundaries; you cannot imagine a boundary line without any content, or a content without a boundary line. Therefore, when I speak of significant form, I mean a combination of lines and colours (counting white and black as colours) that moves me aesthetically.

Some people may be surprised at my not having called this "beauty." Of course, to those who define beauty as "combinations of lines and colours that provoke aesthetic emotion," I willingly concede the right of substituting their word for mine. But most of us, however strict we may be, are apt to apply the epithet "beautiful" to objects that do not provoke that peculiar emotion produced by works of art. Everyone, I suspect, has called a butterfly or a flower beautiful. Does anyone feel the same kind of emotion for a butterfly or a flower that

he feels for a cathedral or a picture? Surely, it is not what I call an aesthetic emotion that most of us feel, generally, for natural beauty. I shall suggest, later, that some people may, occasionally, see in nature what we see in art, and feel for her an aesthetic emotion; but I am satisfied that, as a rule, most people feel a very different kind of emotion for birds and flowers and the wings of butterflies from that which they feel for pictures, pots, temples and statues. Why these beautiful things do not move us as works of art move is another, and not an aesthetic, question. For our immediate purpose we have to discover only what quality is common to objects that do move us as works of art. In the last part of this chapter, when I try to answer the question—" Why are we so profoundly moved by some combinations of lines and colours?" I shall hope to offer an acceptable explanation of why we are less profoundly moved by others.

Since we call a quality that does not raise the characteristic aesthetic emotion " Beauty," it would be misleading to call by the same name the quality that does. To make " beauty" the object of the aesthetic emotion, we must give to the

word an over-strict and unfamiliar definition. Everyone sometimes uses "beauty" in an unaesthetic sense; most people habitually do so. To everyone, except perhaps here and there an occasional aesthete, the commonest sense of the word is unaesthetic. Of its grosser abuse, patent in our chatter about "beautiful huntin'" and "beautiful shootin'," I need not take account; it would be open to the precious to reply that they never do so abuse it. Besides, here there is no danger of confusion between the aesthetic and the non-aesthetic use; but when we speak of a beautiful woman there is. When an ordinary man speaks of a beautiful woman he certainly does not mean only that she moves him aesthetically; but when an artist calls a withered old hag beautiful he may sometimes mean what he means when he calls a battered torso beautiful. The ordinary man, if he be also a man of taste, will call the battered torso beautiful, but he will not call a withered hag beautiful because, in the matter of women, it is not to the aesthetic quality that the hag may possess, but to some other quality that he assigns the epithet. Indeed, most of us never dream of going for aesthetic emotions to human

beings, from whom we ask something very different. This "something," when we find it in a young woman, we are apt to call "beauty." We live in a nice age. With the man-in-the-street "beautiful" is more often than not synonymous with "desirable"; the word does not necessarily connote any aesthetic reaction whatever, and I am tempted to believe that in the minds of many the sexual flavour of the word is stronger than the aesthetic. I have noticed a consistency in those to whom the most beautiful thing in the world is a beautiful woman, and the next most beautiful thing a picture of one. The confusion between aesthetic and sensual beauty is not in their case so great as might be supposed. Perhaps there is none; for perhaps they have never had an aesthetic emotion to confuse with their other emotions. The art that they call "beautiful" is generally closely related to the women. A beautiful picture is a photograph of a pretty girl; beautiful music, the music that provokes emotions similar to those provoked by young ladies in musical farces; and beautiful poetry, the poetry that recalls the same emotions felt, twenty years earlier, for the rector's daughter. Clearly the word "beauty" is used to con-

note the objects of quite distinguishable
emotions, and that is a reason for not em-
ploying a term which would land me in-
evitably in confusions and misunderstandings
with my readers.

On the other hand, with those who
judge it more exact to call these com-
binations and arrangements of form that
provoke our aesthetic emotions, not "signi-
ficant form," but "significant relations of
form," and then try to make the best of
two worlds, the aesthetic and the meta-
physical, by calling these relations "rhythm,"
I have no quarrel whatever.[4] Having made
it clear that by "significant form" I mean
arrangements and combinations that move
us in a particular way, I willingly join
hands with those who prefer to give a
different name to the same thing.

The hypothesis that significant form is
the essential quality in a work of art has
at least one merit denied to many more
famous and more striking—it does help to
explain things. We are all familiar with
pictures that interest us and excite our
admiration, but do not move us as works
of art. To this class belongs what I call
"Descriptive Painting"—that is, painting
in which forms are used not as objects of

emotion, but as means of suggesting emotion or conveying information. Portraits of psychological and historical value, topographical works, pictures that tell stories and suggest situations, illustrations of all sorts, belong to this class. That we all recognise the distinction is clear, for who has not said that such and such a drawing was excellent as illustration, but as a work of art worthless? Of course many descriptive pictures possess, amongst other qualities, formal significance, and are therefore works of art: but many more do not. They interest us; they may move us too in a hundred different ways, but they do not move us aesthetically. According to my hypothesis they are not works of art. They leave untouched our aesthetic emotions because it is not their forms but the ideas or information suggested or conveyed by their forms that affect us.

Few pictures are better known or liked than Frith's "Paddington Station";[5] certainly I should be the last to grudge it its popularity. Many a weary forty minutes have I whiled away disentangling its fascinating incidents and forging for each an imaginary past and an improbable future. But certain though it is that Frith's master-

piece, or engravings of it, have provided thousands with half-hours of curious and fanciful pleasure, it is not less certain that no one has experienced before it one half-second of aesthetic rapture — and this although the picture contains several pretty passages of colour, and is by no means badly painted. "Paddington Station" is not a work of art; it is an interesting and amusing document. In it line and colour are used to recount anecdotes, suggest ideas, and indicate the manners and customs of an age: they are not used to provoke aesthetic emotion. Forms and the relations of forms were for Frith not objects of emotion, but means of suggesting emotion and conveying ideas.

The ideas and information conveyed by "Paddington Station" are so amusing and so well presented that the picture has considerable value and is well worth preserving. But, with the perfection of photographic processes and of the cinematograph, pictures of this sort are becoming otiose. Who doubts that one of those *Daily Mirror* photographers in collaboration with a *Daily Mail* reporter can tell us far more about "London day by day" than any Royal Academician? For an account of manners and fashions we shall go, in

future, to photographs, supported by a little bright journalism, rather than to descriptive painting. Had the imperial academicians of Nero, instead of manufacturing incredibly loathsome imitations of the antique, recorded in fresco and mosaic the manners and fashions of their day, their stuff, though artistic rubbish, would now be an historical gold-mine. If only they had been Friths instead of being Alma Tademas![6] But photography has made impossible any such transmutation of modern rubbish. Therefore it must be confessed that pictures in the Frith tradition are grown superfluous; they merely waste the hours of able men who might be more profitably employed in works of a wider beneficence. Still, they are not unpleasant, which is more than can be said for that kind of descriptive painting of which "The Doctor"[7] is the most flagrant example. Of course "The Doctor" is not a work of art. In it form is not used as an object of emotion, but as a means of suggesting emotions. This alone suffices to make it nugatory; it is worse than nugatory because the emotion it suggests is false. What it suggests is not pity and admiration but a sense of complacency in our

own pitifulness and generosity. It is senti-
mental. Art is above morals, or, rather,
all art is moral because, as I hope to show
presently, works of art are immediate means
to good. Once we have judged a thing a
work of art, we have judged it ethically
of the first importance and put it beyond
the reach of the moralist. But descriptive
pictures which are not works of art, and,
therefore, are not necessarily means to good
states of mind, are proper objects of the
ethical philosopher's attention. Not being
a work of art, " The Doctor " has none of
the immense ethical value possessed by all
objects that provoke aesthetic ecstasy ; and
the state of mind to which it is a means,
as illustration, appears to me undesirable.

The works of those enterprising young
men, the Italian Futurists, are notable
examples of descriptive painting.[8] Like the
Royal Academicians, they use form, not to
provoke aesthetic emotions, but to convey
information and ideas. Indeed, the published
theories of the Futurists prove that their
pictures ought to have nothing whatever to
do with art. Their social and political
theories are respectable, but I would suggest
to young Italian painters that it is possible to
become a Futurist in thought and action and

yet remain an artist, if one has the luck to be born one. To associate art with politics is always a mistake. Futurist pictures are descriptive because they aim at presenting in line and colour the chaos of the mind at a particular moment; their forms are not intended to promote aesthetic emotion but to convey information. These forms, by the way, whatever may be the nature of the ideas they suggest, are themselves anything but revolutionary. In such Futurist pictures as I have seen—perhaps I should except some by Severini[9]—the drawing, whenever it becomes representative as it frequently does, is found to be in that soft and common convention brought into fashion by Besnard[10] some thirty years ago, and much affected by Beaux-Art students ever since. As works of art, the Futurist pictures are negligible; but they are not to be judged as works of art. A good Futurist picture would succeed as a good piece of psychology succeeds; it would reveal, through line and colour, the complexities of an interesting state of mind. If Futurist pictures seem to fail, we must seek an explanation, not in a lack of artistic qualities that they never were intended to possess, but rather in the minds the states of which they are intended to reveal.

ART

Most people who care much about art find that of the work that moves them most the greater part is what scholars call "Primitive." Of course there are bad primitives. For instance, I remember going, full of enthusiasm, to see one of the earliest Romanesque churches in Poitiers (Notre-Dame-la-Grande), and finding it as ill-proportioned, over-decorated, coarse, fat and heavy as any better class building by one of those highly civilised architects who flourished a thousand years earlier or eight hundred later. But such exceptions are rare. As a rule primitive art is good—and here again my hypothesis is helpful—for, as a rule, it is also free from descriptive qualities. In primitive art you will find no accurate representation; you will find only significant form. Yet no other art moves us so profoundly. Whether we consider Sumerian sculpture or pre-dynastic Egyptian art, or archaic Greek, or the Wei and T'ang masterpieces, * or those early Japanese works of

* The existence of the Ku K'ai-chih makes it clear that the art of this period (fifth to eighth centuries), was a typical primitive movement. To call the great vital art of the Liang, Chen, Wei, and Tang dynasties a development out of the exquisitely refined and exhausted art of the Han decadence—from which Ku K'ai-chih is a delicate straggler—is to call Romanesque sculpture a development out of Praxiteles. Between the two some-

which I had the luck to see a few superb
examples (especially two wooden Bodhi-
sattvas) at the Shepherd's Bush Exhibition in
1910,[11] or whether, coming nearer home, we
consider the primitive Byzantine art of the
sixth century and its primitive developments
amongst the Western barbarians, or, turning
far afield, we consider that mysterious and
majestic art that flourished in Central and
South America before the coming of the
white men, in every case we observe three
common characteristics—absence of repre-
sentation, absence of technical swagger, sub-
limely impressive form. Nor is it hard to
discover the connection between these three.
Formal significance loses itself in preoccupa-
tion with exact representation and ostentatious
cunning.*

thing has happened to refill the stream of art. What
had happened in China was the spiritual and emotional
revolution that followed the onset of Buddhism.

* This is not to say that exact representation is bad in
itself. It is indifferent. A perfectly represented form
may be significant, only it is fatal to sacrifice significance
to representation. The quarrel between significance and
illusion seems to be as old as art itself, and I have little
doubt that what makes most palaeolithic art so bad is
a preoccupation with exact representation. Evidently
palaeolithic draughtsmen had no sense of the significance
of form. Their art resembles that of the more capable
and sincere Royal Academicians: it is a little higher
than that of Sir Edward Poynter and a little lower than
that of the late Lord Leighton.[12] That this is no paradox

ART

Naturally, it is said that if there is little representation and less saltimbancery in primitive art, that is because the primitives were unable to catch a likeness or cut intellectual capers. The contention is beside the point. There is truth in it, no doubt, though, were I a critic whose reputation depended on a power of impressing the public with a semblance of knowledge, I should be more cautious about urging it than such people generally are. For to suppose that the Byzantine masters wanted skill, or could not have created an illusion had they wished to do so, seems to imply ignorance of the amazingly dexterous realism of the notoriously bad works of that age. Very often, I fear, the misrepresentation of the primitives must be attributed to what the critics call, " wilful distortion." Be that as it may, the point is that, either from want of skill or want of will, primitives neither create illusions, nor make display of ex-

let the cave-drawings of Altamira, or such works as the sketches of horses found at Bruniquel and now in the British Museum, bear witness. If the ivory head of a girl from the Grotte du Pape, Brassempouy (*Musée St. Germain*) and the ivory torso found at the same place (*Collection St. Cric*), be, indeed, palaeolithic, then there were good palaeolithic artists who created and did not imitate form. Neolithic art is, of course, a very different matter.

travagant accomplishment, but concentrate their energies on the one thing needful—the creation of form. Thus have they created the finest works of art that we possess.

Let no one imagine that representation is bad in itself; a realistic form may be as significant, in its place as part of the design, as an abstract. But if a representative form has value, it is as form, not as representation. The representative element in a work of art may or may not be harmful; always it is irrelevant. For, to appreciate a work of art we need bring with us nothing from life, no knowledge of its ideas and affairs, no familiarity with its emotions. Art transports us from the world of man's activity to a world of aesthetic exaltation. For a moment we are shut off from human interests; our anticipations and memories are arrested; we are lifted above the stream of life. The pure mathematician rapt in his studies knows a state of mind which I take to be similar, if not identical. He feels an emotion for his speculations which arises from no perceived relation between them and the lives of men, but springs, inhuman or super-human, from the heart of an abstract science. I wonder, sometimes, whether the appreciators of art and of

mathematical solutions are not even more closely allied. Before we feel an aesthetic emotion for a combination of forms, do we not perceive intellectually the rightness and necessity of the combination? If we do, it would explain the fact that passing rapidly through a room we recognise a picture to be good, although we cannot say that it has provoked much emotion. We seem to have recognised intellectually the rightness of its forms without staying to fix our attention, and collect, as it were, their emotional significance. If this were so, it would be permissible to inquire whether it was the forms themselves or our perception of their rightness and necessity that caused aesthetic emotion. But I do not think I need linger to discuss the matter here. I have been inquiring why certain combinations of forms move us; I should not have travelled by other roads had I enquired, instead, why certain combinations are perceived to be right and necessary, and why our perception of their rightness and necessity is moving. What I have to say is this: the rapt philosopher, and he who contemplates a work of art, inhabit a world with an intense and peculiar significance of its own; that significance is unrelated to the significance of

life. In this world the emotions of life find no place. It is a world with emotions of its own.

To appreciate a work of art we need bring with us nothing but a sense of form and colour and a knowledge of three-dimensional space. That bit of knowledge, I admit, is essential to the appreciation of many great works, since many of the most moving forms ever created are in three dimensions. To see a cube or a rhomboid as a flat pattern is to lower its significance, and a sense of three-dimensional space is essential to the full appreciation of most architectural forms. Pictures which would be insignificant if we saw them as flat patterns are profoundly moving because, in fact, we see them as related planes. If the representation of three-dimensional space is to be called "representation," then I agree that there is one kind of representation which is not irrelevant. Also, I agree that along with our feeling for line and colour we must bring with us our knowledge of space if we are to make the most of every kind of form. Nevertheless, there are magnificent designs to an appreciation of which this knowledge is not necessary : so, though it is not irrelevant to the appreciation of some works of

art it is not essential to the appreciation of all. What we must say is that the representation of three - dimensional space is neither irrelevant nor essential to all art, and that every other sort of representation is irrelevant.

That there is an irrelevant representative or descriptive element in many great works of art is not in the least surprising. Why it is not surprising I shall try to show elsewhere. Representation is not of necessity baneful, and highly realistic forms may be extremely significant. Very often, however, representation is a sign of weakness in an artist. A painter too feeble to create forms that provoke more than a little aesthetic emotion will try to eke that little out by suggesting the emotions of life. To evoke the emotions of life he must use representation. Thus a man will paint an execution, and, fearing to miss with his first barrel of significant form, will try to hit with his second by raising an emotion of fear or pity. But if in the artist an inclination to play upon the emotions of life is often the sign of a flickering inspiration, in the spectator a tendency to seek, behind form, the emotions of life is a sign of defective sensibility always. It means that his aesthetic

emotions are weak or, at any rate, imperfect. Before a work of art people who feel little or no emotion for pure form find themselves at a loss. They are deaf men at a concert. They know that they are in the presence of something great, but they lack the power of apprehending it. They know that they ought to feel for it a tremendous emotion, but it happens that the particular kind of emotion it can raise is one that they can feel hardly or not at all. And so they read into the forms of the work those facts and ideas for which they are capable of feeling emotion, and feel for them the emotions that they can feel—the ordinary emotions of life. When confronted by a picture, instinctively they refer back its forms to the world from which they came. They treat created form as though it were imitated form, a picture as though it were a photograph. Instead of going out on the stream of art into a new world of aesthetic experience, they turn a sharp corner and come straight home to the world of human interests. For them the significance of a work of art depends on what they bring to it; no new thing is added to their lives, only the oid material is stirred. A good work of visual art carries a person who is

capable of appreciating it out of life into
ecstasy: to use art as a means to the
emotions of life is to use a telescope for
reading the news. You will notice that
people who cannot feel pure aesthetic emo-
tions remember pictures by their subjects;
whereas people who can, as often as not,
have no idea what the subject of a picture
is. They have never noticed the repre-
sentative element, and so when they discuss
pictures they talk about the shapes of forms
and the relations and quantities of colours.
Often they can tell by the quality of a
single line whether or no a man is a good
artist. They are concerned only with lines
and colours, their relations and quantities
and qualities; but from these they win an
emotion more profound and far more
sublime than any that can be given by the
description of facts and ideas.

This last sentence has a very confident
ring—over-confident, some may think. Per-
haps I shall be able to justify it, and make
my meaning clearer too, if I give an account
of my own feelings about music. I am
not really musical. I do not understand
music well. I find musical form exceedingly
difficult to apprehend, and I am sure that
the profounder subtleties of harmony and

rhythm more often than not escape me. The form of a musical composition must be simple indeed if I am to grasp it honestly. My opinion about music is not worth having. Yet, sometimes, at a concert, though my appreciation of the music is limited and humble, it is pure. Sometimes, though I have a poor understanding, I have a clean palate. Consequently, when I am feeling bright and clear and intent, at the beginning of a concert for instance, when something that I can grasp is being played, I get from music that pure aesthetic emotion that I get from visual art. It is less intense, and the rapture is evanescent; I understand music too ill for music to transport me far into the world of pure aesthetic ecstasy. But at moments I do appreciate music as pure musical form, as sounds combined according to the laws of a mysterious necessity, as pure art with a tremendous significance of its own and no relation whatever to the significance of life; and in those moments I lose myself in that infinitely sublime state of mind to which pure visual form transports me. How inferior is my normal state of mind at a concert. Tired or perplexed, I let slip my sense of form, my aesthetic emotion collapses, and I begin

31

weaving into the harmonies, that I cannot
grasp, the ideas of life. Incapable of feeling
the austere emotions of art, I begin to read
into the musical forms human emotions
of terror and mystery, love and hate, and
spend the minutes, pleasantly enough, in
a world of turbid and inferior feeling. At
such times, were the grossest pieces of
onomatopoeic representation—the song of
a bird, the galloping of horses, the cries
of children, or the laughing of demons—
to be introduced into the symphony, I should
not be offended. Very likely I should be
pleased ; they would afford new points of
departure for new trains of romantic feeling
or heroic thought. I know very well what
has happened. I have been using art as
a means to the emotions of life and reading
into it the ideas of life. I have been cutting
blocks with a razor. I have tumbled from
the superb peaks of aesthetic exaltation to
the snug foothills of warm humanity. It is
a jolly country. No one need be ashamed
of enjoying himself there. Only no one
who has ever been on the heights can help
feeling a little crestfallen in the cosy valleys
And let no one imagine, because he has
made merry in the warm tilth and quaint
nooks of romance, that he can even guess

at the austere and thrilling raptures of those who have climbed the cold, white peaks of art.

About music most people are as willing to be humble as I am. If they cannot grasp musical form and win from it a pure aesthetic emotion, they confess that they understand music imperfectly or not at all. They recognise quite clearly that there is a difference between the feeling of the musician for pure music and that of the cheerful concert-goer for what music suggests. The latter enjoys his own emotions, as he has every right to do, and recognises their inferiority. Unfortunately, people are apt to be less modest about their powers of appreciating visual art. Everyone is inclined to believe that out of pictures, at any rate, he can get all that there is to be got; everyone is ready to cry "humbug" and "impostor" at those who say that more can be had. The good faith of people who feel pure aesthetic emotions is called in question by those who have never felt anything of the sort. It is the prevalence of the representative element, I suppose, that makes the man in the street so sure that he knows a good picture when he sees one. For I have noticed that in matters of architecture,

pottery, textiles, &c., ignorance and ineptitude are more willing to defer to the opinions of those who have been blest with peculiar sensibility. It is a pity that cultivated and intelligent men and women cannot be induced to believe that a great gift of aesthetic appreciation is at least as rare in visual as in musical art. A comparison of my own experience in both has enabled me to discriminate very clearly between pure and impure appreciation. Is it too much to ask that others should be as honest about their feelings for pictures as I have been about mine for music? For I am certain that most of those who visit galleries do feel very much what I feel at concerts. They have their moments of pure ecstasy; but the moments are short and unsure. Soon they fall back into the world of human interests and feel emotions, good no doubt, but inferior. I do not dream of saying that what they get from art is bad or nugatory; I say that they do not get the best that art can give. I do not say that they cannot understand art; rather I say that they cannot understand the state of mind of those who understand it best. I do not say that art means nothing or little to them; I say they miss its full significance. I do not suggest for one moment that their apprecia-

tion of art is a thing to be ashamed of; the majority of the charming and intelligent people with whom I am acquainted appreciate visual art impurely; and, by the way, the appreciation of almost all great writers has been impure. But provided that there be some fraction of pure aesthetic emotion, even a mixed and minor appreciation of art is, I am sure, one of the most valuable things in the world—so valuable, indeed, that in my giddier moments I have been tempted to believe that art might prove the world's salvation.

Yet, though the echoes and shadows of art enrich the life of the plains, her spirit dwells on the mountains. To him who woos, but woos impurely, she returns enriched what is brought. Like the sun, she warms the good seed in good soil and causes it to bring forth good fruit. But only to the perfect lover does she give a new strange gift—a gift beyond all price. Imperfect lovers bring to art and take away the ideas and emotions of their own age and civilisation. In twelfth-century Europe a man might have been greatly moved by a Romanesque church and found nothing in a T'ang picture. To a man of a later age, Greek sculpture meant much and Mexican

nothing, for only to the former could he bring a crowd of associated ideas to be the objects of familiar emotions. But the perfect lover, he who can feel the profound significance of form, is raised above the accidents of time and place. To him the problems of archaeology, history, and hagiography are impertinent. If the forms of a work are significant its provenance is irrelevant. Before the grandeur of those Sumerian figures in the Louvre he is carried on the same flood of emotion to the same aesthetic ecstasy as, more than four thousand years ago, the Chaldean lover was carried. It is the mark of great art that its appeal is universal and eternal.* Significant form

* Mr. Roger Fry permits me to make use of an interesting story that will illustrate my view. When Mr. Okakura, the Government editor of *The Temple Treasures of Japan*, first came to Europe, he found no difficulty in appreciating the pictures of those who from want of will or want of skill did not create illusions but concentrated their energies on the creation of form. He understood immediately the Byzantine masters and the French and Italian Primitives. In the Renaissance painters, on the other hand, with their descriptive pre-occupations, their literary and anecdotic interests, he could see nothing but vulgarity and muddle. The universal and essential quality of art, significant form, was missing, or rather had dwindled to a shallow stream, overlaid and hidden beneath weeds, so the universal response, aesthetic emotion, was not evoked. It was not till he came on to Henri-Matisse that he again found himself in the familiar world of pure art. Similarly, sensitive Europeans who

36

stands charged with the power to provoke aesthetic emotion in anyone capable of feeling it. The ideas of men go buzz and die like gnats; men change their institutions and their customs as they change their coats; the intellectual triumphs of one age are the follies of another; only great art remains stable and unobscure. Great art remains stable and unobscure because the feelings that it awakens are independent of time and place, because its kingdom is not of this world. To those who have and hold a sense of the significance of form what does it matter whether the forms that move them were created in Paris the day before yesterday or in Babylon fifty centuries ago? The forms of art are inexhaustible; but all lead by the same road of aesthetic emotion to the same world of aesthetic ecstasy.

respond immediately to the significant forms of great Oriental art, are left cold by the trivial pieces of anecdote and social criticism so lovingly cherished by Chinese dilettanti. It would be easy to multiply instances did not decency forbid the labouring of so obvious a truth.

II

AESTHETICS AND POST-IMPRESSIONISM

By the light of my aesthetic hypothesis I can read more clearly than before the history of art; also I can see in that history the place of the contemporary movement. As I shall have a great deal to say about the contemporary movement, perhaps I shall do well to seize this moment, when the aesthetic hypothesis is fresh in my mind and, I hope, in the minds of my readers, for an examination of the movement in relation to the hypothesis. For anyone of my generation to write a book about art that said nothing of the movement dubbed in this country Post-Impressionist would be a piece of pure affectation. I shall have a great deal to say about it, and therefore I wish to see at the earliest possible opportunity how Post-Impressionism stands with regard to my theory of aesthetics. The

survey will give me occasion for stating some of the things that Post-Impressionism is and some that it is not. I shall have to raise points that will be dealt with at greater length elsewhere. Here I shall have a chance of raising them, and at least suggesting a solution.

Primitives produce art because they must; they have no other motive than a passionate desire to express their sense of form. Untempted, or incompetent, to create illusions, to the creation of form they devote themselves entirely. Presently, however, the artist is joined by a patron and a public, and soon there grows up a demand for "speaking likenesses." While the gross herd still clamours for likeness, the choicer spirits begin to affect an admiration for cleverness and skill. The end is in sight. In Europe we watch art sinking, by slow degrees, from the thrilling design of Ravenna to the tedious portraiture of Holland, while the grand proportion of Romanesque and Norman architecture becomes Gothic juggling in stone and glass. Before the late noon of the Renaissance art was almost extinct. Only nice illusionists and masters of craft abounded. That was the moment for a Post-Impressionist revival.

ART

For various reasons there was no revolution. The tradition of art remained comatose. Here and there a genius appeared and wrestled with the coils of convention and created significant form. For instance, the art of Nicolas Poussin, Claude, El Greco, Chardin, Ingres, and Renoir,[1] to name a few, moves us as that of Giotto and Cézanne moves. The bulk, however, of those who flourished between the high Renaissance and the contemporary movement may be divided into two classes, virtuosi and dunces. The clever fellows, the minor masters, who might have been artists if painting had not absorbed all their energies, were throughout that period for ever setting themselves technical acrostics and solving them. The dunces continued to elaborate chromophotographs, and continue.

The fact that significant form was the only common quality in the works that moved me, and that in the works that moved me most and seemed most to move the most sensitive people—in primitive art, that is to say—it was almost the only quality, had led me to my hypothesis before ever I became familiar with the works of Cézanne and his followers. Cézanne carried me off my feet before ever I noticed that his strongest char-

acteristic was an insistence on the supremacy of significant form. When I noticed this, my admiration for Cézanne and some of his followers confirmed me in my aesthetic theories. Naturally I had found no difficulty in liking them since I found in them exactly what I liked in everything else that moved me.

There is no mystery about Post-Impressionism; a good Post-Impressionist picture is good for precisely the same reasons that any other picture is good. The essential quality in art is permanent. Post-Impressionism, therefore, implies no violent break with the past. It is merely a deliberate rejection of certain hampering traditions of modern growth. It does deny that art need ever take orders from the past; but that is not a badge of Post-Impressionism, it is the commonest mark of vitality. Even to speak of Post-Impressionism as a movement may lead to misconceptions; the habit of speaking of movements at all is rather misleading. The stream of art has never run utterly dry: it flows through the ages, now broad now narrow, now deep now shallow, now rapid now sluggish: its colour is changing always. But who can set a mark against the exact point of change? In the earlier nineteenth

century the stream ran very low. In the days of the Impressionists, against whom the contemporary movement is in some ways a reaction, it had already become copious. Any attempt to dam and imprison this river, to choose out a particular school or movement and say : " Here art begins and there it ends," is a pernicious absurdity. That way Academization lies. At this moment there are not above half a dozen good painters alive who do not derive, to some extent, from Cézanne, and belong, in some sense, to the Post-Impressionist movement; but to-morrow a great painter may arise who will create significant form by means superficially opposed to those of Cézanne. Superficially, I say, because, essentially, all good art is of the same movement : there are only two kinds of art, good and bad. Nevertheless, the division of the stream into reaches, distinguished by differences of manner, is intelligible and, to historians at any rate, useful The reaches also differ from each other in volume; one period of art is distinguished from another by its fertility. For a few fortunate years or decades the output of considerable art is great. Suddenly it ceases; or slowly it dwindles : a movement has exhausted itself. How far a movement is

made by the fortuitous synchronisation of a number of good artists, and how far the artists are helped to the creation of significant form by the pervasion of some underlying spirit of the age, is a question that can never be decided beyond cavil. But however the credit is to be apportioned—and I suspect it should be divided about equally—we are justified, I think, looking at the history of art as a whole, in regarding such periods of fertility as distinct parts of that whole. Primarily, it is as a period of fertility in good art and artists that I admire the Post-Impressionist movement. Also, I believe that the principles which underlie and inspire that movement are more likely to encourage artists to give of their best, and to foster a good tradition, than any of which modern history bears record. But my interest in this movement, and my admiration for much of the art it has produced, does not blind me to the greatness of the products of other movements; neither, I hope, will it blind me to the greatness of any new creation of form even though that novelty may seem to imply a reaction against the tradition of Cézanne.

Like all sound revolutions, Post-Impressionism is nothing more than a return to

first principles. Into a world where the painter was expected to be either a photographer or an acrobat burst the Post-Impressionist, claiming that, above all things, he should be an artist. Never mind, said he, about representation or accomplishment—mind about creating significant form, mind about art. Creating a work of art is so tremendous a business that it leaves no leisure for catching a likeness or displaying address. Every sacrifice made to representation is something stolen from art. Far from being the insolent kind of revolution it is vulgarly supposed to be, Post-Impressionism is, in fact, a return, not indeed to any particular tradition of painting, but to the great tradition of visual art. It sets before every artist the ideal set before themselves by the primitives, an ideal which, since the twelfth century, has been cherished only by exceptional men of genius. Post-Impressionism is nothing but the reassertion of the first commandment of art—Thou shalt create form. By this assertion it shakes hands across the ages with the Byzantine primitives and with every vital movement that has struggled into existence since the arts began.

Post-Impressionism is not a matter of technique. Certainly Cézanne invented a

44

technique, admirably suited to his purpose, which has been adopted and elaborated, more or less, by the majority of his followers. The important thing about a picture, however, is not how it is painted, but whether it provokes aesthetic emotion. As I have said, essentially, a good Post-Impressionist picture resembles all other good works of art, and only differs from some, superficially, by a conscious and deliberate rejection of those technical and sentimental irrelevancies that have been imposed on painting by a bad tradition. This becomes obvious when one visits an exhibition such as the *Salon d' Automne* or *Les Indépendants*,[2] where there are hundreds of pictures in the Post-Impressionist manner, many of which are quite worthless.*

* Anyone who has visited the very latest French exhibitions will have seen scores of what are called "Cubist" pictures.[3] These afford an excellent illustration of my thesis. Of a hundred cubist pictures three or four will have artistic value. Thirty years ago the same might have been said of "Impressionist" pictures ; forty years before that of romantic pictures in the manner of Delacroix. The explanation is simple,—the vast majority of those who paint pictures have neither originality nor any considerable talent. Left to themselves they would probably produce the kind of painful absurdity which in England is known as an "Academy picture." But a student who has no original gift may yet be anything but a fool, and many students understand that the ordinary cultivated picture-goer knows an "Academy picture" at a glance and knows that it is bad. Is it fair to condemn

These, one realises, are bad in precisely the same way as any other picture is bad; their forms are insignificant and compel no aesthetic reaction. In truth, it was an unfortunate necessity that obliged us to speak of "Post-Impressionist pictures," and now, I think, the moment is at hand when we shall be able to return to the older and more adequate nomenclature, and speak of good pictures and bad. Only we must not forget that the movement of which Cézanne is the earliest manifestation, and which has borne so amazing a crop of good art, owes something, though not everything, to the liberating and revolutionary doctrines of Post-Impressionism.

The silliest things said about Post-Impressionist pictures are said by people

severely a young painter for trying to give his picture a factitious interest, or even for trying to conceal beneath striking wrappers the essential mediocrity of his wares? If not heroically sincere he is surely not inhumanly base. Besides, he has to imitate someone, and he likes to be in the fashion. And, after all, a bad cubist picture is no worse than any other bad picture. If anyone is to be blamed, it should be the spectator who cannot distinguish between good cubist pictures and bad. Blame alike the fools who think that because a picture is cubist it must be worthless, and their idiotic enemies who think it must be marvellous. People of sensibility can see that there is as much difference between Picasso and a Montmartre sensationalist as there is between Ingres and the President of the Royal Academy.

who regard Post-Impressionism as an isolated movement, whereas, in fact, it takes its place as part of one of those huge slopes into which we can divide the history of art and the spiritual history of mankind. In my enthusiastic moments I am tempted to hope that it is the first stage in a new slope to which it will stand in the same relation as sixth-century Byzantine art stands to the old. In that case we shall compare Post-Impressionism with that vital spirit which, towards the end of the fifth century, flickered into life amidst the ruins of Graeco-Roman realism. Post-Impressionism, or, let us say the Contemporary Movement, has a future ; but when that future is present Cézanne and Matisse will no longer be called Post-Impressionists. They will certainly be called great artists, just as Giotto and Masaccio are called great artists ; they will be called the masters of a movement ; but whether that movement is destined to be more than a movement, to be something as vast as the slope that lies between Cézanne and the masters of S. Vitale,⁴ is a matter of much less certainty than enthusiasts care to suppose.

Post-Impressionism is accused of being a negative and destructive creed. In art no creed is healthy that is anything else. You

cannot give men genius; you can only give them freedom—freedom from superstition. Post-Impressionism can no more make good artists than good laws can make good men. Doubtless, with its increasing popularity, an annually increasing horde of nincompoops will employ the so-called "Post-Impressionist technique" for presenting insignificant patterns and recounting foolish anecdotes. Their pictures will be dubbed "Post-Impressionist," but only by gross injustice will they be excluded from Burlington House. Post-Impressionism is no specific against human folly and incompetence. All it can do for painters is to bring before them the claims of art. To the man of genius and to the student of talent it can say: "Don't waste your time and energy on things that don't matter: concentrate on what does: concentrate on the creation of significant form." Only thus can either give the best that is in him. Formerly because both felt bound to strike a compromise between art and what the public had been taught to expect, the work of one was grievously disfigured, that of the other ruined. Tradition ordered the painter to be photographer, acrobat, archaeologist and littérateur: Post-Impressionism invites him to become an artist.

III

THE METAPHYSICAL HYPOTHESIS

FOR the present I have said enough about the aesthetic problem and about Post-Impressionism; I want now to consider that metaphysical question—"Why do certain arrangements and combinations of form move us so strangely?" For aesthetics it suffices that they do move us; to all further inquisition of the tedious and stupid it can be replied that, however queer these things may be, they are no queerer than anything else in this incredibly queer universe. But to those for whom my theory seems to open a vista of possibilities I willingly offer, for what they are worth, my fancies.

It seems to me possible, though by no means certain, that created form moves us so profoundly because it expresses the emotion of its creator. Perhaps the lines and colours of a work of art convey to us something that the artist felt. If this be so, it will

49

explain that curious but undeniable fact, to which I have already referred, that what I call material beauty (*e.g.* the wing of a butterfly) does not move most of us in at all the same way as a work of art moves us. It is beautiful form, but it is not significant form. It moves us, but it does not move us aesthetically. It is tempting to explain the difference between "significant form" and "beauty"—that is to say, the difference between form that provokes our aesthetic emotions and form that does not—by saying that significant form conveys to us an emotion felt by its creator and that beauty conveys nothing.

For what, then, does the artist feel the emotion that he is supposed to express? Sometimes it certainly comes to him through material beauty. The contemplation of natural objects is often the immediate cause of the artist's emotion. Are we to suppose, then, that the artist feels, or sometimes feels, for material beauty what we feel for a work of art? Can it be that sometimes for the artist material beauty is somehow significant —that is, capable of provoking aesthetic emotion? And if the form that provokes aesthetic emotion be form that expresses something, can it be that material beauty is

to him expressive? Does he feel something behind it as we imagine that we feel something behind the forms of a work of art? Are we to suppose that the emotion which the artist expresses is an aesthetic emotion felt for something the significance of which commonly escapes our coarser sensibilities? All these are questions about which I had sooner speculate than dogmatise.

Let us hear what the artists have got to say for themselves. We readily believe them when they tell us that, in fact, they do not create works of art in order to provoke our aesthetic emotions, but because only thus can they materialise a particular kind of feeling. What, precisely, this feeling is they find it hard to say. One account of the matter, given me by a very good artist, is that what he tries to express in a picture is "a passionate apprehension of form." I have set myself to discover what is meant by "a passionate apprehension of form," and, after much talking and more listening, I have arrived at the following result. Occasionally when an artist—a real artist—looks at objects (the contents of a room, for instance) he perceives them as pure forms in certain relations to each other, and feels emotion for them as such. These are his

moments of inspiration: follows the desire
to express what has been felt. The emotion
that the artist felt in his moment of inspira-
tion he did not feel for objects seen as
means, but for objects seen as pure forms—
that is, as ends in themselves. He did not
feel emotion for a chair as a means to
physical well-being, nor as an object associated
with the intimate life of a family, nor as the
place where someone sat saying things unfor-
gettable, nor yet as a thing bound to the
lives of hundreds of men and women, dead
or alive, by a hundred subtle ties; doubtless
an artist does often feel emotions such as
these for the things that he sees, but in the
moment of aesthetic vision he sees objects,
not as means shrouded in associations, but
as pure forms. It is for, or at any rate
through, pure form that he feels his inspired
emotion.

Now to see objects as pure forms is to see
them as ends in themselves. For though, of
course, forms are related to each other as
parts of a whole, they are related on terms
of equality; they are not a means to any-
thing except emotion. But for objects seen
as ends in themselves, do we not feel a pro-
founder and a more thrilling emotion than
ever we felt for them as means? All of us,

I imagine, do, from time to time, get a vision of material objects as pure forms. We see things as ends in themselves, that is to say; and at such moments it seems possible, and even probable, that we see them with the eye of an artist. Who has not, once at least in his life, had a sudden vision of landscape as pure form? For once, instead of seeing it as fields and cottages, he has felt it as lines and colours. In that moment has he not won from material beauty a thrill indistinguishable from that which art gives? And, if this be so, is it not clear that he has won from material beauty the thrill that, generally, art alone can give, because he has contrived to see it as a pure formal combination of lines and colours? May we go on to say that, having seen it as pure form, having freed it from all casual and adventitious interest, from all that it may have acquired from its commerce with human beings, from all its significance as a means, he has felt its significance as an end in itself?

What is the significance of anything as an end in itself? What is that which is left when we have stripped a thing of all its associations, of all its significance as a means? What is left to provoke our emotion? What but that which philosophers used to call " the

thing in itself" and now call "ultimate reality"? Shall I be altogether fantastic in suggesting, what some of the profoundest thinkers have believed, that the significance of the thing in itself is the significance of Reality? Is it possible that the answer to my question, "Why are we so profoundly moved by certain combinations of lines and colours?" should be, "Because artists can express in combinations of lines and colours an emotion felt for reality which reveals itself through line and colour"?

If this suggestion were accepted it would follow that "significant form" was form behind which we catch a sense of ultimate reality. There would be good reason for supposing that the emotions which artists feel in their moments of inspiration, that others feel in the rare moments when they see objects artistically, and that many of us feel when we contemplate works of art, are the same in kind. All would be emotions felt for reality revealing itself through pure form. It is certain that this emotion can be expressed only in pure form. It is certain that most of us can come at it only through pure form. But is pure form the only channel through which anyone can come at this mysterious emotion? That is a dis-

turbing and a most distasteful question, for at this point I thought I saw my way to cancelling out the word "reality," and saying that all are emotions felt for pure form which may or may not have something behind it. To me it would be most satisfactory to say that the reason why some forms move us aesthetically, and others do not, is that some have been so purified that we can feel them aesthetically and that others are so clogged with unaesthetic matter (*e.g.* associations) that only the sensibility of an artist can perceive their pure, formal significance. I should be charmed to believe that it is as certain that everyone must come at reality through form as that everyone must express his sense of it in form. But is that so? What kind of form is that from which the musician draws the emotion that he expresses in abstract harmonies? Whence come the emotions of the architect and the potter? I know that the artist's emotion can be expressed only in form; I know that only by form can my aesthetic emotions be called into play; but can I be sure that it is always by form that an artist's emotion is provoked? Back to reality.

Those who incline to believe that the artist's emotion is felt for reality will readily

admit that visual artists—with whom alone
we are concerned—come at reality generally
through material form. But don't they
come at it sometimes through imagined
form? And ought we not to add that
sometimes the sense of reality comes we
know not whence? The best account I
know of this state of being rapt in a
mysterious sense of reality is the one that
Dante gives:

"O immaginativa, che ne rube
 tal volta sì di fuor, ch' uom non s'accorge
 perchè d'intorno suonin mille tube ;

chi move te, se il senso non ti porge ?
 Moveti lume, che nel ciel s'informa,
 per sè, o per voler che giù lo scorge.

.

e qui fu la mia mente sì ristretta
 dentro da sè, che di fuor non venia
 cosa che fosse allor da lei recetta."[1]

Certainly, in those moments of exaltation
that art can give, it is easy to believe that we
have been possessed by an emotion that
comes from the world of reality. Those
who take this view will have to say that
there is in all things the stuff out of which
art is made—reality; artists, even, can

grasp it only when they have reduced things to their purest condition of being—to pure form—unless they be of those who come at it mysteriously unaided by externals; only in pure form can a sense of it be expressed. On this hypothesis the peculiarity of the artist would seem to be that he possesses the power of surely and frequently seizing reality (generally behind pure form), and the power of expressing his sense of it, in pure form always. But many people, though they feel the tremendous significance of form, feel also a cautious dislike for big words; and " reality " is a very big one. These prefer to say that what the artist surprises behind form, or seizes by sheer force of imagination, is the all-pervading rhythm that informs all things; and I have said that I will never quarrel with that blessed word " rhythm."[2]

The ultimate object of the artist's emotion will remain for ever uncertain. But, unless we assume that all artists are liars, I think we must suppose that they do feel an emotion which they can express in form—and form alone. And note well this further point; artists try to express emotion, not to make statements about its ultimate or immediate object. Naturally, if an artist's emotion comes to him from, or through,

the perception of forms and formal relations, he will be apt to express it in forms derived from those through which it came; but he will not be bound by his vision. He will be bound by his emotion. Not what he saw, but only what he felt will necessarily condition his design. Whether the connection between the forms of a created work and the forms of the visible universe be patent or obscure, whether it exist or whether it does not, is a matter of no consequence whatever. No one ever doubted that a Sung pot or a Romanesque church was as much an expression of emotion as any picture that ever was painted. What was the object of the potter's emotion? What of the builder's? Was it some imagined form, the synthesis of a hundred different visions of natural things; or was it some conception of reality, un-related to sensual experience, remote al-together from the physical universe? These are questions beyond all conjecture. In any case, the form in which he expresses his emotion bears no memorial of any external form that may have provoked it. Expres-sion is no wise bound by the forms or emotions or ideas of life. We cannot know exactly what the artist feels. We only know what he creates. If reality be the goal of his

emotion, the roads to reality are several. Some artists come at it through the appearance of things, some by a recollection of appearance, and some by sheer force of imagination.

To the question—"Why are we so profoundly moved by certain combinations of forms?" I am unwilling to return a positive answer. I am not obliged to, for it is not an aesthetic question. I do suggest, however, that it is because they express an emotion that the artist has felt, though I hesitate to make any pronouncement about the nature or object of that emotion. If my suggestion be accepted, criticism will be armed with a new weapon; and the nature of this weapon is worth a moment's consideration. Going behind his emotion and its object, the critic will be able to surprise that which gives form its significance. He will be able to explain why some forms are significant and some are not; and thus he will be able to push all his judgments a step further back. Let me give one example. Of copies of pictures there are two classes; one class contains some works of art, the other none. A literal copy is seldom reckoned even by its owner a work of art. It leaves us cold; its forms are not significant. Yet if it were an absolutely

exact copy, clearly it would be as moving as the original, and a photographic reproduction of a drawing often is—almost. Evidently, it is impossible to imitate a work of art exactly; and the differences between the copy and the original, minute though they may be, exist and are felt immediately. So far the critic is on sure and by this time familiar ground. The copy does not move him, because its forms are not identical with those of the original; and just what made the original moving is what does not appear in the copy. But why is it impossible to make an absolutely exact copy? The explanation seems to be that the actual lines and colours and spaces in a work of art are caused by something in the mind of the artist which is not present in the mind of the imitator. The hand not only obeys the mind, it is impotent to make lines and colours in a particular way without the direction of a particular state of mind. The two visible objects, the original and the copy, differ because that which ordered the work of art does not preside at the manufacture of the copy. That which orders the work of art is, I suggest, the emotion which empowers artists to create significant form. The good copy, the copy

that moves us, is always the work of one who is possessed by this mysterious emotion. Good copies are never attempts at exact imitation; on examination we find always enormous differences between them and their originals: they are the work of men or women who do not copy but can translate the art of others into their own language. The power of creating significant form depends, not on hawklike vision, but on some curious mental and emotional power. Even to copy a picture one needs, not to see as a trained observer, but to feel as an artist. To make the spectator feel, it seems that the creator must feel too. What is this that imitated forms lack and created forms possess? What is this mysterious thing that dominates the artist in the creation of forms? What is it that lurks behind forms and seems to be conveyed by them to us? What is it that distinguishes the creator from the copyist? What can it be but emotion? Is it not because the artist's forms express a particular kind of emotion that they are significant? —because they fit and envelop it, that they are coherent?—because they communicate it, that they exalt us to ecstasy?

One word of warning is necessary. Let no one imagine that the expression of emotion

is the outward and visible sign of a work of art. The characteristic of a work of art is its power of provoking aesthetic emotion; the expression of emotion is possibly what gives it that power. It is useless to go to a picture gallery in search of expression; you must go in search of significant form. When you have been moved by form, you may begin to consider what makes it moving. If my theory be correct, rightness of form is invariably a consequence of rightness of emotion. Right form, I suggest, is ordered and conditioned by a particular kind of emotion; but whether my theory be true or false, the form remains right. If the forms are satisfactory, the state of mind that ordained them must have been aesthetically right. If the forms are wrong, it does not follow that the state of mind was wrong; between the moment of inspiration and the finished work of art there is room for many a slip. Feeble or defective emotion is at best only one explanation of unsatisfactory form. Therefore, when the critic comes across satisfactory form he need not bother about the feelings of the artist; for him to feel the aesthetic significance of the artist's forms suffices. If the artist's state of mind be important, he may be sure that it was right because the forms are right. But

when the critic attempts to account for the unsatisfactoriness of forms he may consider the state of mind of the artist. He cannot be sure that because the forms are wrong the state of mind was wrong; because right forms imply right feeling, wrong forms do not necessarily imply wrong feeling; but if he has got to explain the wrongness of form, here is a possibility he cannot overlook. He will have left the firm land of aesthetics to travel in an unstable element; in criticism one catches at any straw. There is no harm in that, provided the critic never forgets that, whatever ingenious theories he may put forward, they can be nothing more than attempts to explain the one central fact—that some forms move us aesthetically and others do not.

This discussion has brought me close to a question that is neither aesthetic nor metaphysical but impinges on both. It is the question of the artistic problem, and it is really a technical question. I have suggested that the task of the artist is either to create significant form or to express a sense of reality—whichever way you prefer to put it. But it is certain that few artists, if any, can sit down or stand up just to create nothing more definite than significant form, just to

express nothing more definite than a sense of reality. Artists must canalise their emotion, they must concentrate their energies on some definite problem. The man who sets out with the whole world before him is unlikely to get anywhere. In that fact lies the explanation of the absolute necessity for artistic conventions. That is why it is easier to write good verse than good prose, why it is more difficult to write good blank verse than good rhyming couplets. That is the explanation of the sonnet, the ballade, and the rondeau; severe limitations concentrate and intensify the artist's energies.

It would be almost impossible for an artist who set himself a task no more definite than that of creating, without conditions or limitations material or intellectual, significant form ever so to concentrate his energies as to achieve his object. His objective would lack precision and therefore his efforts would lack intention. He would almost certainly be vague and listless at his work. It would seem always possible to pull the thing round by a happy fluke, it would rarely be absolutely clear that things were going wrong. The effort would be feeble and the result would be feeble. That is the danger of aestheticism for the artist. The man who feels that he

has got nothing to do but to make something beautiful hardly knows where to begin or where to end, or why he should set about one thing more than another. The artist has got to feel the necessity of making his work of art "right." It will be "right" when it expresses his emotion for reality or is capable of provoking aesthetic emotion in others, whichever way you care to look at it. But most artists have got to canalise their emotion and concentrate their energies on some more definite and more maniable problem than that of making something that shall be aesthetically "right." They need a problem that will become the focus of their vast emotions and vague energies, and when that problem is solved their work will be "right."

"Right" for the spectator means aesthetically satisfying; for the artist at work it means the complete realisation of a conception, the perfect solution of a problem. The mistake that the vulgar make is to suppose that "right" means the solution of one particular problem. The vulgar are apt to suppose that the problem which all visual and literary artists set themselves is to make something lifelike. Now, all artistic problems —and their possible variety is infinite—must

65

be the *foci* of one particular kind of emotion, that specific artistic emotion which I believe to be an emotion felt for reality, generally perceived through form : but the nature of the focus is immaterial. It is almost, though not quite. true to say that one problem is as good as another. Indeed all problems are, in themselves, equally good, though, owing to human infirmity, there are two which tend to turn out badly. One, as we have seen, is the pure aesthetic problem ; the other is the problem of accurate representation.

The vulgar imagine that there is but one focus, that " right " means always the realisation of an accurate conception of life. They cannot understand that the immediate problem of the artist may be to express himself within a square or a circle or a cube, to balance certain harmonies, to reconcile certain dissonances, to achieve certain rhythms, or to conquer certain difficulties of medium, just as well as to catch a likeness. This error is at the root of the silly criticism that Mr. Shaw has made it fashionable to print.[3] In the plays of Shakespeare there are details of psychology and portraiture so realistic as to astonish and enchant the multitude, but the conception, the thing that Shakespeare set

66

himself to realise, was not a faithful presentation of life. The creation of Illusion was not the artistic problem that Shakespeare used as a channel for his artistic emotion and a focus for his energies. The world of Shakespeare's plays is by no means so lifelike as the world of Mr. Galsworthy's, and therefore those who imagine that the artistic problem must always be the achieving of a correspondence between printed words or painted forms and the world as they know it are right in judging the plays of Shakespeare inferior to those of Mr. Galsworthy. As a matter of fact, the achievement of verisimilitude, far from being the only possible problem, disputes with the achievement of beauty the honour of being the worst possible. It is so easy to be lifelike, that an attempt to be nothing more will never bring into play the highest emotional and intellectual powers of the artist. Just as the aesthetic problem is too vague, so the representative problem is too simple.

Every artist must choose his own problem. He may take it from wherever he likes, provided he can make it the focus of those artistic emotions he has got to express and the stimulant of those energies he will need

to express them. What we have got to
remember is that the problem—in a picture
it is generally the subject—is of no conse-
quence in itself. It is merely one of the
artist's means of expression or creation.
In any particular case one problem may be
better than another, as a means, just as
one canvas or one brand of colours may be;
that will depend upon the temperament of
the artist, and we may leave it to him. For
us the problem has no value; for the artist
it is the working test of absolute "rightness."
It is the gauge that measures the pressure
of steam; the artist stokes his fires to set
the little handle spinning; he knows that
his machine will not move until he has got
his pointer to the mark; he works up to it
and through it; but it does not drive the
engine.

What, then, is the conclusion of the
whole matter? No more than this, I think.
The contemplation of pure form leads to a
state of extraordinary exaltation and com-
plete detachment from the concerns of life:
of so much, speaking for myself, I am sure.
It is tempting to suppose that the emotion
which exalts has been transmitted through
the forms we contemplate by the artist who
created them. If this be so, the transmitted

emotion, whatever it may be, must be of such a kind that it can be expressed in any sort of form—in pictures, sculptures, buildings, pots, textiles, &c., &c. Now the emotion that artists express comes to some of them, so they tell us, from the apprehension of the formal significance of material things; and the formal significance of any material thing is the significance of that thing considered as an end in itself. But if an object considered as an end in itself moves us more profoundly (*i.e.* has greater significance) than the same object considered as a means to practical ends or as a thing related to human interests—and this undoubtedly is the case—we can only suppose that when we consider anything as an end in itself we become aware of that in it which is of greater moment than any qualities it may have acquired from keeping company with human beings. Instead of recognising its accidental and conditioned importance, we become aware of its essential reality, of the God in everything, of the universal in the particular, of the all-pervading rhythm. Call it by what name you will, the thing that I am talking about is that which lies behind the appearance of all things—that which gives to all things their individual signific-

ance, the thing in itself, the ultimate reality. And if a more or less unconscious apprehension of this latent reality of material things be, indeed, the cause of that strange emotion, a passion to express which is the inspiration of many artists, it seems reasonable to suppose that those who, unaided by material objects, experience the same emotion have come by another road to the same country.

That is the metaphysical hypothesis. Are we to swallow it whole, accept a part of it, or reject it altogether? Each must decide for himself. I insist only on the rightness of my aesthetic hypothesis. And of one other thing am I sure. Be they artists or lovers of art, mystics or mathematicians, those who achieve ecstasy are those who have freed themselves from the arrogance of humanity. He who would feel the significance of art must make himself humble before it. Those who find the chief importance of art or of philosophy in its relation to conduct or its practical utility—those who cannot value things as ends in themselves or, at any rate, as direct means to emotion—will never get from anything the best that it can give. Whatever the world of aesthetic contemplation may be,

THE METAPHYSICAL HYPOTHESIS

it is not the world of human business and passion; in it the chatter and tumult of material existence is unheard, or heard only as the echo of some more ultimate harmony.

II

ART AND LIFE

I

ART AND RELIGION

IF in my first chapter I had been at pains to show that art owed nothing to life the title of my second would invite a charge of inconsistency. The danger would be slight, however; for though art owed nothing to life, life might well owe something to art. The weather is admirably independent of human hopes and fears, yet few of us are so sublimely detached as to be indifferent to the weather. Art does affect the lives of men; it moves to ecstasy, thus giving colour and moment to what might be otherwise a rather grey and trivial affair. Art for some makes life worth living. Also, art is affected by life; for to create art there must be men with hands and a sense of form and colour and three-dimensional space and the power to feel and the passion to create. Therefore art has a great deal to do with life—

75

with emotional life. That it is a means to a state of exaltation is unanimously agreed, and that it comes from the spiritual depths of man's nature is hardly contested. The appreciation of art is certainly a means to ecstasy, and the creation probably the expression of an ecstatic state of mind. Art is, in fact, a necessity to and a product of the spiritual life.

Those who do not part company with me till the last stage of my metaphysical excursion agree that the emotion expressed in a work of art springs from the depths of man's spiritual nature; and those even who will hear nothing of expression agree that the spiritual part is profoundly affected by works of art. Art, therefore, has to do with the spiritual life, to which it gives and from which, I feel sure, it takes. Indirectly, art has something to do with practical life, too; for those emotional experiences must be very faint and contemptible that leave quite untouched our characters. Through its influence on character and point of view art may affect practical life. But practical life and human sentiment can affect art only in so far as they can affect the conditions in which artists work. Thus they may affect the production of works of art to some

extent; to how great an extent I shall consider in another place.

Also a great many works of visual art are concerned with life, or rather with the physical universe of which life is a part, in that the men who created them were thrown into the creative mood by their surroundings. We have observed, as we could hardly fail to do, that, whatever the emotion that artists express may be, it comes to many of them through the contemplation of the familiar objects of life. The object of an artist's emotion seems to be more often than not either some particular scene or object, or a synthesis of his whole visual experience. Art may be concerned with the physical universe, or with any part or parts of it, as a means to emotion—a means to that peculiar spiritual state that we call inspiration. But the value of these parts as means to anything but emotion art ignores—that is to say, it ignores their practical utility. Artists are often concerned with things, but never with the labels on things. These useful labels were invented by practical people for practical purposes. The misfortune is that, having acquired the habit of recognising labels, practical people tend to lose the power of feeling emotion;

and, as the only way of getting at the thing in itself is by feeling its emotional significance, they soon begin to lose their sense of reality. Mr. Roger Fry has pointed out that few can hope ever to see a charging bull as an end in itself and yield themselves to the emotional significance of its forms, because no sooner is the label "Charging Bull" recognised than we begin to dispose ourselves for flight rather than contemplation.[1] This is where the habit of recognising labels serves us well. It serves us ill, however, when, although there is no call for action or hurry, it comes between things and our emotional reaction to them. The label is nothing but a symbol that epitomises for busy humanity the significance of things regarded as "means." A practical person goes into a room where there are chairs, tables, sofas, a hearth-rug and a mantelpiece. Of each he takes note intellectually, and if he wants to set himself down or set down a cup, he will know all he needs to know for his purpose. The label tells him just those facts that serve his practical ends; of the thing itself that lurks behind the label nothing is said. Artists, *qua* artists, are not concerned with labels. They are concerned

with things only as means to a particular kind of emotion, which is the same as saying that they are only concerned with things perceived as ends in themselves; for it is only when things are *perceived* as ends that they *become* means to this emotion. It is only when we cease to regard the objects in a landscape as means to anything that we can feel the landscape artistically. But when we do succeed in regarding the parts of a landscape as ends in themselves—as pure forms, that is to say—the landscape becomes *ipso facto* a means to a peculiar, aesthetic state of mind. Artists are concerned only with this peculiar emotional significance of the physical universe: because they *perceive* things as "ends," things *become* for them "means" to ecstasy.

The habit of recognising the label and overlooking the thing, of seeing intellectually instead of seeing emotionally, accounts for the amazing blindness, or rather visual shallowness, of most civilised adults. We do not forget what has moved us, but what we have merely recognised leaves no deep impression on the mind. A friend of mine, a man of taste, desired to make some clearance in his gardens, encumbered as they

were with a multitude of trees; unfortunately most of his friends and all his family objected on sentimental or aesthetic grounds, declaring that the place would never be the same to them if the axe were laid to a single trunk. My friend was in despair, until, one day, I suggested to him that whenever his people were all away on visits or travels, as was pretty often the case, he should have as many trees cut down as could be completely and cleanly removed during their absence. Since then, several hundreds have been carted from his small park and pleasure grounds, and should the secret be betrayed to the family I am cheerfully confident that not one of them would believe it. I could cite innumerable instances of this insensibility to form. How often have I been one of a party in a room with which all were familiar, the decoration of which had lately been changed, and I the only one to notice it. For practical purposes the room remained unaltered; only its emotional significance was new Question your friend as to the disposition of the furniture in his wife's drawing-room; ask him to sketch the street down which he passes daily; ten to one he goes hopelessly astray. Only artists and educated

people of extraordinary sensibility and some
savages and children feel the significance
of form so acutely that they know how
things look. These see, because they see
emotionally; and no one forgets the things
that have moved him. Those forget who
have never felt the emotional significance
of pure form; they are not stupid nor are
they generally insensitive, but they use their
eyes only to collect information, not to
capture emotion. This habit of using the
eyes exclusively to pick up facts is the
barrier that stands between most people
and an understanding of visual art. It is
not a barrier that has stood unbreached
always, nor need it stand so for all future
time.

In ages of great spiritual exaltation the
barrier crumbles and becomes, in places,
less insuperable. Such ages are commonly
called great religious ages: nor is the name
ill-chosen. For, more often than not, re-
ligion is the whetstone on which men
sharpen the spiritual sense. Religion, like
art, is concerned with the world of emo-
tional reality, and with material things only
in so far as they are emotionally significant.
For the mystic, as for the artist, the physical
universe is a means to ecstasy. The mystic

feels things as "ends" instead of seeing them as "means." He seeks within all things that ultimate reality which provokes emotional exaltation; and, if he does not come at it through pure form, there are, as I have said, more roads than one to that country. Religion, as I understand it, is an expression of the individual's sense of the emotional significance of the universe; I should not be surprised to find that art was an expression of the same thing. Anyway, both seem to express emotions different from and transcending the emotions of life. Certainly both have the power of transporting men to superhuman ecstasies; both are means to unearthly states of mind. Art and religion belong to the same world. Both are bodies in which men try to capture and keep alive their shyest and most ethereal conceptions. The kingdom of neither is of this world. Rightly, therefore, do we regard art and religion as twin manifestations of the spirit; wrongly do some speak of art as a manifestation of religion.

If it were said that art and religion were twin manifestations of something that, for convenience sake, may be called "the religious spirit," I should make no serious

complaint. But I should insist on the distinction between "religion," in the ordinary acceptation of the word, and "the religious spirit" being stated beyond all possibility of cavil. I should insist that if we are to say that art is a manifestation of the religious spirit, we must say the same of every respectable religion that ever has existed or ever can exist. Above all, I should insist that whoever said it should bear in mind, whenever he said it, that "manifestation" is at least as different from "expression" as Monmouth is from Macedon.

The religious spirit is born of a conviction that some things matter more than others. To those possessed by it there is a sharp distinction between that which is unconditioned and universal and that which is limited and local. It is a consciousness of the unconditioned and universal that makes people religious; and it is this consciousness or, at least, a conviction that some things are unconditioned and universal, that makes their attitude towards the conditioned and local sometimes a little unsympathetic. It is this consciousness that makes them set justice above law, passion above principle, sensibility above culture, intelligence above knowledge, intuition above experience. the

ideal above the tolerable. It is this con-
sciousness that makes them the enemies of
convention, compromise, and common-sense.
In fact, the essence of religion is a convic-
tion that because some things are of infinite
value most are profoundly unimportant, that
since the gingerbread is there one need not
feel too strongly about the gilt.

It is useless for liberal divines to pretend
that there is no antagonism between the
religious nature and the scientific. There is
no antagonism between religion and science,
but that is a very different matter. In fact,
the hypotheses of science begin only where
religion ends : but both religion and science
are born trespassers. The religious and the
scientific both have their prejudices; but
their prejudices are not the same. The
scientific mind cannot free itself from a
prejudice against the notion that effects may
exist the causes of which it ignores. Not
only do religious minds manage to believe
that there may be effects of which they do
not know, and may never know, the causes
—they cannot even see the absolute neces-
sity for supposing that everything is caused.
Scientific people tend to trust their senses
and disbelieve their emotions when they
contradict them; religious people tend to

trust emotion even though sensual experience be against it. On the whole, the religious are the more open-minded. Their assumption that the senses may mislead is less arrogant than the assumption that through them alone can we come at reality, for, as Dr. McTaggart has wittily said, "If a man is shut up in a house, the transparency of the windows is an essential condition of his seeing the sky. But it would not be prudent to infer that, if he walked out of the house, he could not see the sky, because there was no longer any glass through which he might see it." [2]

Examples of scientific bigotry are as common as blackberries. The attitude of the profession towards unorthodox medicine is the classical instance. In the autumn of 1912 I was walking through the Grafton Galleries with a man who is certainly one of the ablest, and is reputed one of the most enlightened, of contemporary men of science.[3] Looking at the picture of a young girl with a cat by Henri-Matisse,[4] he exclaimed—"I see how it is, the fellow's astigmatic." I should have let this bit of persiflage go unanswered, assuming it to be one of those witty sallies for which the princes of science

85

are so justly famed and to which they often treat us even when they are not in the presence of works of art, had not the professor followed up his clue with the utmost gravity, assuring me at last that no picture in the gallery was beyond the reach of optical diagnostic. Still suspicious of his good faith, I suggested, tentatively, that perhaps the discrepancies between the normal man's vision and the pictures on the wall were the result of intentional distortion on the part of the artists. At this the professor became passionately serious—" Do you mean to tell me," he bawled, "that there has ever been a painter who did not try to make his objects as lifelike as possible? Dismiss such silly nonsense from your head." It is the old story: "Clear your mind of cant," that is to say, of anything which appears improbable or unpalatable to Dr. Johnson.

The religious, on the other hand, are apt to be a little prejudiced against common-sense; and, for my own part, I confess that I am often tempted to think that a common-sense view is necessarily a wrong one. It was common-sense to see that the world must be flat and that the sun must go round it; only when those fantastical people made themselves heard who thought that the solar

system could not be quite so simple an affair as common-sense knew it must be were these opinions knocked on the head. Dr. Johnson, the great exemplar of British common-sense, observing in autumn the gathered swallows skimming over pools and rivers, pronounced it certain that these birds sleep all the winter—" A number of them conglobulate together, by flying round and round, and then all in a heap throw themselves under water, and lie in the bed of a river " :[5] how sensibly, too, did he dispose of Berkeley's Idealism—" striking his foot with mighty force against a large stone "—" I refute it thus."[6] Seriously, is the common-sense view ever the right one ?

Lately, the men of sense and science have secured allies who have brought to their cause what most it lacked, a little fundamental thought. Those able and honest people, the Cambridge rationalists, headed by Mr. G. E. Moore, to whose *Principia Ethica*[7] I owe so much, are, of course, profoundly religious and live by a passionate faith in the absolute value of certain states of mind; also they have fallen in love with the conclusions and methods of science. Being extremely intelligent, they perceive, however, that empirical arguments can avail

nothing for or against a metaphysical theory, and that ultimately all the conclusions of science are based on a logic that precedes experience. Also they perceive that emotions are just as real as sensations. They find themselves confronted, therefore, by this difficulty; if someone steps forward to say that he has a direct, disinterested, *a priori*, conviction of the goodness of his emotions towards the Mass, he puts himself in the same position as Mr. Moore, who feels a similar conviction about the goodness of his towards the Truth.[8] If Mr. Moore is to infer the goodness of one state of mind from his feelings, why should not someone else infer the goodness of another from his? The Cambridge rationalists have a short way with such dissenters. They simply assure them that they do not feel what they say they feel. Some of them have begun to apply their cogent methods to aesthetics; and when we tell them what we feel for pure form they assure us that, in fact, we feel nothing of the sort. This argument, however, has always struck me as lacking in subtlety.

Much as he dislikes mentioning the fact or hearing it mentioned, the common man of science recognises no other end in life

than protracted and agreeable existence. That is where he joins issue with the religious; it is also his excuse for being a eugenist. He declines to believe in any reality other than that of the physical universe. On that reality he insists dogmatically.* Man, he says, is an animal who, like other animals, desires to live; he is provided with senses, and these, like other animals, he seeks to gratify: in these facts he bids us find an explanation of all human aspiration. Man wants to live and he wants to have a good time; to compass these ends he has devised an elaborate machinery. All emotion, says the common man of science, must ultimately be traced to the senses. All moral, religious and aesthetic emotions are derived from physical needs, just as political ideas are based on that gregarious instinct which is simply the result of a desire to live long and to live in comfort. We obey the by-law that forbids us to ride a bicycle on the foot-path, because we see that, in the long run, such a law is conducive to continued and

* I am aware that there are men of science who preserve an open mind as to the reality of the physical universe, and recognise that what is known as "the scientific hypothesis" leaves out of account just those things that seem to us most real. Doubtless these are the true men of science; they are not the common ones.

agreeable existence, and for very similar reasons, says the man of science, we approve of magnanimous characters and sublime works of art.

"Not so," reply saints, artists, Cambridge rationalists, and all the better sort ; for they feel that their religious, aesthetic, or moral emotions are not conditioned, directly or indirectly, by physical needs, nor, indeed, by anything in the physical universe. Some things, they feel, are good, not because they are means to physical well-being, but because they are good in themselves. In nowise does the value of aesthetic or religious rapture depend upon the physical satisfaction it affords. There are things in life the worth of which cannot be related to the physical universe, —things of which the worth is not relative but absolute. Of these matters I speak cautiously and without authority : for my immediate purpose—to present my conception of the religious character—I need say only that to some the materialistic conception of the universe does not seem to explain those emotions which they feel with supreme certainty and absolute disinterestedness. The fact is, men of science, having got us into the habit of attempting to justify all our feelings and states of mind

by reference to the physical universe, have almost bullied some of us into believing that what cannot be so justified does not exist.

I call him a religious man who, feeling with conviction that some things are good in themselves, and that physical existence is not amongst them, pursues, at the expense of physical existence, that which appears to him good. All those who hold with uncompromising sincerity that spiritual is more important than material life, are, in my sense, religious. For instance, in Paris I have seen young painters, penniless, half-fed, unwarmed, ill-clothed, their women and children in no better case, working all day in feverish ecstasy at unsaleable pictures, and quite possibly they would have killed or wounded anyone who suggested a compromise with the market. When materials and credit failed altogether, they stole newspapers and boot-blacking that they might continue to serve their masterful passion. They were superbly religious. All artists are religious. All uncompromising belief is religious. A man who so cares for truth that he will go to prison, or death, rather than acknowledge a God in whose existence he does not believe, is as religious, and as much a martyr in the cause of re-

ligion, as Socrates or Jesus. He has set
his criterion of values outside the physical
universe.

In material things, half a loaf is said to be
better than no bread. Not so in spiritual.
If he thinks that it may do some good, a
politician will support a bill which he con-
siders inadequate. He states his objections
and votes with the majority. He does well,
perhaps. In spiritual matters such compro-
mises are impossible. To please the public
the artist cannot give of his second best. To
do so would be to sacrifice that which makes
life valuable. Were he to become a liar and
express something different from what he
feels, truth would no longer be in him.
What would it profit him to gain the whole
world and lose his own soul? He knows
that there is that within him which is more
important than physical existence—that to
which physical existence is but a means.
That he may feel and express it, it is good
that he should be alive. But unless he may
feel and express the best, he were better
dead.

Art and Religion are, then, two roads by
which men escape from circumstance to
ecstasy. Between aesthetic and religious
rapture there is a family alliance. Art and

ART AND RELIGION

Religion are means to similar states of mind.
And if we are licensed to lay aside the science
of aesthetics and, going behind our emotion
and its object, consider what is in the mind of
the artist, we may say, loosely enough, that
art is a manifestation of the religious sense.
If it be an expression of emotion—as I am
persuaded that it is—it is an expression of
that emotion which is the vital force in every
religion, or, at any rate, it expresses an
emotion felt for that which is the essence of
all. We may say that both art and religion
are manifestations of man's religious sense, if
by "man's religious sense" we mean his
sense of ultimate reality. What we may not
say is, that art is the expression of any parti-
cular religion; for to do so is to confuse the
religious spirit with the channels in which it
has been made to flow. It is to confuse the
wine with the bottle. Art may have much
to do with that universal emotion that has
found a corrupt and stuttering expression in
a thousand different creeds: it has nothing
to do with historical facts or metaphysical
fancies. To be sure, many descriptive paint-
ings are manifestos and expositions of re-
ligious dogmas: a very proper use for
descriptive painting too. Certainly the blot
on many good pictures is the descriptive

element introduced for the sake of edification and instruction. But in so far as a picture is a work of art, it has no more to do with dogmas or doctrines, facts or theories, than with the interests and emotions of daily life.

II

ART AND HISTORY

AND yet there is a connection between art
and religion, even in the common and limited
sense of that word. There is an historical
connection : or, to be more exact, there is a
fundamental connection between the history
of art and the history of religion. Religions
are vital and sincere only so long as they are
animated by that which animates all great
art—spiritual ferment. It is a mistake, by
the way, to suppose that dogmatic religion
cannot be vital and sincere. Religious emo-
tions tend always to anchor themselves to
earth by a chain of dogma. That tendency
is the enemy within the gate of every move-
ment. Dogmatic religion can be vital and
sincere, and what is more, theology and
ritual have before now been the trumpet and
drum of spiritual revolutions. But dogmatic
or intellectually free, religious ages, ages of
spiritual turmoil, ages in which men set the

spirit above the flesh and the emotions above the intellect, are the ages in which is felt the emotional significance of the universe. Then it is men live on the frontiers of reality and listen eagerly to travellers' tales. Thus it comes about that the great ages of religion are commonly the great ages of art. As the sense of reality grows dim, as men become more handy at manipulating labels and symbols, more mechanical, more disciplined, more specialised, less capable of feeling things directly, the power of escaping to the world of ecstasy decays, and art and religion begin to sink. When the majority lack, not only the emotion out of which art and religion are made, but even the sensibility to respond to what the few can still offer, art and religion founder. After that, nothing is left of art and religion but their names; illusion and prettiness are called art, politics and sentimentality religion.

Now, if I am right in thinking that art is a manifestation—a manifestation, mark, and not an expression—of man's spiritual state, then in the history of art we shall read the spiritual history of the race. I am not surprised that those who have devoted their lives to the study of history should take it ill when one who professes only to under-

stand the nature of art hints that by under-
standing his own business he may become a
judge of theirs. Let me be as conciliatory
as possible. No one can have less right than
I, or, indeed, less inclination to assume the
proud title of "scientific historian" : no one
can care less about historical small-talk or be
more at a loss to understand what precisely
is meant by "historical science." Yet if
history be anything more than a chronologi-
cal catalogue of facts, if it be concerned with
the movements of mind and spirit, then I
submit that to read history aright we must
know, not only the works of art that each
age produced, but also their value as works
of art. If the aesthetic significance or in-
significance of works of art does, indeed,
bear witness to a spiritual state, then he who
can appreciate that significance should be in
a position to form some opinion concerning
the spiritual state of the men who produced
those works and of those who appreciated
them. If art be at all the sort of thing it is
commonly supposed to be, the history of art
must be an index to the spiritual history of
the race. Only, the historian who wishes to
use art as an index must possess not merely
the nice observation of the scholar and the
archaeologist, but also a fine sensibility. For

it is the aesthetic significance of a work that gives a clue to the state of mind that produced it; so the ability to assign a particular work to a particular period avails nothing unaccompanied by the power of appreciating its aesthetic significance.

To understand completely the history of an age must we know and understand the history of its art? It seems so. And yet the idea is intolerable to scientific historians. What becomes of the great scientific principle of water-tight compartments? Again, it is unjust: for assuredly, to understand art we need know nothing whatever about history. It may be that from works of art we can draw inferences as to the sort of people who made them: but the longest and most intimate conversations with an artist will not tell us whether his pictures are good or bad. We must see them: then we shall know. I may be partial or dishonest about the work of my friend, but its aesthetic significance is not more obvious to me than that of a work that was finished five thousand years ago. To appreciate fully a work of art we require nothing but sensibility. To those that can hear Art speaks for itself: facts and dates do not; to make bricks of such stuff one must glean the uplands and hollows for tags

of auxiliary information and suggestion; and the history of art is no exception to the rule. To appreciate a man's art I need know nothing whatever about the artist; I can say whether this picture is better than that without the help of history; but if I am trying to account for the deterioration of his art, I shall be helped by knowing that he has been seriously ill or that he has married a wife who insists on his boiling her pot. To mark the deterioration was to make a pure, aesthetic judgment: to account for it was to become an historian. To understand the history of art we must know something of other kinds of history. Perhaps, to understand thoroughly any kind of history we must understand every kind of history. Perhaps the history of an age or of a life is an indivisible whole. Another intolerable idea! What becomes of the specialist? What of those formidable compendiums in which the multitudinous activities of man are kept so jealously apart? The mind boggles at the monstrous vision of its own conclusions.

But, after all, does it matter to me? I am not an historian of art or of anything else. I care very little when things were made, or why they were made; I care about

their emotional significance to us. To the historian everything is a means to some other means; to me everything that matters is a direct means to emotion. I am writing about art, not about history. With history I am concerned only in so far as history serves to illustrate my hypothesis : and whether history be true or false matters very little, since my hypothesis is not based on history but on personal experience, not on facts but on feelings. Historical fact and falsehood are of no consequence to people who try to deal with realities. They need not ask, "Did this happen?"; they need ask only, "Do I feel this?" Lucky for us that it is so: for if our judgments about real things had to wait upon historical certitude they might have to wait for ever. Nevertheless it is amusing to see how far that of which we are sure agrees with that which we should expect. My aesthetic hypothesis—that the essential quality in a work of art is significant form—was based on my aesthetic experience. Of my aesthetic experiences I am sure. About my second hypothesis, that significant form is the expression of a peculiar emotion felt for reality—I am far from confident. However, I assume it to be true, and go on to suggest that this sense of reality leads men

to attach greater importance to the spiritual than to the material significance of the universe, that it disposes men to feel things as ends instead of merely recognising them as means, that a sense of reality is, in fact, the essence of spiritual health. If this be so, we shall expect to find that ages in which the creation of significant form is checked are ages in which the sense of reality is dim, and that these ages are ages of spiritual poverty. We shall expect to find the curves of art and spiritual fervour ascending and descending together. In my next chapter I shall glance at the history of a cycle of art with the intention of following the movement of art and discovering how far that movement keeps pace with changes in the spiritual state of society. My view of the rise, decline and fall of art in Christendom is based entirely on a series of independent aesthetic judgments in the rightness of which I have the arrogance to feel considerable confidence. I pretend to a power of distinguishing between significant and insignificant form, and it will interest me to see whether a decline in the significance of forms—a deterioration of art, that is to say—synchronises generally with a lowering of the religious sense. I shall expect to find that whenever artists have allowed themselves

to be seduced from their proper business, the creation of form, by other and irrelevant interests, society has been spiritually decadent. Ages in which the sense of formal significance has been swamped utterly by preoccupation with the obvious, will turn out, I suspect, to have been ages of spiritual famine. Therefore, while following the fortunes of art across a period of fourteen hundred years, I shall try to keep an eye on that of which art may be a manifestation—man's sense of ultimate reality.

To criticise a work of art historically is to play the science-besotted fool. No more disastrous theory ever issued from the brain of a charlatan than that of evolution in art. Giotto did not creep, a grub, that Titian might flaunt, a butterfly. To think of a man's art as leading on to the art of someone else is to misunderstand it. To praise or abuse or be interested in a work of art because it leads or does not lead to another work of art is to treat it as though it were not a work of art. The connection of one work of art with another may have everything to do with history: it has nothing to do with appreciation. So soon as we begin to consider a work as anything else than an end in itself we leave the world of art. Though

the development of painting from Giotto to Titian may be interesting historically, it cannot affect the value of any particular picture: aesthetically, it is of no consequence whatever. Every work of art must be judged on its own merits.

Therefore, be sure that, in my next chapter, I am not going to make aesthetic judgments in the light of history; I am going to read history in the light of aesthetic judgments. Having made my judgments, independently of any theory, aesthetic or non-aesthetic, I shall be amused to see how far the view of history that may be based on them agrees with accepted historical hypotheses. If my judgments and the dates furnished by historians be correct, it will follow that some ages have produced more good art than others: but, indeed, it is not disputed that the variety in the artistic significance of different ages is immense. I shall be curious to see what relation can be established between the art and the age that produced it. If my second hypothesis—that art is the expression of an emotion for ultimate reality —be correct, the relation between art and its age will be inevitable and intimate. In that case, an aesthetic judgment will imply some sort of judgment about the general state of

mind of the artist and his admirers. In fact, anyone who accepts absolutely my second hypothesis with all its possible implications —which is more than I am willing to do— will not only see in the history of art the spiritual history of the race, but will be quite unable to think of one without thinking of the other.

If I do not go quite so far as that, I stop short only by a little. Certainly it is less absurd to see in art the key to history than to imagine that history can help us to an appreciation of art. In ages of spiritual fervour I look for great art. By ages of spiritual fervour I do not mean pleasant or romantic or humane or enlightened ages; I mean ages in which, for one reason or another, men have been unusually excited about their souls and unusually indifferent about their bodies. Such ages, as often as not, have been superstitious and cruel. Pre-occupation with the soul may lead to superstition, indifference about the body to cruelty. I never said that ages of great art were sympathetic to the middle-classes. Art and a quiet life are incompatible I think; some stress and turmoil there must be. Need I add that in the snuggest age of materialism great artists may arise and

flourish? Of course : but when the pro-
duction of good art is at all widespread and
continuous, near at hand I shall expect to
find a restless generation. Also, having
marked a period of spiritual stir, I shall
look, not far off, for its manifestation in
significant form. But the stir must be
spiritual and genuine ; a swirl of emotional-
ism or political frenzy will provoke nothing
fine.* How far in any particular age the
production of art is stimulated by general
exaltation, or general exaltation by works
of art, is a question hardly to be decided.
Wisest, perhaps, is he who says that the
two seem to have been interdependent. Just
how dependent I believe them to have been,
will appear when, in my next chapter, I
attempt to sketch the rise, decline, and fall
of the Christian slope.

* I should not have expected the wars of so-called
religion or the Puritan revolution to have awakened in
men a sense of the emotional significance of the universe,
and I should be a good deal surprised if Sir Edward
Carson's agitation were to produce in the North-East of
Ireland a crop of first-rate formal expression.

III

ART AND ETHICS

BETWEEN me and the pleasant places of history remains, however, one ugly barrier. I cannot dabble and paddle in the pools and shallows of the past until I have answered a question so absurd that the nicest people never tire of asking it : "What is the moral justification of art?" Of course they are right who insist that the creation of art must be justified on ethical grounds : all human activities must be so justified. It is the philosopher's privilege to call upon the artist to show that what he is about is either good in itself or a means to good. It is the artist's duty to reply : "Art is good because it exalts to a state of ecstasy better far than anything a benumbed moralist can even guess at ; so shut up." Philosophically he is quite right ; only, philosophy is not so simple as that. Let us try to answer philosophically.

ART AND ETHICS

The moralist inquires whether art is either good in itself or a means to good. Before answering, we will ask what he means by the word "good," not because it is in the least doubtful, but to make him think. In fact, Mr. G. E. Moore has shown pretty conclusively in his *Principia Ethica* that by "good" everyone means just good. We all know quite well what we mean though we cannot define it.[1] "Good" can no more be defined than "Red": no quality can be defined. Nevertheless we know perfectly well what we mean when we say that a thing is "good" or "red." This is so obviously true that its statement has greatly disconcerted, not to say enraged, the orthodox philosophers.

Orthodox philosophers are by no means agreed as to what we do mean by "good," only they are sure that we cannot mean what we say. They used to be fond of assuming that "good" meant pleasure; or, at any rate, that pleasure was the sole good as an end: two very different propositions. That "good" means "pleasure" and that pleasure is the sole good was the opinion of the Hedonists, and is still the opinion of any Utilitarians who may have lingered on into the twentieth century. They enjoy the

honour of being the only ethical fallacies
worth the powder and shot of a writer on
art. I can imagine no more delicate or
convincing piece of logic than that by
which Mr. G. E. Moore disposes of
both.[2] But it is none of my business
to do clumsily what Mr. Moore has done
exquisitely. I have no mind by attempt-
ing to reproduce his dialectic to incur
the merited ridicule of those familiar with
the *Principia Ethica* or to spoil the pleasure
of those who will be wise enough to
run out this very minute and order a
masterpiece with which they happen to be
unacquainted. For my immediate purpose
it is necessary only to borrow one shaft
from that well-stocked armoury.

To him who believes that pleasure is
the sole good, I will put this question:
Does he, like John Stuart Mill,[3] and
everyone else I ever heard of, speak of
"higher and lower" or "better and worse"
or "superior and inferior" pleasures? And,
if so, does he not perceive that he has
given away his case? For, when he says
that one pleasure is "higher" or "better"
than another, he does not mean that it
is greater in *quantity* but superior in
quality.

On page 7 of *Utilitarianism*, J. S. Mill says :—

"If one of the two (pleasures) is, by those who are competently acquainted with both, placed so far above the other that they prefer it, even though knowing it to be attended with a greater amount of discontent, and would not resign it for any quantity of the other pleasure which their nature is capable of, we are justified in ascribing to the preferred enjoyment a superiority in quality, so far outweighing quantity as to render it, in comparison, of small account."[4]

But if pleasure be the sole good, the only possible criterion of pleasures is quantity of pleasure. "Higher" or "better" can only mean containing more pleasure. To speak of "better pleasures" in any other sense is to make the goodness of the sole good as an end depend upon something which, *ex hypothesi*, is not good as an end. Mill is as one who, having set up sweetness as the sole good quality in jam, prefers Tiptree to Crosse and Blackwell, not because it is sweeter, but because it possesses a better kind of sweetness. To do so is to discard sweetness as an ultimate criterion and to set up something else in its place. So, when Mill,

like everyone else, speaks of "better" or
"higher" or "superior" pleasures, he dis-
cards pleasure as an ultimate criterion, and
thereby admits that pleasure is not the sole
good. He feels that some pleasures are
better than others, and determines their
respective values by the degree in which they
possess that quality which all recognise but
none can define—goodness. By higher and
lower, superior and inferior pleasures we
mean simply more good and less good
pleasures. There are, therefore, two differ-
ent qualities, Pleasantness and Goodness.
Pleasure, amongst other things, may be
good; but pleasure cannot mean good. By
"good" we cannot mean "pleasureable;"
for, as we see, there is a quality, "good-
ness," so distinct from pleasure that we
speak of pleasures that are more or less
good without meaning pleasures that are
more or less pleasant. By "good," then, we
do not mean "pleasure," neither is pleasure
the sole good.

Mr. Moore goes on to inquire what
things are good in themselves, as ends that
is to say.[5] He comes to a conclusion with
which we all agree, but for which few could
have found convincing and logical argu-
ments: "states of mind," he shows, alone

are good as ends.* People who have very little taste for logic will find a simple and satisfactory proof of this conclusion afforded by what is called "the method of isolation."

That which is good as an end will retain some, at any rate, of its value in complete isolation : it will retain all its value as an end. That which is good as a means only will lose all its value in isolation. That which is good as an end will remain valuable even when deprived of all its consequences and left with nothing but bare existence. Therefore, we can discover whether honestly we feel some thing to be good as an end, if only we can conceive it in complete isolation, and be sure that so isolated it remains valuable. Bread is good. Is bread good as an end or as a means? Conceive a loaf existing in an uninhabited and uninhabitable planet. Does it seem to lose its value? That is a little too easy. The physical universe appears to most people immensely good, for towards nature they feel violently that emotional reaction which brings to the lips the epithet " good "; but if the physical universe were not related to mind, if it were

* Formerly he held that inanimate beauty also was good in itself. But this tenet, I am glad to learn, he has discarded.

never to provoke an emotional reaction, if no mind were ever to be affected by it, and if it had no mind of its own, would it still appear good? There are two stars: one is, and ever will be, void of life, on the other exists a fragment of just living protoplasm which will never develop, will never become conscious. Can we say honestly that we feel one to be better than the other? Is life itself good as an end? A clear judgment is made difficult by the fact that one cannot conceive anything without feeling something for it; one's very conceptions provoke states of mind and thus acquire value as means. Let us ask ourselves, bluntly, can that which has no mind and affects no mind have value? Surely not. But anything which has a mind can have intrinsic value, and anything that affects a mind may become valuable as a means, since the state of mind produced may be valuable in itself. Isolate that mind. Isolate the state of mind of a man in love or rapt in contemplation; it does not seem to lose all its value. I do not say that its value is not decreased; obviously, it loses its value as a means to producing good states of mind in others. But a certain value does subsist—an intrinsic value. Populate the lone star with one human mind and every

part of that star becomes potentially valuable as a means, because it may be a means to that which is good as an end—a good state of mind. The state of mind of a person in love or rapt in contemplation suffices in itself. We do not stay to inquire "What useful purpose does this serve, whom does it benefit, and how?" We say directly and with conviction—"This is good."

When we are challenged to justify our opinion that anything, other than a state of mind, is good, we, feeling it to be a means only, do very properly seek its good effects, and our last justification is always that it produces good states of mind. Thus, when asked why we call a patent fertiliser good, we may, if we can find a listener, show that the fertiliser is a means to good crops, good crops a means to food, food a means to life, and life a necessary condition of good states of mind. Further we cannot go. When asked why we hold a particular state of mind to be good, the state of aesthetic contemplation for instance, we can but reply that to us its goodness is self-evident. Some states of mind appear to be good independently of their consequences. No other things appear to be good in this way. We

conclude, therefore, that good states of mind are alone good as ends.

To justify ethically any human activity, we must inquire—"Is this a means to good states of mind?" In the case of art our answer will be prompt and emphatic. Art is not only a means to good states of mind, but, perhaps, the most direct and potent that we possess. Nothing is more direct, because nothing affects the mind more immediately; nothing is more potent, because there is no state of mind more excellent or more intense than the state of aesthetic contemplation. This being so, to seek any other moral justification for art, to seek in art a means to anything less than good states of mind, is an act of wrong-headedness to be committed only by a fool or a man of genius.

Many fools have committed it and one man of genius has made it notorious. Never was cart put more obstructively before horse than when Tolstoi announced that the justification of art was its power of promoting good actions. As if actions were ends in themselves![6] There is neither virtue nor vice in running: but to run with good tidings is commendable, to run away with an old lady's purse is not. There is no merit in shouting: but to speak up for truth and justice is well,

to deafen the world with charlatanry is damnable. Always it is the end in view that gives value to action; and, ultimately, the end of all good actions must be to create or encourage or make possible good states of mind. Therefore, inciting people to good actions by means of edifying images is a respectable trade and a roundabout means to good. Creating works of art is as direct a means to good as a human being can practise. Just in this fact lies the tremendous importance of art: there is no more direct means to good.

To pronounce anything a work of art is, therefore, to make a momentous moral judgment. It is to credit an object with being so direct and powerful a means to good that we need not trouble ourselves about any other of its possible consequences. But even were this not the case, the habit of introducing moral considerations into judgments between particular works of art would be inexcusable. Let the moralist make a judgment about art as a whole, let him assign it what he considers its proper place amongst means to good, but in aesthetic judgments, in judgments between members of the same class, in judgments between works of art considered as art, let him hold his tongue. If he esteem art

anything less than equal to the greatest means to good he mistakes. But granting, for the sake of peace, its inferiority to some, I will yet remind him that his moral judgments about the value of particular works of art have nothing to do with their artistic value. The judge at Epsom is not permitted to disqualify the winner of the Derby in favour of the horse that finished last but one on the ground that the latter is just the animal for the Archbishop of Canterbury's brougham.

Define art as you please, preferably in accordance with my ideas; assign it what place you will in the moral system; and then discriminate between works of art according to their excellence in that quality, or those qualities, that you have laid down in your definition as essential and peculiar to works of art. You may, of course, make ethical judgments about particular works, not as works of art, but as members of some other class, or as independent and unclassified parts of the universe. You may hold that a particular picture by the President of the Royal Academy is a greater means to good than one by the glory of the New English Art Club,[7] and that a penny bun is better than either. In such a case you will be making a moral and not an aesthetic judgment. Therefore it

will be right to take into account the area of
the canvases, the thickness of the frames,
and the potential value of each as fuel or
shelter against the rigours of our climate.
In casting up accounts you should not neglect
their possible effects on the middle-aged
people who visit Burlington House and the
Suffolk Street Gallery ;[8] nor must you forget
the consciences of those who handle the
Chantry funds, or of those whom high prices
provoke to emulation. You will be making
a moral and not an aesthetic judgment ; and
if you have concluded that neither picture is
a work of art, though you may be wasting
your time, you will not be making yourself
ridiculous. But when you treat a picture
as a work of art, you have, unconsciously
perhaps, made a far more important moral
judgment. You have assigned it to a class
of objects so powerful and direct as means
to spiritual exaltation that all minor merits
are inconsiderable. Paradoxical as it may
seem, the only relevant qualities in a work
of art, judged as art, are artistic qualities :
judged as a means to good, no other qualities
are worth considering ; for there are no
qualities of greater moral value than artistic
qualities, since there is no greater means to
good than art.

III

THE CHRISTIAN SLOPE

I

THE RISE OF CHRISTIAN ART

WHAT do I mean by a slope? That I hope
to make clear in the course of this chapter
and the next. But, as readers may expect
something to go on with, I will explain
immediately that, though I recognise the
continuity of the stream of art, I believe
that it is possible and proper to divide that
stream into slopes and movements. About
the exact line of division there can be
no certainty. It is easy to say that in the
passage of a great river from the hills to the
sea, the depth, the width, the colour, the
temperature, and the velocity of the waters
are bound to change; to fix precisely the
point of change is another matter. If I try
to picture for myself the whole history of
art from earliest times in all parts of the
world I am unable, of course, to see it as a
single thread. The stuff of which it is made
is unchangeable, it is always water that flows

down the river, but there is more than one channel: for instance, there is European art and Oriental. To me the universal history of art has the look of a map in which several streams descend from the same range of mountains to the same sea. They start from different altitudes but all descend at last to one level. Thus, I should say that the slope at the head of which stand the Buddhist master-pieces of the Wei, Liang, and T'ang¹ dynasties begins a great deal higher than the slope at the head of which are the Greek primitives of the seventh century, and higher than that of which early Sumerian sculpture is the head; but when we have to consider con-temporary Japanese art, Graeco-Roman and Roman sculpture, and late Assyrian, we see that all have found the same sea-level of nasty naturalism.

By a slope, then, I mean that which lies between a great primitive morning, when men create art because they must, and that darkest hour when men confound imitation with art. These slopes can be subdivided into movements. The downward course of a slope is not smooth and even, but broken and full of accidents. Indeed the procession of art does not so much resemble a river as a road from the mountains to the plain. That

road is a sequence of ups and downs. An up and a down together form a movement. Sometimes the apex of one movement seems to reach as high as the apex of the movement that preceded it, but always its base carries us farther down the slope. Also, in the history of art the summit of one movement seems always to spring erect from the trough of its predecessor. The upward stroke is vertical, the downward an inclined plane. For instance, from Duccio[2] to Giotto is a step up, sharp and shallow. From Giotto to Lionardo[3] is a long and, at times, almost imperceptible fall. Duccio is a fine decadent of that Basilian[4] movement which half survived the Latin conquest and came to an exquisite end under the earlier Palaeologi[5] The peak of that movement rises high above Giotto, though Duccio near its base is below him. Giotto's art is definitely inferior to the very finest Byzantine of the eleventh and twelfth centuries, and Giotto is the crest of a new movement destined and doomed inevitably to sink to depths undreamed of by Duccio.

All that was spiritual in Greek civilisation was sick before the sack of Corinth[6] and all that was alive in Greek art had died many years earlier. That it had died before the

death of Alexander let his tomb at Constanti-
nople be my witness.[7] Before they set the
last stone of the Parthenon it was ailing: the
big marbles in the British Museum are the
last significant examples of Greek art; the
frieze, of course, proves nothing, being mere
artisan work. But the man who made what
one may as well call "The Theseus" and
"The Ilissus,"[8] the man whom one may as
well call Phidias,[9] crowns the last vital move-
ment in the Hellenic slope. He is a genius,
but he is no oddity: he falls quite naturally
into his place as the master of the early
decadence; he is the man in whom runs
rich and fast but a little coarsened the
stream of inspiration that gave life to archaic
Greek sculpture. He is the Giotto—but an
inferior Giotto—of the slope that starts from
the eighth century B.C.—so inferior to the
sixth century A.D.—to peter out in the bogs
of Hellenistic and Roman rubbish. Whence
sprang that Hellenic impulse? As yet we
cannot tell. Probably, from the ruins of
some venerable Mediterranean civility, against
the complex materialism of which it was, in
its beginnings, I dare say, a reaction. The
story of its prime can be read in fragments
of archaic sculpture scattered throughout
Europe, and studied in the National Museum

at Athens, where certain statues of athletes, dating from about 600, reveal the excellences and defects of Greek art at its best. Of its early decline in the fifth century Phidias is the second-rate Giotto; the copies of his famous contemporaries and immediate predecessors are too loathsome to be at all just; Praxiteles,[10] in the fourth century, the age of accomplished prettiness, is the Correggio,[11] or whatever delightful trifler your feeling for art and chronology may suggest. Fifth and fourth century architecture forbid us to forget the greatness of the Greeks in the golden age of their intellectual and political history. The descent from sensitive, though always rather finikin, drawing through the tasteful and accomplished to the feebly forcible may be followed in the pots and vases of the sixth, fifth, fourth, and third centuries. In the long sands and flats of Roman realism the stream of Greek inspiration is lost for ever.

Before the death of Marcus Aurelius,[12] Europe was as weary of materialism as England before the death of Victoria.[13] But what power was to destroy a machine that had enslaved men so completely that they dared not conceive an alternative? The machine was grown so huge that man could

no longer peer over its side ; man could see
nothing but its cranks and levers, could hear
nothing but its humming, could mark the
spinning fly-wheel and fancy himself in con-
templation of the revolving spheres. Anni-
hilation was the only escape for the Roman
citizen from the Roman Empire. Yet, while
in the West Hadrian[14] was raising the Imperial
talent for brutalisation to a system and a
science, somewhere in the East, in Egypt, or
in Asia Minor, or, more probably in Syria,
in Mesopotamia, or even Persia, the new
leaven was at work. That power which
was to free the world was in ferment. The
religious spirit was again coming to birth.
Here and there, in face of the flat contra-
diction of circumstances, one would arise
and assert that man does not live by bread
alone. Orphism, Mythraism, Christianity,
many forms of one spirit, were beginning to
mean something more than curious ritual
and discreet debauch. Very slowly a change
was coming over the face of Europe.

There was change before the signs of it
became apparent. The earliest Christian
paintings in the catacombs are purely classical.
If the early Christians felt anything new
they could not express it. But before the
second century was out Coptic craftsmen

had begun to weave into dead Roman designs something vital. The academic patterns are queerly distorted and flattened out into forms of a certain significance, as we can feel for ourselves if we go to the textile room at South Kensington. Certainly, these second century Coptic textiles are more like works of art than anything that had been produced in the Roman Empire for more than four hundred years. Egyptian paintings of the third century bear less positive witness to the fumblings of a new spirit. But at the beginning of the fourth century Diocletian built his palace at Spalato, where we have all learned to see classicism and the new spirit from the East fighting it out side by side; and, if we may trust Strzygowski,[15] from the end of that century dates the beautiful church of Kodja-Kalessi in Isauria. The century in which the East finally dominated the West (350-450) is a period of incubation. It is a time of disconcerting activity that precedes the unmistakable launch of art upon the Christian slope. I would confidently assert that every artistic birth is preceded by a period of uneasy gestation in which the unborn child acquires the organs and energy that are to carry it forward on its long journey, if only I possessed the data

that would give a tottering support to so comforting a generalisation. Alas! the births of the great slopes of antiquity are shrouded in a night scarcely ruffled by the minute researches of patient archaeologists and impervious to the startling discoveries by experts of more or less palpable forgeries. Of these critical periods we dare not speak confidently; nevertheless we can compare the fifth century with the nineteenth and draw our own conclusions.

In 450 they built the lovely Galla Placidia at Ravenna. It is a building essentially un-Roman; that is to say, the Romanism that clings to it is accidental and adds nothing to its significance. The mosaics within, however, are still coarsely classical. There is a nasty, woolly realism about the sheep, and about the good shepherd more than a suspicion of the stodgy, Graeco-Roman, Apollo. Imitation still fights, though it fights a losing battle, with significant form. When S. Vitale was begun in 526 the battle was won. Sta. Sophia at Constantinople was building between 532 and 537; the finest mosaics in S. Vitale, S. Apollinare-Nuovo and S. Apollinare-in-Classe belong to the sixth century; so do SS. Sergius and Bacchus at Constantinople and the Duomo at Parenzo.

In fact, to the sixth century belong the most majestic monuments of Byzantine art. It is the primitive and supreme summit of the Christian slope. The upward spring from the levels of ·Graeco-Romanism is immeasurable. The terms in which it could be stated have yet to be discovered. It is the whole length of the slope from Sta. Sophia to the Victoria Memorial[16] pushed upright to stand on a base of a hundred years. We are on heights from which the mud-flats are invisible; resting here, one can hardly believe that the flats ever were, or, at any rate, that they will ever be again. Go to Ravenna, and you will see the masterpieces of Christian art, the primitives of the slope: go to the Tate Gallery or the Luxembourg, and you will see the end of that slope—Christian art at its last gasp. These *memento mori* are salutary in an age of assurance when, looking at the pictures of Cézanne, we feel, not inexcusably, that we are high above the mud and malaria. Between Cézanne and another Tate Gallery, what lies in store for the human spirit? Are we in the period of a new incubation? Or is the new age born? Is it a new slope that we are on, or are we merely part of a surprisingly

vigorous premonitory flutter? These are queries to ponder. Is Cézanne the beginning of a slope, a portent, or merely the crest of a movement? The oracles are dumb. This alone seems to me sure: since the Byzantine primitives set their mosaics at Ravenna no artist in Europe has created forms of greater significance unless it be Cézanne.

With Sta. Sophia at Constantinople, and the sixth century churches and mosaics at Ravenna, the Christian slope establishes itself in Europe.* In the same century it took a downward twist at Constantinople; but in one part of Europe or another the new inspiration continued to manifest itself supremely for more than six hundred years. There were ups and downs, of course, movements and reactions; in some places art was almost always good, in others it was never first-rate; but there was no universal, irreparable

* I am not being so stupid as to suggest that in the sixth century the Hellenistic influence died. It persisted for another 300 years at least. In sculpture and ivory carving it was only ousted by the Romanesque movement of the eleventh century. Inevitably a great deal of Hellenistic stuff continued to be produced after the rise of Byzantine art. For how many years after the maturity of Cézanne will painters continue to produce chromophotographs? Hundreds perhaps. For all that, Cézanne marks a change—the birth of a movement if not of a slope.

depreciation till Norman and Romanesque architecture gave way to Gothic, till twelfth-century sculpture became thirteenth-century figuration.

Christian art preserved its primitive significance for more than half a millennium. Therein I see no marvel. Even ideas and emotions travelled slowly in those days. In one respect, at any rate, trains and steam-boats have fulfilled the predictions of their exploiters—they have made everything move faster: the mistake lies in being quite so positive that this is a blessing. In those dark ages things moved slowly; that is one reason why the new force had not spent itself in six hundred years. Another is that the revelation came to an age that was constantly breaking fresh ground. Always there was a virgin tract at hand to take the seed and raise a lusty crop. Between 500 and 1000 A.D. the population of Europe was fluid. Some new race was always catching the inspiration and feeling and expressing it with primitive sensibility and passion. The last to be infected was one of the finest; and in the eleventh century Norman power and French intelligence produced in the west of Europe a manifestation of the Christian ferment only

a little inferior to that which five hundred years earlier had made glorious the East.

Let me insist once again that, when I speak of the Christian ferment or the Christian slope, I am not thinking of dogmatic religion. I am thinking of that religious spirit of which Christianity, with its dogmas and rituals, is one manifestation, Buddhism another. And when I speak of art as a manifestation of the religious spirit I do not mean that art expresses particular religious emotions, much less that it expresses anything theological. I have said that if art expresses anything, it expresses an emotion felt for pure form and that which gives pure form its extraordinary significance. So, when I speak of Christian art, I mean that this art was one product of that state of enthusiasm of which the Christian Church is another. So far was the new spirit from being a mere ebullition of Christian faith that we find manifestations of it in Mohammedan art; everyone who has seen a photograph of the Mosque of Omar at Jerusalem knows that. The emotional renaissance in Europe was not the wide-spreading of Christian doctrines, but it was through Christian doctrine that Europe came to know of the rediscovery

of the emotional significance of the Universe.
Christian art is not an expression of specific
Christian emotions; but it was only when
men had been roused by Christianity that
they began to feel the emotions that express
themselves in form. It was Christianity
that put Europe into that state of emotional
turmoil from which sprang Christian art.

For a moment, in the sixth century, the
flood of enthusiasm seems to have carried
the Eastern world, even the official world,
off its feet. But Byzantine officials were
no fonder of swimming than others. The
men who worked the imperial machine,
studied the Alexandrine poets, and dabbled
in classical archaeology were not the men
to look forward. Only the people, led by
the monks, were vaguely, and doubtless
stupidly, on the side of emotion and the
future. Soon after Justinian's death the
Empire began to divide itself into two
camps. Appropriately, religious art was the
standard of the popular party, and around
that standard the battle raged. "No man,"
said Lord Melbourne,[17] "has more respect for
the Christian religion than I; but when it
comes to dragging it into private life . . ."
At Constantinople they began dragging
religion, and art too, into the sanctity of

private capital. Now, no official worth his salt can watch the shadow being recklessly sacrificed to the substance without itching to set the police on somebody; and the vigilance and sagacity of Byzantine civilians has become proverbial. We learn from a letter written by Pope Gregory II to the Emperor Leo, the iconoclast, that men were willing to give their estates for a picture. This, to Pope, Emperor, and Mr. Finlay the historian,[18] was proof enough of appalling demoralisation. For a parallel, I suppose, they recalled the shameful imprudence of the Magdalene. There were people at Constantinople who took art seriously, though in a rather too literary spirit—"dicunt enim artem pictoriam piam esse."[19] This sort of thing had to be stopped. Early in the eighth century began the iconoclast onslaught. The history of that hundred years' war, in which the popular party carried on a spirited and finally successful resistance, does not concern us. One detail, however, is worth noticing. During the iconoclast persecution a new popular art makes its appearance in and about those remote monasteries that were the strongholds of the mystics. Of this art the Chloudof Psalter[20] is the most famous example. Certainly the

art of the Chloudof Psalter is not great.
A desire to be illustrative generally mars
both the drawing and the design. It mars,
but does not utterly ruin; in many of
the drawings something significant persists.
There is, however, always too much realism
and too much literature. But neither the
realism nor the literature is derived from
classical models. The work is essentially
original. It is also essentially popular.
Indeed, it is something of a party pamphlet;
and in one place we see the Emperor and
his cabinet doing duty as a conclave of the
damned. It would be easy to overrate the
artistic value of the Chloudof Psalter, but
as a document it is of the highest import-
ance, because it brings out clearly the
opposition between the official art of the
iconoclasts that leaned on the Hellenistic
tradition and borrowed bluntly from Bagdad,
and the vital art that drew its inspiration
from the Christian movement and trans-
muted all its borrowing into something new.
Side by side with this live art of the Christian
movement we shall see a continuous output
of work based on the imitation of classical
models. Those coarse and dreary objects
that crop up more or less frequently in
early Byzantine, Merovingian, Carolingian,

Ottonian, Romanesque, and early Italian art,
are not, however, an inheritance from the
iconoclastic period; they are the long shadow
thrown across history by the gigantic finger
of imperial Rome. The mischief done by
the iconoclasts was not irreparable, but it
was grave. True to their class, Byzantine
officials indulged a taste for furniture, giving
thereby an unintentional sting to their attack.
Like the grandees of the Classical Renais-
sance, they degraded art, which is a religion,
to upholstery, a menial trade. They patro-
nised craftsmen who looked not into their
hearts, but into the past—who from the
court of the Kalif brought pretty patterns,
and from classical antiquity elegant illusions,
to do duty for significant design. They
looked to Greece and Rome as did the men of
the Renaissance, and, like them, lost in the
science of representation the art of creation.
In the age of the iconoclasts, modelling—the
coarse Roman modelling—begins to bulge
and curl luxuriously at Constantinople. The
eighth century in the East is a portent of
the sixteenth in the West. It is the restora-
tion of materialism with its paramour, obse-
quious art. The art of the iconoclasts tells
us the story of their days; it is descriptive,
official, eclectic, historical, plutocratic, palatial,

and vulgar. Fortunately, its triumph was partial and ephemeral.

For art was still too vigorous to be strangled by a pack of cultivated mandarins. In the end the mystics triumphed. Under the Regent Theodora (842) the images were finally restored ; under the Basilian dynasty (867-1057) and under the Comneni Byzantine art enjoyed a second golden age. And though I cannot rate the best Byzantine art of the ninth, tenth, eleventh, and twelfth centuries quite so high as I rate that of the sixth, I am inclined to hold it superior, not only to anything that was to come, but also to the very finest achievement of the greatest ages of Egypt, Crete, and Greece.

II

GREATNESS AND DECLINE

HAVING glanced at the beginnings of Christian art, we must not linger over the history of Byzantine. Eastern traders and artisans, pushing into Western Europe from the Adriatic and along the valley of the Rhone, carried with them the ferment. Monks driven out of the East by the iconoclast persecutions found Western Europe Christian and left it religious. The strength of the movement in Europe between 500 and 900 is commonly under-rated. That is partly because its extant monuments are not obvious. Buildings are the things to catch the eye, and, outside Ravenna, there is comparatively little Christian architecture of this period. Also the cultivated, spoon-fed art of the renaissance court of Charlemagne[1] is too often allowed to misrepresent one age and disgust another. Of course the bulk of those opulent knick-knacks manu-

138

factured for the Carolingian and Ottonian
Emperors, and now to be seen at Aachen,[2]
are as beastly as anything else that is made
simply to be precious. They reflect German
taste at its worst; and, in tracing the line,
or estimating the value, of the Christian slope
it is prudent to overlook even the best of
Teutonic effort.* For the bulk of it is not
primitive or mediaeval or renaissance art,
but German art. At any rate it is a mani-
festation of national character rather than
of aesthetic inspiration. Most aesthetic
creation bears the mark of nationality; very
few manifestations of German nationality bear
a trace of aesthetic creation. The differences
between the treasures of Aachen, early German
architecture, fifteenth-century German sculp-
ture, and the work produced to-day at Munich
are superficial. Almost all is profoundly
German, and nothing else. That is to say, it
is conscientious, rightly intentioned, exces-
sively able, and lacking in just that which dis-
tinguishes a work of art from everything else

* It will be found instructive to study cases 10–14 of
enamels and metal-work at South Kensington. The tyro
will have no difficulty in "spotting" the German and
Rheinish productions. Alas! the only possible mistake
would be a confusion between German and English.
Certainly the famous Gloucester candlestick (1100) is as
common as anything in the place, unless it be the even
more famous Cologne Reliquary (1170).

in the world. The inspiration and sensibility of the dark ages can be felt most surely and most easily in the works of minor art produced in France and Italy.* In Italy, however, there is enough architecture to prove up to the hilt, were further proof required, that the spirit was vigorous. It is the age of what Sig. Rivoira calls Pre-Lombardic Architecture—Italian Byzantine[3]: it is the age of the Byzantine school of painting at Rome.**

What the "Barbarians" did, indirectly, for art cannot be over-estimated. They almost extinguished the tradition of culture, they began to destroy the bogey of imperialism, they cleaned the slate. They were able to provide new bottles for the new wine. Artists can scarcely repress their envy when they hear that academic painters and masters were sold into slavery by the score. The Barbarians handed on the torch and wrought marvels in its light. But in those days men were too busy

* Patriots can take pleasure in the study of Saxon sculpture.
** Several schools of painting and drawing flourished during these centuries in Italy and north of the Alps. In S. Clemente alone it is easy to discover the work of two distinct periods between 600 and 900. The extant examples of both are superb.

fighting and ploughing and praying to have much time for anything else. Material needs absorbed their energies without fattening them; their spiritual appetite was ferocious, but they had a live religion as well as a live art to satisfy it. It is supposed that in the dark ages insecurity and want reduced humanity to something little better than bestiality. To this their art alone gives the lie, and there is other evidence. If turbulence and insecurity could reduce people to bestiality, surely the Italians of the ninth century were the men to roar and bleat. Constantly harassed by Saracens, Hungarians, Greeks, French, and every sort of German, they had none of those encouragements to labour and create which in the vast security of the *pax Romana* and the *pax Britannica* have borne such glorious fruits of private virtue and public magnificence. Yet in 898 Hungarian scouts report that northern Italy is thickly populated and full of fortified towns.[4] At the sack of Parma[5] (924) forty-four churches were burnt, and these churches were certainly more like Santa Maria di Pomposa or San Pietro at Toscanella than the Colosseum or the Royal Courts of Justice. That the

artistic output of the dark ages was to some extent limited by its poverty is not to be doubted; nevertheless, more first-rate art was produced in Europe between the years 500 and 900 than was produced in the same countries between 1450 and 1850.

For in estimating the artistic value of a period one tends first to consider the splendour of its capital achievements. After that one reckons the quantity of first-rate work produced. Lastly, one computes the proportion of undeniable works of art to the total output. In the dark ages the proportion seems to have been high. This is a characteristic of primitive periods. The market is too small to tempt a crowd of capable manufacturers, and the conditions of life are too severe to support the ordinary academy or salon exhibitor who lives on his private means and takes to art because he is unfit for anything else. This sort of producer, whose existence tells us less about the state of art than about the state of society, who would be the worst navvy in his gang or the worst trooper in his squadron, and is the staple product of official art schools, is unheard of in primitive ages. In drawing inferences, therefore,

we must not overlook the advantage enjoyed by barbarous periods in the fact that of those who come forward as artists the vast majority have some real gift. I would hazard a guess that of the works that survive from the dark age as high a proportion as one in twelve has real artistic value. Were a proportion of the work produced between 1450 and 1850 identical with that of the work produced between 500 and 900 to survive, it might very well happen that it would not contain a single work of art. In fact, we tend to see only the more important things of this period and to leave unvisited the notorious trash. Yet judging from the picked works brought to our notice in galleries, exhibitions, and private collections, I cannot believe that more than one in a hundred of the works produced between 1450 and 1850 can be properly described as a work of art.

Between 900 and 1200 the capital achievements of Christian art are not superior in quality to those of the preceding age—indeed, they fall short of the Byzantine masterpieces of the sixth century; but the first-rate art of this second period was more abundant, or, at any rate, has survived more successfully, than that of

the first. The age that has bequeathed us Romanesque, Lombardic, and Norman architecture gives no sign of dissolution. We are still on the level heights of the Christian Renaissance. Artists are still primitive. Men still feel the significance of form sufficiently to create it copiously. Increased wealth purchases increased leisure, and some of that leisure is devoted to the creation of art. I do not marvel, therefore, at the common, though I think inexact, opinion that this was the period in which Christian Europe touched the summit of its spiritual history: its monuments are everywhere majestic before our eyes. Not only in France, Italy, and Spain, but in England, and as far afield as Denmark, Norway, and Sweden, we can see the triumphs of Romanesque art. This was the last level stage on the long journey from Santa Sophia to St. John's Wood.

With Gothic architecture the descent began. Gothic architecture is juggling in stone and glass. It is the convoluted road that ends in a bridecake or a cucumber frame. A Gothic cathedral is a *tour de force* ; it is also a melodrama. Enter, and you will be impressed by the incredible skill of the constructor ; perhaps you will be impressed

by a sense of dim mystery and might; you will not be moved by pure form. You may groan " A-a-h " and collapse : you will not be strung to austere ecstasy. Walk round it, and take your pleasure in subtleties of the builder's craft, quaint corners, gargoyles, and flying buttresses, but do not expect the thrill that answers the perception of sheer rightness of form. In architecture the new spirit first came to birth; in architecture first it dies.

We find the spirit alive at the very end of the twelfth century in Romanesque sculpture and in stained glass : we can see it at Chartres and at Bourges. At Bourges there is an indication of the way things are going in the fact that in an unworthy building we find glass and some fragments of sculpture worthy of Chartres, and not unworthy of any age or place. Cimabue[6] and Duccio are the last great exponents in the West of the greater tradition—the tradition that held the essential everything and the accidental nothing. For with Duccio, at any rate, the sense of form was as much traditional as vital : and the great Cimabue is *fin de siècle*. They say that Cimabue died in 1302 ; Duccio about fifteen years later. With Giotto (born 1276), a greater artist than either, we turn a corner

as sharp as that which had been turned a hundred years earlier with the invention of Gothic architecture in France. For Giotto could be intentionally second-rate. He was capable of sacrificing form to drama and anecdote. He never left the essential out, but he sometimes knocked its corners off. He was always more interested in art than in St. Francis, but he did not always remember that St. Francis has nothing whatever to do with art.[7] In theory that is right enough; the Byzantines had believed that they were more interested in dogmatic theology than in form, and almost every great artist has had some notion of the sort Indeed, it seems that there is nothing so dangerous for an artist as consciously to care about nothing but art. For an artist to believe that his art is concerned with religion or politics or morals or psychology or scientific truth is well; it keeps him alive and passionate and vigorous: it keeps him up out of sentimental aestheticism: it keeps to hand a suitable artistic problem. But for an artist not to be able to forget all about these things as easily as a man who is playing a salmon forgets his lunch is the devil. Giotto lacked facility in forgetting. There are frescoes in which, failing to grasp the

significance of a form, he allows it to state a fact or suggest a situation. Giotto went higher than Cimabue but he often aimed lower. Compare his " Virgin and Child " in the Accademia with that of Cimabue in the same gallery, and you will see how low his humanism could bring him.[8] The coarse heaviness of the forms of that woman and her baby is unthinkable in Cimabue; for Cimabue had learnt from the Byzantines that forms should be significant and not life-like. Doubtless in the minds of both there was something besides a preoccupation with formal combinations; but Giotto has allowed that " something " to dominate his design, Cimabue has forced his design to dominate it. There is something protestant about Giotto's picture. He is so dreadfully obsessed by the idea that the humanity of the mother and child is the important thing about them that he has insisted on it to the detriment of his art. Cimabue was incapable of such commonness. Therefore make the comparison—it is salutary and instructive; and then go to Santa Croce[9] or the Arena Chapel[10] and admit that if the greatest name in European painting is not Cézanne it is Giotto.

From the peak that is Giotto the road

falls slowly but steadily. Giotto heads a movement towards imitation and scientific picture-making. A genius such as his was bound to be the cause of a movement; it need not have been the cause of such a movement. But the spirit of an age is stronger than the echoes of tradition, sound they never so sweetly. And the spirit of that age, as every extension lecturer[11]knows, moved towards Truth and Nature, away from supernatural ecstasies. There is a moment at which the spirit begins to crave for Truth and Nature, for naturalism and verisimilitude; in the history of art it is known as the early decadence. Nevertheless, on naturalism and materialism a constant war is waged by one or two great souls athirst for pure aesthetic rapture; and this war, strangely enough, is invariably described by the extension lecturer as a fight for Truth and Nature. Never doubt it, in a hundred years or less they will be telling their pupils that in an age of extreme artificiality arose two men, Cézanne and Gauguin, who, by simplicity and sincerity, led back the world to the haunts of Truth and Nature. Strangest of all, some part of what they say will be right.

The new movement broke up the great

Byzantine tradition,* and left the body of
art a victim to the onslaught of that strange,
new disease, the Classical Renaissance. The
tract that lies between Giotto and Lionardo
is the beginning of the end; but it is not
the end. Painting came to maturity late,
and died hard; and the art of the fourteenth
and fifteenth centuries—especially the Tuscan
schools—is not a mere historical link: it is
an important movement, or rather two. The
great Sienese names, Ugolino, Ambrogio
Lorenzetti,**and Simone Martini,[12]belong to
the old world as much as to the new; but
the movement that produced Masaccio,
Masolino, Castagno, Donatello, Piero della
Francesca, and Fra Angelico[13] is a reaction from
the Giottesque tradition of the fourteenth
century, and an extremely vital movement.
Often, it seems, the stir and excitement pro-
voked by the ultimately disastrous scientific
discoveries were a cause of good art. It was

* Throughout the whole primitive and middle period,
however, two tendencies are distinguishable—one vital,
derived from Constantinople, the other, dead and swollen,
from imperial Rome. Up to the thirteenth century the
Byzantine influence is easily predominant. I have often
thought that an amusing book might be compiled in
which the two tendencies would be well distinguished
and illustrated. In Pisa and its neighbourhood the
author will find a surfeit of Romanised primitives.

** Pietro [Lorenzetti] is, of course, nearer to Giotto.

the disinterested adoration of perspective, I
believe, that enabled Uccello and the Paduan
Mantegna[14] to apprehend form passionately.
The artist must have something to get into
a passion about.

Outside Italy, at the beginning of the
thirteenth century, the approaches of spiritual
bankruptcy are more obvious, though here,
too, painting makes a better fight than archi-
tecture. Seven hundred years of glorious
and incessant creation seem to have exhausted
the constructive genius of Europe. Gothic
architecture becomes something so nauseous*
that one can only rejoice when, in the six-
teenth century, the sponge is thrown up for
good, and, abandoning all attempt to create,
Europe settles down quietly to imitate clas-
sical models. All true creation was dead
long before that ; its epitaph had been com-
posed by the master of the " Haute Œuvre "
at Beauvais. Only intellectual invention
dragged on a sterile and unlucky existence.
A Gothic church of the late Middle Ages
is a thing made to order. A building
formula has been devised within which the

* Owing to the English invention of " Perpendicular,"
the least unsatisfactory style of Gothic architecture, the
English find it hard to realise the full horrors of late
Gothic.

artificer, who has ousted the artist, finds endless opportunity for displaying his address. The skill of the juggler and the taste of the pastrycook are in great demand now that the power to feel and the genius to create have been lost. There is brisk trade in pretty things; buildings are stuck all over with them. Go and peer at each one separately if you have a tooth for cheap sweet-meats.

Painting, outside Italy, was following more deliberately the road indicated by architecture. In illuminated manuscripts it is easy to watch the steady coarsening of line and colour. By the beginning of the fourteenth century, Limoges enamels have fallen into that state of damnation from which they have never attempted to rise. Of trans-Alpine figuration after 1250 the less said the better. If in Italian painting the slope is more gentle, that is partly because the spirit of the Byzantine renaissance died harder there, partly because the descent was broken by individual artists who rose superior to their circumstances. But here, too, intellect is filling the void left by emotion; science and culture are doing their work. By the year 1500 the stream of inspiration had grown so alarmingly thin that

there was only just enough to turn the wheels of the men of genius. The minor artists seem already prepared to resign themselves to the inevitable. Since we are no longer artists who move, let us be craftsmen who astonish. 'Tis a fine thing to tempt urchins with painted apples : that makes the people stare. To be sure, such feats are rather beneath the descendants of Giotto ; we leave them to the Dutchmen, whom we envy a little all the same. We have lost art ; let us study the science of imitation. Here is a field for learning and dexterity. And, as our patrons who have lost their aesthetic perceptions have not lost all their senses, let us flatter them with grateful objects : let our grapes and girls be as luscious as lifelike. But the patrons are not all sensualists ; some of them are scholars. The trade in imitations of the antique is almost as good as the trade in imitations of nature. Archaeology and connoisseurship, those twin ticks on palsied art, are upon us. To react to form a man needs sensibility ; to know whether rules have been respected knowledge of these rules alone is necessary. By the end of the fifteenth century art is becoming a question of rules ; appreciation a matter of connoisseurship.

GREATNESS AND DECLINE

Literature is never pure art. Very little literature is a pure expression of emotion; none, I think is an expression of pure inhuman emotion. Most of it is concerned, to some extent, with facts and ideas: it is intellectual. Therefore literature is a misleading guide to the history of art. Its history is the history of literature; and it is a good guide to the history of thought. Yet sometimes literature will provide the historian of art with a pretty piece of collateral evidence. For instance, the fact that Charles the Great[15] ordained that the Frankish songs should be collected and written down makes a neat pendant to the renaissance art of Aachen. People who begin to collect have lost the first fury of creation. The change that came over plastic art in France towards the end of the twelfth century is reflected in the accomplished triviality of Chrétien de Troyes.[16] The eleventh century had produced the *Chanson de Roland*, a poem as grand and simple as a Romanesque church. Chrétien de Troyes melted down the massive conceptions of his betters and twisted them into fine-spun conceits. He produced a poem as pinnacled, deft, and insignificant as Rouen Cathedral. In literature, as in the visual arts, Italy held out longest, and, when

she fell, fell like Lucifer, never to rise again.
In Italy there was no literary renaissance;
there was just a stirring of the rubbish heap.
If ever man was a full-stop, that man was
Boccaccio.[17] Dante died at Ravenna in 1321.
His death is a landmark in the spiritual
history of Europe. Behind him lies that
which, taken with the *Divina Commedia*, has
won for Italy an exaggerated literary reputa-
tion. In the thirteenth century there was
plenty of poetry hardly inferior to the
Lamento of Rinaldo;[18] in the fourteenth comes
Petrarch[19] with the curse of mellifluous phrase-
making.

May God forget me if I forget the great
Italian art of the fifteenth century. But, a
host of individual geniuses and a cloud of
admirable painters notwithstanding, the art
of the fifteenth century was further from
grace than that of the Giottesque painters of
the fourteenth. And the whole output of
the fourteenth and fifteenth centuries is im-
measurably inferior to the great Byzantine
and Romanesque production of the eleventh
and twelfth. Indeed, it is inferior in quality,
if not in quantity, to the decadent Byzantine
and Italian Byzantine of the thirteenth.
Therefore I will say that, already at the end
of the fourteenth century, though Castagno

and Masolino[20] and Gentile da Fabriano[21] and Fra Angelico were alive, and Masaccio and Piero and Bellini had yet to be born, it looked as if the road that started from Constantinople in the sixth century were about to end in a glissade. From Buda-Pest to Sligo, "late Gothic" stands for something as foul almost as "revival." Having come through the high passes, Europe, it seemed, was going to end her journey by plunging down a precipice. Perhaps it would have been as well; but it was not to be. The headlong rush was to be checked. The descent was to be eased by a strange detour, by a fantastic adventure, a revival that was no re-birth, a Medea's cauldron rather, an extravagant disease full of lust and laughter; the life of the old world was to be prolonged by four hundred years or so, by the galvanising power of the Classical Renaissance.

III

THE CLASSICAL RENAISSANCE AND ITS DISEASES

THE Classical Renaissance is nothing more than a big kink in the long slope; but it is a very big one. It is an intellectual event. Emotionally the consumption that was wasting Europe continued to run its course; the Renaissance was a mere fever-flash. To literature, however, its importance is immense: for literature can make itself independent of spiritual health, and is as much concerned with ideas as with emotions. Literature can subsist in dignity on ideas. Finlay's history of the Byzantine Empire provokes no emotion worth talking about, yet I would give Mr. Finlay[1] a place amongst men of letters, and I would do as much for Hobbes, Mommsen, Sainte-Beuve, Samuel Johnson, and Aristotle.[2] Great thinking without great feeling will make great literature. It is not for their emotional qualities that

we value many of our most valued books
And when it is for an emotional quality, to
what extent is that emotion aesthetic? I know
how little the intellectual and factual content
of great poetry has to do with its significance.
The actual meaning of the words in Shake-
speare's songs, the purest poetry in English,
is generally either trivial or trite. They are
nursery-rhymes or drawing-room ditties;—

> "Come away, come away, death,
> And in sad cypress let me be laid;
> Fly away, fly away, breath;
> I am slain by a fair cruel maid."[3]

Could anything be more commonplace?

> "Hark, hark!
> Bow, wow,
> The watch-dogs bark;
> Bow, wow,
> Hark, hark! I hear
> The strain of strutting chanticleer
> Cry, Cock-a-diddle-dow!"[4]

What could be more nonsensical? In the
verse of our second poet, Milton—so great
that before his name the word "second"
rings false as the giggle of fatuity—the
ideas are frequently shallow and the facts
generally false. In Dante, if the ideas are

sometimes profound and the emotions awful, they are also, as a rule, repugnant to our better feelings : the facts are the hoardings of a parish scold. In great poetry it is the formal music that makes the miracle. The poet expresses in verbal form an emotion but distantly related to the words set down. But it is related ; it is not a purely artistic emotion. In poetry form and its significance are not everything ; the form and the content are not one. Though some of Shakespeare's songs approach purity, there is, in fact, an alloy. The form is burdened with an intellectual content, and that content is a mood that mingles with and reposes on the emotions of life. That is why poetry, though it has its raptures, does not transport us to that remote aesthetic beatitude in which, freed from humanity, we are upstayed by musical and pure visual form.

The Classical Renaissance was a new reading of human life, and what it added to the emotional capital of Europe was a new sense of the excitingness of human affairs. If the men and women of the Renaissance were moved by Art and Nature, that was because in Art and Nature they saw their own reflections. The Classical Renaissance was not a re-birth but a re-discovery ; and

that superb mess of thought and observation, lust, rhetoric, and pedantry, that we call Renaissance literature, is its best and most characteristic monument. What it rediscovered were the ideas from the heights of which the ancients had gained a view of life. This view the Renaissance borrowed. By doing so it took the sting out of the spiritual death of the late Middle Ages. It showed men that they could manage very well without a soul. It made materialism tolerable by showing how much can be done with matter and intellect. That was its great feat. It taught men how to make the best of a bad job; it proved that by cultivating the senses and setting the intellect to brood over them it is easy to whip up an emotion of sorts. When men had lost sight of the spirit it covered the body with a garment of glamour.

That the Classical Renaissance was essentially an intellectual movement is proved, I think, by the fact that it left the uneducated classes untouched almost. They suffered from its consequences; it gave them nothing. A wave of emotion floods the back-gardens; an intellectual stream is kept within the irrigation channels. The Classical Renaissance made absolute the divorce of

the classes from the masses. The mediaeval
lord in his castle and the mediaeval hind
in his hut were spiritual equals who thought
and felt alike, held the same hopes and
fears, and shared, to a surprising extent, the
pains and pleasures of a simple and rather
cruel society. The Renaissance changed all
that. The lord entered the new world of
ideas and refined sensuality; the peasant
stayed where he was, or, as the last vestiges
of spiritual religion began to disappear with
the commons, sank lower. Popular art
changed so gradually that in the late
fifteenth and in the sixteenth century we
still find, in remote corners, things that
are rude but profoundly moving. Village
masons could still create in stone at the
time when Jacques Cœur[5] was building
himself the first "residence worthy of a
millionaire" that had been "erected" since
the days of Honorius.[6] But that popular
art pursued the downhill road sedately while
plutocratic art went with a run is a curious
accident of which the traces are soon lost;
the outstanding fact is that with the Re-
naissance Europe definitely turns her back
on the spiritual view of life. With that
renunciation the power of creating signi-
ficant form becomes the inexplicable gift of

the occasional genius. Here and there an individual produces a work of art, so art comes to be regarded as something essentially sporadic and peculiar. The artist is reckoned a freak. We are in the age of names and catalogues and genius-worship. Now, genius-worship is the infallible sign of an uncreative age. In great ages, though we may not all be geniuses, many of us are artists, and where there are many artists art tends to become anonymous.

The Classical Renaissance was something different in kind from what I have called the Christian Renaissance. It must be placed somewhere between 1350 and 1600. Place it where you will. For my part I always think of it as the gorgeous and well-cut garment of the years that fall between 1453 and 1594, between the capture of Constantinople and the death of Tintoretto.[7] To me, it is the age of Lionardo, of Charles VIII and Francis I, of Cesare Borgia and Leo X, of Raffael, of Machiavelli, and of Erasmus,[8] who carries us on to the second stage, the period of angry ecclesiastical politics, of Clement VII, Fontainebleau, Rabelais, Titian, Palladio, and Vasari.[9] But, on any computation, in the years that lie between the spiritual exaltation of the early

twelfth century and the sturdy materialism of the late sixteenth lies the Classical Renaissance. Whatever happened, happened between those dates. And all that did happen was nothing more than a change from late manhood to early senility complicated by a house-moving, bringing with it new hobbies and occupations. The decline from the eleventh to the seventeenth century is continuous and to be foreseen; the change from the world of Aurelian[10] to the world of Gregory the Great[11] is catastrophic. Since the Christian Renaissance, new ideas and knowledge notwithstanding, the world has grown rotten with decency and order. It takes more than the rediscovery of Greek texts and Graeco-Roman statues to provoke the cataclysms and earthquakes with which it grew young.

The art of the High Renaissance was conditioned by the demands of its patrons. There is nothing odd about that; it is a recognised stage in the rake's progress. The patrons of the Renaissance wanted plenty of beauty of the kind dear to the impressionable stock-jobber. Only, the plutocrats of the sixteenth century had a delicacy and magnificence of taste which would have made the houses and manners of modern

stock-jobbers intolerable to them. Renaissance millionaires could be vulgar and brutal, but they were great gentlemen. They were neither illiterate cads nor meddlesome puritans, nor even saviours of society. Yet, if we are to understand the amazing popularity of Titian's and of Veronese's women, we must take note of their niceness to kiss and obvious willingness to be kissed. That beauty for which can be substituted the word "desirableness," and that insignificant beauty which is the beauty of gems, were in great demand. Imitation was wanted, too; for if pictures are to please as suggestions and mementoes, the objects that suggest and remind must be adequately portrayed. These pictures had got to stimulate the emotions of life, first; aesthetic emotion was a secondary matter. A Renaissance picture was meant to say just those things that a patron would like to hear. That way lies the end of art: however wicked it may be to try to shock the public, it is not so wicked as trying to please it. But whatever the Italian painters of the Renaissance had to say they said in the grand manner. Remember, we are not Dutchmen. Therefore let all your figures suggest the appropriate emotion by means

of the appropriate gesture—the gesture consecrated by the great tradition. Straining limbs, looks of love, hate, envy, fear and horror, up-turned or downcast eyes, hands outstretched or clasped in despair—by means of our marvellous machinery, and still more marvellous skill, we can give them all they ask without forestalling the photographers. But we are not recounters all, for some of our patrons are poets. To them the visible Universe is suggestive of moods or, at any rate, sympathetic with them. These value objects for their association with the fun and folly and romance of life. For them, too, we paint pictures, and in their pictures we lend Nature enough humanity to make her interesting. My lord is lascivious? Correggio[13] will give him a background to his mood. My lord is majestic? Michelangelo[14] will tell him that man is, indeed, a noble animal whose muscles wriggle heroically as watch-springs. The sixteenth century produced a race of artists peculiar in their feeling for material beauty, but normal, coming as they do at the foot of the hills, in their technical proficiency and aesthetic indigence. Craft holds the candle that betrays the bareness of the cupboard. The aesthetic significance of form is feebly and

impurely felt, the power of creating it is lost almost; but finer descriptions have rarely been painted. They knew how to paint in the sixteenth century: as for the primitives—God bless them—they did their best: what more could they do when they couldn't even round a lady's thighs?

The Renaissance was a re-birth of other things besides a taste for round limbs and the science of representing them; we begin to hear again of two diseases, endemic in imperial Rome, from which a lively and vigorous society keeps itself tolerably free —Rarity-hunting and Expertise. These parasites can get no hold on a healthy body; it is on dead and dying matter that they batten and grow fat. The passion to possess what is scarce, and nothing else, is a disease that develops as civilisation grows old and dogs it to the grave: it is saprophytic. The rarity-hunter may be called a "collector" if by "collector" you do not mean one who buys what pleases or moves him. Certainly, such an one is unworthy of the name; he lacks the true magpie instinct. To the true collector the intrinsic value of a work of art is irrelevant; the reasons for which he prizes a picture are those for which a philatelist prizes a postage-stamp. To him

the question "Does this move me?" is
ludicrous: the question "Is it beautiful?"
—otiose. Though by the very tasteful
collector of stamps or works of art beauty is
allowed to be a fair jewel in the crown of
rarity, he would have us understand from
the first that the value it gives is purely
adventitious and depends for its existence
on rarity. No rarity, no beauty. As for
the profounder aesthetic significance, if a
man were to believe in its existence he
would cease to be a collector. The question
to be asked is—"Is this rare?" Suppose the
answer favourable, there remains another—
"Is it genuine?" If the work of any
particular artist is not rare, if the supply
meets the demand, it stands to reason that
the work is of no great consequence. For
good art is art that fetches good prices, and
good prices come of a limited supply. But
though it be notorious that the work of
Velasquez[15] is comparatively scarce and there-
fore good, it has yet to be decided whether
the particular picture offered at fifty thou-
sand is really the work of Velasquez.

Enter the Expert, whom I would dis-
tinguish from the archaeologist and the
critic. The archaeologist is a man with a
foolish and dangerous curiosity about the

past : I am a bit of an archaeologist myself.
Archaeology is dangerous because it may
easily overcloud one's aesthetic sensibility.
The archaeologist may, at any moment,
begin to value a work of art not because it
is good, but because it is old or interesting.
Though that is less vulgar than valuing it
because it is rare and precious it is equally
fatal to aesthetic appreciation. But so long
as I recognise the futility of my science, so
long as I recognise that I cannot appreciate
a work of art the better because I know
when and where it was made, so long as I
recognise that, in fact, I am at a certain
disadvantage in judging a sixth-century
mosaic compared with a person of equal
sensibility who knows and cares nothing
about Romans and Byzantines, so long as I
recognise that art criticism and archaeology
are two different things, I hope I may be
allowed to dabble unrebuked in my favourite
hobby : I hope I am harmless.

Art criticism, in the present state of
society, seems to me a respectable and pos-
sibly a useful occupation. The prejudice
against critics, like most prejudices, lives on
fear and ignorance. It is quite unnecessary
and rather provincial, for, in fact, critics are not
very formidable. They are suspected of all

sorts of high-handed practices—making and breaking reputations, running up and down, booming and exploiting—of which I should hardly think them capable. Popular opinion notwithstanding, I doubt whether critics are either omnipotent or utterly depraved. Indeed, I believe that some of them are not only blameless but even lovable characters. Those sinister but flattering insinuations and open charges of corruption fade woefully when one considers how little the critic of contemporary art can hope to get for "writing up" pictures that sell for twenty or thirty guineas apiece. The expert, to be sure, is exposed to some temptation, since a few of his words, judiciously placed, may promote a canvas from the twenty to the twenty thousand mark; but, as everyone knows, the morality of the expert is above suspicion. Useless as the occupation of the critic may be, it is probably honest; and, after all, is it more useless than all other occupations, save only those of creating art, producing food, drink, and tobacco, and bearing beautiful children?

If the collector asks me, as a critic, for my opinion of the Velasquez he is about to buy, I will tell him honestly what I think of it, as a work of art. I will tell him whether it

moves me much or little, and I will try to
point out those qualities and relations of line
and colour in which it seems to me to excel
or fall short. I will try to account for the
degree of my aesthetic emotion. That, I
conceive, is the function of the critic. But
all conjectures as to the authenticity of a
work based on its formal significance, or even
on its technical perfection, are extremely
hazardous. It is always possible that some-
one else was the master's match as artist and
craftsman, and of that someone's work there
may be an overwhelming supply. The critic
may sell the collector a common pup instead
of the one uncatalogued specimen of Pseudo-
kuniskos; and therefore the wary collector
sends for someone who can furnish him with
the sort of evidence of the authenticity of
his picture that would satisfy a special jury-
man and confound a purchasing dealer. At
artistic evidence he laughs noisily in half-
crown periodicals and five-guinea tomes.
Documentary evidence is what he prefers;
but, failing that, he will put up with a
cunning concoction of dates and water-
marks, cabalistic signatures, craquelure, pa-
tina, chemical properties of paint and
medium, paper and canvas, all sorts of col-
lateral evidence, historical and biographical,

and racy tricks of brush or pen. It is to adduce and discuss this sort of evidence that the Collector calls in the Expert.

Anyone whom chance or misfortune has led into the haunts of collectors and experts will admit that I have not exaggerated the horror of the diseases that we have inherited from the Classical Renaissance. He will have heard the value of a picture made to depend on the interpretation of a letter. He will have heard the picture discussed from every point of view except that of one who feels its significance. By whom was it made? For whom was it made? When was it made? Where was it made? Is it all the work of one hand? Who paid for it? How much did he pay? Through what collections has it passed? What are the names of the figures portrayed? What are their histories? What the style and cut of their coats, breeches, and beards? How much will it fetch at Christie's? All these are questions to moot; and mooted they will be, by the hour. But in expert conclaves who has ever heard more than a perfunctory and silly comment on the aesthetic qualities of a masterpiece?

We have seen the scholars at loggerheads over the genuineness of a picture in the National Gallery. The dispute rages round

the interpretation of certain marks in the corner of the canvas. Are they, or are they not, a signature? Whatever the final decision may be, the picture will remain unchanged; but if it can be proved that the marks are the signature of the disciple, it will be valueless. If the Venus of Velasquez[16] should turn out to be a Spanish model by del Mazo,[17] the great ones who guide us and teach the people to love art will see to it, I trust, that the picture is moved to a position befitting its mediocrity. It is this unholy alliance between Expertise and Officialdom* that squanders twenty thousand on an unimpeachable Frans Hals, and forty thousand on a Mabuse[18] for which no minor artist will wish to take credit.** For the money a judicious purchaser could have made one of the finest collections in England. The unholy alliance

* In speaking of officialdom it is not the directors of galleries and departments whom I have in mind. Many of them are on the right side ; we should all be delighted to see Sir Charles Holroyd or Mr. Maclagan,[19] for instances, let loose amongst the primitives with forty thousand pounds in pocket. I am thinking of those larger luminaries who set their important faces against the acquisition of works of art, the men who have been put in authority over directors and the rest of us.

** The Mabuse, however, was a bargain that the merchants and money-lenders who settle these things could hardly be expected to resist. The ticket price is said to have been £120,000,

has no use for contemporary art. The supply
is considerable and the names are not historic.
Snobbery makes acceptable the portrait of a
great lady, though it be by Boldini ;[20] and even
Mr. Lavery[21] may be welcome if he come with
the picture of a king. But how are our
ediles to know whether a picture of a com-
moner, or of some inanimate and undistin-
guished object, by Degas[22] or Cézanne is good
or bad ? They need not know whether a
picture by Hals is good; they need only
know that it is by Hals.

I will not describe in any detail the end of
the slope, from the beginning of the seven-
teenth to the middle of the nineteenth
century. The seventeenth century is rich
in individual geniuses; but they are in-
dividual. The level of art is very low.
The big names of El Greco, Rembrandt,
Velasquez, Vermeer, Rubens, Jordaens,
Poussin, and Claude, Wren and Bernini[23] (as
architects) stand out; had they lived in the
eleventh century they might all have been
lost in a crowd of anonymous equals.
Rembrandt, indeed, perhaps the greatest
genius of them all, is a typical ruin of his
age. For, except in a few of his later works,
his sense of form and design is utterly lost in
a mess of rhetoric, romance, and chiaroscuro.

THE CLASSICAL RENAISSANCE

It is difficult to forgive the seventeenth century for what it made of Rembrandt's genius. One great advantage over its predecessor it did enjoy: the seventeenth century had ceased to believe sincerely in the ideas of the Classical Renaissance. Painters could not devote themselves to suggesting the irrelevant emotions of life because they did not feel them.[1] For lack of human emotion they were driven back on art. They talked a great deal about Magnanimity and Nobility, but they thought more of Composition. For instance, in the best works of Nicolas Poussin,[24] the greatest artist of the age, you will notice that the human figure is treated as a shape cut out of coloured paper to be pinned on as the composition directs. That is the right way to treat the human figure; the mistake lay in making these shapes retain the characteristic gestures of Classical rhetoric. In much the same way Claude treats temples and palaces, trees, mountains, harbours and lakes, as you may see in his superb pictures at the National Gallery. There they hang, beside the Turners,[25] that all the world may see the difference between a great artist and an

[1] It was Mr. Roger Fry who made this illuminating discovery.

173

after-dinner poet. Turner was so much excited by his observations and his sentiments that he set them all down without even trying to co-ordinate them in a work of art: clearly he could not have done so in any case. That was a cheap and spiteful thought that prompted the clause wherein it is decreed that his pictures shall hang for ever beside those of Claude. He wished to call attention to a difference and he has succeeded beyond his expectations: curses, like hens, come home to roost.

In the eighteenth century, with its dearth of genius, we perceive more clearly that we are on the flats. Chardin[26] is the one great artist. Painters are, for the most part, upholsterers to the nobility and gentry. Some fashion handsome furniture for the dining-room, others elegant knick-knacks for the boudoir; many are kept constantly busy delineating for the respect of future generations his lordship, or her ladyship's family. The painting of the eighteenth century is brilliant illustration still touched with art. For instance, in Watteau, Canaletto, Crome, Cotman, and Guardi[27] there is some art, some brilliance, and a great deal of charming illustration. In Tiepolo[28] there is hardly anything but brilliance; only when

one sees his work beside that of Mr. Sargent[29] does one realise the presence of other qualities. In Hogarth[30] there is hardly anything but illustration; one realises the presence of other qualities only by remembering the work of the Hon. John Collier.[31] Beside the upholsterers who work for the aristocracy there is another class supported by the connoisseurs. There are the conscientious bores, whose modest aim it is to paint and draw correctly in the manner of Raffael and Michelangelo. Their first object is to stick to the rules, their second to show some cleverness in doing so. One need not bother about them.

So the power of creating is almost lost, and limners must be content to copy pretty things. The twin pillars of painting in the eighteenth century were what they called "Subject" and "Treatment." To paint a beautiful picture, a boudoir picture, take a pretty woman, note those things about her that a chaste and civil dinner-partner might note, and set them down in gay colours and masses of Chinese white: you may do the same by her toilette battery, her fancy frocks, and picnic parties. Imitate whatever is pretty and you are sure to make a pretty job of it. To make a noble

picture, a dining-room piece, you must take the same lady and invest her in a Doric chiton or diploida and himation; give her a pocillum, a censer, a sacrificial ram, and a distant view of Tivoli; round your modelling, and let your brush-strokes be long and slightly curved; affect sober and rather hot pigments; call the finished article " Dido pouring libations to the Goddess of Love." To paint an exhibition picture, the sort preferred by the more rigid *cognoscenti*, be sure to make no mark for which warrant cannot be found in Rubens, Sarto, Guido Reni, Titian, Tintoretto, Veronese, Raffael, Michelangelo, or Trajan's Column.[32] For further information consult " The Discourses " of Sir Joshua Reynolds, P.R.A.;[33] whose recipes are made palatable by a quality infrequent in his dishes, luminosity.

The intellectual reaction from Classical to Romantic is duly registered by a change of subject. Ruins and mediaeval history come into fashion. For art, which is as little concerned with the elegant bubbles of the eighteenth century as with the foaming superabundance of the Romantic revival, this change is nothing more than the swing of an irrelevant pendulum. But the new ideas led inevitably to antiquarianism, and

antiquarians found something extraordinarily congenial in what was worst in Gothic art. Obedient limners follow the wiseacres. What else is there for them to follow? Stragglers from the age of reason are set down to trick out simpering angels. No longer permitted to stand on the laws of propriety or their personal dignity, they are ordered to sweeten their cold meats with as much amorous and religious sentiment as they can exude. Meanwhile the new fellows, far less sincere than the old, who felt nothing and said so, begin to give themselves the airs of artists. These Victorians are intolerable: for now that they have lost the old craft and the old tradition of taste, the pictures that they make are no longer pleasantly insignificant; they bellow "stinking mackerel."

About the middle of the nineteenth century art was as nearly dead as art can be. The road ran drearily through the sea-level swamps. There were, of course, men who felt that imitation, whether of nature or of another's work, was not enough, who felt the outrage of calling the staple products of the "forties" and "fifties" art; but generally they lacked the power to make an effective protest. Art cannot die out

utterly; but it lay sick in caves and cellars. There were always one or two who had a right to call themselves artists: the great Ingres* overlaps Crome; Corot and Daumier[34] overlap Ingres; and then come the Impressionists. But the mass of painting and sculpture had sunk to something that no intelligent and cultivated person would dream of calling art. It was in those days that they invented the commodity which is still the staple of official exhibitions throughout Europe. You may see acres of it every summer at Burlington House and in the Salon; indeed, you may see little else there. It does not pretend to be art. If the producers mistake it for art sometimes, they do so in all innocence: they have no notion of what art is. By "art" they mean the imitation of objects, preferably pretty or interesting ones; their spokesmen have said so again and again. The

* It is pleasant to remember that by the painters, critics, and rich amateurs of "the old gang" the pictures of Ingres were treated as bad jokes. Ingres was accused of distortion, ugliness, and even of incompetence! His work was called "mad" and "puerile." He was derided as a pseudo-primitive, and hated as one who would subvert the great tradition by trying to put back the clock four hundred years. The same authorities discovered in 1824 that Constable's *Hay Wain* was the outcome of a sponge full of colour having been thrown at a canvas. *Nous avons changé tout ça.*

178

sort of thing that began to do duty for art about 1840, and still passes muster with the lower middle class, would have been inconceivable at any time between the fall of the Roman Empire and the death of George IV. Even in the eighteenth century, when they could not create significant form, they knew that accurate imitation was of no value in itself. It is not until what is still official painting and sculpture and architecture gets itself accepted as a substitute for art, that we can say for certain that the long slope that began with the Byzantine primitives is ended. But when we have reached this point we know that we can sink no lower.

We must mark the spot near which a huge impulse died; but we need not linger in the fetid swamps—or only long enough to say a word of justice. Do not rail too bitterly against official painters, living or dead. They cannot harm art, because they have nothing to do with it: they are not artists. If rail you must, rail at that public which, having lost all notion of what art is, demanded, and still demands, in its stead, the thing that these painters can supply. Official painting is the product of social conditions which have not yet passed

away. Thousands of people who care
nothing about art are able to buy and are
in the habit of buying pictures. They
want a background, just as the ladies and
gentlemen of the *ancien régime* wanted one;
only their idea of what a background should
be is different. The painter of commerce
supplies what is wanted and in his sim-
plicity calls it art. That it is not art,
that it is not even an amenity, should not
blind us to the fact that it is an honest
article. I admit that the man who pro-
duces it satisfies a vulgar and unprofitable
taste; so does the very upright trades-
man who forces insipid asparagus for the
Christmas market. Sir Georgius Midas will
never care for art, but he will always want
a background; and, unless things are going
to change with surprising suddenness, it
will be some time before he is unable to
get what he wants, at a price. However
splendid and vital the new movement may
be, it will not, I fancy, unaided, kill the
business of picture-making. The trade will
dwindle; but I suspect it will survive
until there is no one who can afford osten-
tatious upholstery, until the only purchasers
are those who willingly make sacrifices for
the joy of possessing a work of art.

IV

ALID EX ALIO[1]

In the nineteenth century the spirit seems
to enter one of those prodigious periods of
incubation for a type of which we turn
automatically to the age that saw the last
infirmity of Roman imperialism and of
Hellenistic culture. About Victorian men
and movements there is something uneasy.
It is as though, having seen a shilling come
down "tails," one were suddenly to sur-
prise the ghost of a head—you could have
sworn that "heads" it was. It doesn't
matter, but it's disquieting. And after all,
perhaps it does matter. Seen from odd
angles, Victorian judges and ministers take
on the airs of conspirators: there is some-
thing prophetic about Mr. Gladstone—about
the Newcastle programme something pathe-
tic.[2] Respectable hypotheses are caught
implying the most disreputable conclusions.
And yet the respectable classes speculate,

while anarchists and supermen are merely
horrified by the card-playing and cham-
pagne-drinking of people richer than them-
selves. Agnostics see the finger of God in
the fall of godless Paris. Individualists
clamour for a large and vigilant police
force.

That is how the nineteenth century looks
to us. Most of the mountains are in
labour with ridiculous mice, but the spheres
are shaken by storms in intellectual tea-
cups. The Pre-Raffaelites call in question
the whole tradition of the Classical Renais-
sance, and add a few more names to the
heavy roll of notoriously bad painters.
The French Impressionists profess to do
no more than push the accepted theory of
representation to its logical conclusion, and
by their practice, not only paint some
glorious pictures, but shake the fatal tradi-
tion and remind the more intelligent part
of the world that visual art has nothing
to do with literature. Whistler[3] draws, not
the whole, but a part of the true moral.
What a pity he was not a greater artist!
Still, he was an artist; and about the year
1880 the race was almost extinct in this
country.*

* As Mr. Walter Sickert[4] reminds me, there was Sickert.

ALID EX ALIO

Through the fog of the nineteenth century, which began in 1830, loom gigantic warnings. All the great figures are ominous. If they do not belong to the new order, they make impossible the old. Carlyle and Dickens and Victor Hugo,[5] the products and lovers of the age, scold it. Flaubert[6] points a contemptuous finger. Ibsen,[7] a primitive of the new world, indicates the cracks in the walls of the old. Tolstoi[8] is content to be nothing but a primitive until he becomes little better than a bore. By minding his own business, Darwin[9] called in question the business of everyone else. By hammering new sparks out of an old instrument, Wagner[10] revealed the limitations of literary music. As the twentieth century dawns, a question, which up to the time of the French Revolution had been judiciously kept academic, shoulders its way into politics: "Why is this good?" About the same time, thanks chiefly to the Aesthetes and the French Impressionists, an aesthetic conscience, dormant since before the days of the Renaissance, wakes and begins to cry, "Is this art?"

It is amusing to remember that the first concerted clamour against the Renaissance and its florid sequelae arose in England;

for the Romantic movement, which was as much French and German as English, was merely a reaction from the classicism of the eighteenth century, and hardly attacked, much less threw off, the dominant tyranny. We have a right to rejoice in the Pre-Raffaelite movement as an instance of England's unquestioned supremacy in independence and unconventionality of thought. Depression begins when we have to admit that the revolt led to nothing but a great many bad pictures and a little thin sentiment. The Pre-Raffaelites were men of taste who felt the commonness of the High Renaissance and the distinction of what they called Primitive Art, by which they meant the art of the fifteenth and fourteenth centuries. They saw that, since the Renaissance, painters had been trying to do something different from what the primitives had done; but for the life of them they could not see what it was that the primitives did. They had the taste to prefer Giotto to Raffael, but the only genuine reason they could give for their preference was that they felt Raffael to be vulgar. The reason was good, but not fundamental; so they set about inventing others. They discovered in the primitives scrupulous fidelity to nature, superior piety, chaste lives. How

far they were from guessing the secret of primitive art appeared when they began to paint pictures themselves. The secret of primitive art is the secret of all art, at all times, in all places—sensibility to the profound significance of form and the power of creation. The band of happy brothers lacked both; so perhaps it is not surprising that they should have found in acts of piety, in legends and symbols, the material, and in sound churchmanship the very essence, of mediaeval art. For their own inspiration they looked to the past instead of looking about them. Instead of diving for truth they sought it on the surface. The fact is, the Pre-Raffaelites were not artists, but archaeologists who tried to make intelligent curiosity do the work of impassioned contemplation. As artists they do not differ essentially from the ruck of Victorian painters. They will reproduce the florid ornament of late Gothic as slavishly as the steady Academician reproduces the pimples on an orange; and if they do attempt to simplify—some of them have noticed the simplification of the primitives—they do so in the spirit, not of an artist, but of the "sedulous ape."

Simplification is the conversion of irrelevant detail into significant form. A very

bold Pre-Raffaelite was capable of representing a meadow by two minutely accurate blades of grass. But two minutely accurate blades of grass are just as irrelevant as two million; it is the formal significance of a blade of grass or of a meadow with which the artist is concerned. The Pre-Raffaelite method is at best symbolism, at worst pure silliness. Had the Pre-Raffaelites been blessed with profoundly imaginative minds they might have recaptured the spirit of the Middle Ages instead of imitating its least significant manifestations. But had they been great artists they would not have wished to recapture anything. They would have in vented forms for themselves or derived them from their surroundings, just as the mediaeval artists did. Great artists never look back.

When art is as nearly dead as it was in the middle of the nineteenth century, scientific accuracy is judged the proper end of painting. Very well, said the French Impressionists, be accurate, be scientific. At best the Academic painter sets down his concepts; but the concept is not a scientific reality; the men of science tell us that the visible reality of the Universe is vibrations of light. Let us represent things as they are—scientifically. Let us represent light.

Let us paint what we see, not the intellectual superstructure that we build over our sensations. That was the theory: and if the end of art were representation it would be sound enough. But the end of art is not representation, as the great Impressionists, Renoir, Degas, Manet,[12] knew (two of them happily know it still) the moment they left off arguing and bolted the studio door on that brilliant theorist, Claude Monet.[13] Some of them, to be sure, turned out polychromatic charts of desolating dullness—Monet towards the end, for instance. The Neo-Impressionists—Seurat, Signac, and Cross[14]—have produced little else. And any Impressionist, under the influence of Monet and Watteau,[15] was capable of making a poor, soft, formless thing. But more often the Impressionist masters, in their fantastic and quite unsuccessful pursuit of scientific truth, created works of art tolerable in design and glorious in colour. Of course this oasis in the mid-century desert delighted the odd people who cared about art; they pretended at first to be absorbed in the scientific accuracy of the thing, but before long they realised that they were deceiving themselves, and gave up the pretence. For they saw very clearly

that these pictures differed most profoundly from the anecdotic triumphs of Victorian workshops, not in their respectful attention to scientific theory, but in the fact that, though they made little or no appeal to the interests of ordinary life, they provoked a far more potent and profound emotion. Scientific theories notwithstanding, the Impressionists provoked that emotion which all great art provokes—an emotion in the existence of which the bulk of Victorian artists and critics were, for obvious reasons, unable to believe. The virtue of these Impressionist pictures, whatever it might be, depended on no reference to the outside world. What could it be? "Sheer beauty," said the enchanted spectators. They were not far wrong.

That beauty is the one essential quality in a work of art is a doctrine that has been too insistently associated with the name of Whistler, who is neither its first nor its last, nor its most capable, exponent— but only of his age the most conspicuous. To read Whistler's *Ten o'Clock*[16] will do no one any harm, or much good. It is neither very brilliant nor at all profound, but it is in the right direction. Whistler is not to be compared with the great controversialists

any more than he is to be compared
with the great artists. To set *The Gentle
Art* beside *The Dissertation on the Letters
of Phalaris*, Gibbon's *Vindication*,[17] or the
polemics of Voltaire,[18] would be as unjust
as to hang " Cremorne Gardens "[19] in the
Arena Chapel.[20] Whistler was not even cock
of the Late Victorian walk; both Oscar
Wilde and Mr. Bernard Shaw[21] were his
masters in the art of controversy. But
amongst Londoners of the " eighties " he
is a bright figure, as much alone almost in
his knowledge of what art is, as in his
power of creating it: and it is this that
gives a peculiar point and poignance to all
his quips and quarrels. There is dignity
in his impudence. He is using his rather
obvious cleverness to fight for something
dearer than vanity. He is a lonely artist,
standing up and hitting below the belt for
art. To the critics, painters, and substantial
men of his age he was hateful because he
was an artist; and because he knew that
their idols were humbugs he was disquieting.
Not only did he have to suffer the gross-
ness and malice of the most insensitive pack
of butchers that ever scrambled into the
seat of authority; he had also to know
that not one of them could by any means

be made to understand one word that he spoke in seriousness. Overhaul the English art criticism of that time, from the cloudy rhetoric of Ruskin[22] to the journalese of "'Arry,"[23] and you will hardly find a sentence that gives ground for supposing that the writer has so much as guessed what art is. "As we have hinted, the series does not represent any Venice that we much care to remember; for who wants to remember the degradation of what has been noble, the foulness of what has been fair?"—"'Arry" in the *Times*. No doubt it is becoming in an artist to leave all criticism unanswered; it would be foolishness in a schoolboy to resent stuff of this sort. Whistler replied; and in his replies to ignorance and insensibility, seasoned with malice, he is said to have been ill-mannered and caddish. He was; but in these respects he was by no means a match for his most reputable enemies. And ill-mannered, ill-tempered, and almost alone, he was defending art, while they were flattering all that was vilest in Victorianism.

As I have tried to show in another place,[24] it is not very difficult to find a flaw in the theory that beauty is the essential quality in a work of art—that is, if the word

"beauty" be used, as Whistler and his followers seem to have used it, to mean insignificant beauty. It seems that the beauty about which they were talking was the beauty of a flower or a butterfly; now I have very rarely met a person delicately sensitive to art who did not agree, in the end, that a work of art moved him in a manner altogether different from, and far more profound than, that in which a flower or a butterfly moved him. Therefore, if you wish to call the essential quality in a work of art "beauty" you must be careful to distinguish between the beauty of a work of art and the beauty of a flower, or, at any rate, between the beauty that those of us who are not great artists perceive in a work of art and that which the same people perceive in a flower. Is it not simpler to use different words? In any case, the distinction is a real one: compare your delight in a flower or a gem with what you feel before a great work of art, and you will find no difficulty, I think, in differing from Whistler.

Anyone who cares more for a theory than for the truth is at liberty to say that the art of the Impressionists, with their absurd notions about scientific representation, is a

lovely fungus growing very naturally on the ruins of the Christian slope. The same can hardly be said about Whistler, who was definitely in revolt against the theory of his age. For we must never forget that accurate representation of what the grocer thinks he sees was the central dogma of Victorian art. It is the general acceptance of this view— that the accurate imitation of objects is an essential quality in a work of art—and the general inability to create, or even to recognise, aesthetic qualities, that mark the nineteenth century as the end of a slope. Except stray artists and odd amateurs, and you may say that in the middle of the nineteenth century art had ceased to exist. That is the importance of the official and academic art of that age: it shows us that we have touched bottom. It has the importance of an historical document. In the eighteenth century there was still a tradition of art. Every official and academic painter, even at the end of the eighteenth century, whose name was known to the cultivated public, whose works were patronised by collectors, knew perfectly well that the end of art was not imitation, that forms must have some aesthetic significance. Their successors in the nineteenth century did not. Even the

tradition was dead. That means that generally and officially art was dead. We have seen it die. The Royal Academy and the Salon have been made to serve their useful, historical purpose. We need say no more about them. Whether those definitely artistic cliques of the nineteenth century, the men who made form a means to aesthetic emotion and not a means of stating facts and conveying ideas, the Impressionists and the Aesthetes, Manet and Renoir, Whistler and Conder,[25]&c. &c., are to be regarded as accidental flowers blossoming on a grave or as portents of a new age, will depend upon the temperament of him who regards them.

But a sketch of the Christian slope may well end with the Impressionists, for Impressionist theory is a blind alley. Its only logical development would be an art-machine—a machine for establishing values correctly, and determining what the eye sees scientifically, thereby making the production of art a mechanical certainty. Such a machine, I am told, was invented by an Englishman. Now if the praying-machine be admittedly the last shift of senile religion, the value-finding machine may fairly be taken for the psychopomp of art. Art has passed from the primitive creation of significant

form to the highly civilised statement of scientific fact. I think the machine, which is the intelligent and respectable end, should be preserved, if still it exists, at South Kensington or in the Louvre, along with the earlier monuments of the Christian slope. As for that uninteresting and disreputable end, official nineteenth-century art, it can be studied in a hundred public galleries and in annual exhibitions all over the world. It is the mouldy and therefore the obvious end. The spirit that came to birth with the triumph of art over Graeco-Roman realism dies with the ousting of art by the picture of commerce.

But if the Impressionists, with their scientific equipment, their astonishing technique, and their intellectualism, mark the end of one era, do they not rumour the coming of another? Certainly to-day there is stress in the cryptic laboratory of Time. A great thing is dead; but, as that sagacious Roman[26] noted :

" haud igitur penitus pereunt quaecumque videntur,
 quando alid ex alio reficit natura nec ullam
 rem gigni patitur nisi morte adiuta aliena."[27]

And do not the Impressionists, with their power of creating works of art that stand

on their own feet, bear in their arms a new age? For if the venial sin of Impressionism is a grotesque theory and its justification a glorious practice, its historical importance consists in its having taught people to seek the significance of art in the work itself, instead of hunting for it in the emotions and interests of the outer world.

IV

THE MOVEMENT

I

THE DEBT TO CÉZANNE

THAT with the maturity of Cézanne a new movement came to birth will hardly be disputed by anyone who has managed to survive the "nineties"; that this movement is the beginning of a new slope is a possibility worth discussing, but about which no decided opinion can yet be held. In so far as one man can be said to inspire a whole age, Cézanne inspires the contemporary movement: he stands a little apart, however, because he is too big to take a place in any scheme of historical development; he is one of those figures that dominate an age and are not to be fitted into any of the neat little pigeon-holes so thoughtfully prepared for us by evolutionists. He passed through the greater part of life unnoticed, and came near creeping out of it undiscovered. No one seems to have guessed at what was happening. It is easy now to see how much we owe to

him, and how little he owed to anyone ; for us it is easy to see what Gauguin and Van Gogh borrowed—in 1890, the year in which the latter died, it was not so. They were sharp eyes, indeed, that discerned before the dawn of the new century that Cézanne had founded a movement.

That movement is still young. But I think it would be safe to say that already it has produced as much good art as its predecessor. Cézanne, of course, created far greater things than any Impressionist painter ; and Gauguin, Van Gogh, Matisse, Rousseau, Picasso, de Vlaminck, Derain, Herbin, Marchand, Marquet, Bonnard, Duncan Grant, Maillol, Lewis, Kandinsky, Brancuzi, von Anrep, Roger Fry, Friesz, Goncharova, L'Hôte,[1] are Rolands for the Olivers of any other artistic period.* They are not all great artists, but they all are artists. If the Impressionists raised the proportion of works of art in the general pictorial output from about one in five hundred thousand to one in a hundred thousand, the Post-Impressionists (for after all it is sensible to call the group of vital artists who immediately follow the Impressionists by that

* Need I say that this list is not intended to be exhaustive ? It is merely representative.

name) have raised the average again. To-day, I daresay, it stands as high as one in ten thousand. Indeed, it is this that has led some people to see in the new movement the dawn of a new age; for nothing is more characteristic of a "primitive" movement than the frequent and widespread production of genuine art. Another hopeful straw at which the sanguine catch is the admirable power of development possessed by the new inspiration. As a rule, the recognition of a movement as a movement is its death. As soon as the pontiffs discovered Impressionism, some twenty years after its patent manifesta-tion, they academized it. They set their faces against any sort of development and drove into revolt or artistic suicide every student with an ounce of vitality in him. Before the inspiration of Cézanne had time to grow stale, it was caught up by such men as Matisse and Picasso; by them it was moulded into forms that suited their dif-ferent temperaments, and already it shows signs of taking fresh shape to express the sensibility of a younger generation.*

* Let us hope that it will. There certainly are ominous signs of academization amongst the minor men of the movement. There is the beginning of a tendency to regard certain simplifications and distortions as ends in

ART

This is very satisfactory but it does not suffice to prove that the new movement is the beginning of a new slope; it does not prove that we stand now where the early Byzantines stood, with the ruins of a civilisation clattering about our ears and our eyes set on a new horizon. In favour of that view there are no solid arguments; yet are there general considerations, worth stating and pondering, though not to be pushed too violently. He who would cast the horoscope of humanity, or of any human activity, must neither neglect history nor trust her over-much. Certainly the neglect of history is the last mistake into which a modern speculator is likely to fall. To compare Victorian England with Imperial Rome has been the pastime of the half-educated these fifty years. "*Tu regere imperio populos, Romane, memento*,"[2] is about as much Latin as it is becoming in a public schoolman to remember. The historically minded should travel a little further with their comparison (to be sure, some have done so in search of arguments against Socialism), on their way, they will not have

themselves and party badges. There is some danger of an attempt to impose a formula on the artist's individuality. At present the infection has not spread far, and the disease has taken a mild form.

failed to remark the materialism, the mechanical cunning, the high standard of comfort, the low standard of honesty, the spiritual indigence, the unholy alliance of cynicism with sentimentality, the degradation of art and religion to menial and mountebank offices, common in both, and in both signifying the mouldy end of what was once a vital agitation. To similise the state superstitions and observances of Rome with our official devotions and ministration, the precise busts in the British Museum with the "speaking likenesses" in the National Portrait Gallery, the academic republicanism of the cultivated patricians with English Liberalism, and the thrills of the arena with those of the playing-field, would be pretty sport for any little German boy. I shall not encourage the brat to lay an historical finger on callousness, bravado, trembling militarism, superficial culture, mean political passion, megalomania, and a taste for being in the majority as attributes common to Imperial Rome and Imperial England. Rather I will inquire whether the rest of Europe does not labour under the proverbial disability of those who live in glass-houses. It is not so much English politics as Western civilisation that reminds me of the last days of the Empire.

The facility of the comparison disfavours
the raking up of similarities; I need not
compare Mr. Shaw with Lucian[3] or the
persecution of Christians with the savage out-
bursts of our shopkeepers against anarchists.
One may note, though, that it is as impos-
sible to determine exactly when and whence
came the religious spirit that was to make
an end of Graeco-Roman materialism as to
assign a birth-place to the spiritual ferment
that pervades modern Europe. For though
we may find a date for the maturity of
Cézanne, and though I agree that the art
of one genius may produce a movement, even
Cézanne will hardly suffice to account for
what looks like the beginning of an artistic
slope and a renaissance of the human spirit.
One would hesitate to explain the dark and
middle ages by the mosaics at Ravenna.
The spirit that was to revive the moribund
Roman world came from the East; that we
know. It was at work long before the
world grew conscious of its existence. Its
remotest origins are probably undiscover-
able. To-day we can name pioneers, beside
Cézanne, in the new world of emotion;
there was Tolstoi, and there was Ibsen;
but who can say that these did not set out
in search of Eldorados of which already

they had heard travellers' tales. Ruskin
shook his fist at the old order to some
purpose; and, if he could not see clearly
what things counted, succeeded at least in
making contemptible some that did not.
Nietzsche's preposterous nonsense[4] knocked
the bottom out of nonsense more prepos-
terous and far more vile. But to grub for
origins is none of my business; when the
Church shall be established be sure that
industrious hagiographers will do justice to
its martyrs and missionaries.

Consider, too, that a great emotional
renaissance must be preceded by an intel-
lectual, destructive movement. To that how
shall we assign a starting-point? It could
be argued, I suppose, that it began with
Voltaire and the Encyclopædists. Having
gone so far back, the historian would find
cause for going further still. How could he
justify any frontier? Every living organism
is said to carry in itself the germ of its
own decay, and perhaps a civilisation is no
sooner alive than it begins to contrive its
end. Gradually the symptoms of disease
become apparent to acute physicians who
state the effect without perceiving the cause.
Be it so; circular fatalism is as cheerful
as it is sad. If ill must follow good, good

must follow ill. In any case, I have said enough to show that if Europe be again at the head of a pass, if we are about to take the first step along a new slope, the historians of the new age will have plenty to quarrel about.

It may be because the nineteenth century was preparing Europe for a new epoch, that it understood better its destructive critics than its constructive artists. At any rate before that century ended it had produced one of the great constructive artists of the world, and overlooked him. Whether or no he marks the beginning of a slope, Cézanne certainly marks the beginning of a movement the main characteristics of which it will be my business to describe. For, though there is some absurdity in distinguishing one artistic movement from another, since all works of art, to whatever age they belong, are essentially the same: yet these superficial differences which are the characteristics of a movement have an importance beyond that dubious one of assisting historians. The particular methods of creating form, and the particular kinds of form affected by the artists of one generation, have an important bearing on the art of the next. For whereas the methods and

forms of one may admit of almost infinite de-
velopment, the methods and forms of another
may admit of nothing but imitation. For
instance, the fifteenth century movement that
began with Masaccio, Uccello, and Castagno[5]
opened up a rich vein of rather inferior ore;
whereas the school of Raffael was a blind
alley. Cézanne discovered methods and
forms which have revealed a vista of possi-
bilities to the end of which no man can
see; on the instrument that he invented
thousands of artists yet unborn may play
their own tunes.

What the future will owe to Cézanne
we cannot guess: what contemporary art
owes to him it would be hard to compute.
Without him the artists of genius and talent
who to-day delight us with the significance
and originality of their work might have
remained port-bound for ever, ill-discerning
their objective, wanting chart, rudder, and
compass. Cézanne is the Christopher Colum-
bus of a new continent of form. In 1839
he was born at Aix-en-Provence, and for
forty years he painted patiently in the
manner of his master Pissarro. To the eyes
of the world he appeared, so far as he ap-
peared at all, a respectable, minor Impres-
sionist, an admirer of Manet, a friend, if

not a protégé, of Zola,[6] a loyal, negligible
disciple. He was on the right side, of
course—the Impressionist side, the side of
the honest, disinterested artists, against the
academic, literary pests. He believed in
painting. He believed that it could be
something better than an expensive substitute
for photography or an accompaniment to
poor poetry. So in 1870 he was for science
against sentimentality.

But science will neither make nor satisfy
an artist: and perhaps Cézanne saw what
the great Impressionists could not see, that
though they were still painting exquisite
pictures their theories had led art into a *cul
de sac*. So while he was working away in
his corner of Provence, shut off completely
from the aestheticism of Paris, from Baude-
lairism and Whistlerism, Cézanne was always
looking for something to replace the bad
science of Claude Monet. And somewhere
about 1880 he found it. At Aix-en-Provence
came to him a revelation that has set a
gulf between the nineteenth century and the
twentieth: for, gazing at the familiar land-
scape, Cézanne came to understand it, not as
a mode of light, nor yet as a player in the
game of human life, but as an end in itself
and an object of intense emotion. Every

great artist has seen landscape as an end in itself—as pure form, that is to say; Cézanne has made a generation of artists feel that compared with its significance as an end in itself all else about a landscape is negligible. From that time forward Cézanne set himself to create forms that would express the emotion that he felt for what he had learnt to see. Science became as irrelevant as subject. Everything can be seen as pure form. and behind pure form lurks the mysterious significance that thrills to ecstasy. The rest of Cézanne's life is a continuous effort to capture and express the significance of form.

I have tried to say in another place[7] that there are more roads than one by which a man may come at reality. Some artists seem to have come at it by sheer force of imagination, unaided by anything without them; they have needed no material ladder to help them out of matter. They have spoken with reality as mind to mind, and have passed on the message in forms which owe nothing but bare existence to the physical universe. Of this race are the best musicians and architects; of this race is not Cézanne. He travelled towards reality along the traditional road of European painting.

It was in what he saw that he discovered a sublime architecture haunted by that Universal which informs every Particular. He pushed further and further towards a complete revelation of the significance of form, but he needed something concrete as a point of departure. It was because Cézanne could come at reality only through what he saw that he never invented purely abstract forms. Few great artists have depended more on the model. Every picture carried him a little further towards his goal — complete expression; and because it was not the making of pictures but the expression of his sense of the significance of form that he cared about, he lost interest in his work so soon as he had made it express as much as he had grasped. His own pictures were for Cézanne nothing but rungs in a ladder at the top of which would be complete expression. The whole of his later life was a climbing towards an ideal. For him every picture was a means, a step, a stick, a hold, a stepping-stone — something he was ready to discard as soon as it had served his purpose. He had no use for his own pictures. To him they were experiments. He tossed them into bushes, or left them in the open fields to be stumbling-blocks for a future race of luckless critics.

THE DEBT TO CÉZANNE

Cézanne is a type of the perfect artist; he is the perfect antithesis of the professional picture-maker, or poem-maker, or music-maker. He created forms because only by so doing could he accomplish the end of his existence—the expression of his sense of the significance of form. When we are talking about aesthetics, very properly we brush all this aside, and consider only the object and its emotional effect on us; but when we are trying to explain the emotional effectiveness of pictures we turn naturally to the minds of the men who made them, and find in the story of Cézanne an inexhaustible spring of suggestion. His life was a constant effort to create forms that would express what he felt in the moment of inspiration. The notion of uninspired art, of a formula for making pictures, would have appeared to him preposterous. The real business of his life was not to make pictures, but to work out his own salvation. Fortunately for us he could only do this by painting. Any two pictures by Cézanne are bound to differ profoundly. He never dreamed of repeating himself. He could not stand still. That is why a whole generation of otherwise dissimilar artists have drawn inspiration from his work. That is why it implies no disparagement of any

living artist when I say that the prime characteristic of the new movement is its derivation from Cézanne.

The world into which Cézanne tumbled was a world still agitated by the quarrels of Romantics and Realists. The quarrel between Romance and Realism is the quarrel of people who cannot agree as to whether the history of Spain or the number of pips is the more important thing about an orange. The Romantics and Realists were deaf men coming to blows about the squeak of a bat. The instinct of a Romantic invited to say what he felt about anything was to recall its associations. A rose, for instance, made him think of old gardens and young ladies and Edmund Waller[8] and sundials, and a thousand quaint and gracious things that, at one time or another, had befallen him or someone else. A rose touched life at a hundred pretty points. A rose was interesting because it had a past. "Bosh," said the Realist, "I will tell you what a rose is; that is to say, I will give you a detailed account of the properties of *Rosa setigera*, not forgetting to mention the urn-shaped calyx-tube, the five imbricated lobes, or the open corolla of five obovate petals." To a Cézanne one account

would appear as irrelevant as the other, since both omit the thing that matters—what philosophers used to call "the thing in itself," what now, I imagine, they call "the essential reality." For, after all, what is a rose? What is a tree, a dog, a wall, a boat? What is the particular significance of anything? Certainly the essence of a boat is not that it conjures up visions of argosies with purple sails, nor yet that it carries coals to Newcastle. Imagine a boat in complete isolation, detach it from man and his urgent activities and fabulous history, what is it that remains, what is that to which we still react emotionally? What but pure form, and that which, lying behind pure form, gives it its significance. It was for this Cézanne felt the emotion he spent his life in expressing. And the second characteristic of the new movement is a passionate interest, inherited from Cézanne, in things regarded as ends in themselves. In saying this I am saying no more than that the painters of the movement are consciously determined to be artists. Peculiarity lies in the consciousness—the consciousness with which they set themselves to eliminate all that lies between themselves and the pure forms

of things. To be an artist, they think,
suffices. How many men of talent, and
even of genius, have missed being effective
artists because they tried to be something
else?

II

SIMPLIFICATION AND DESIGN

AT the risk of becoming a bore I repeat that there is something ludicrous about hunting for characteristics in the art of to-day or of yesterday, or of any particular period. In art the only important distinction is the distinction between good art and bad. That this pot was made in Mesopotamia about 4000 B.C., and that picture in Paris about 1913 A.D., is of very little consequence. Nevertheless, it is possible, though not very profitable, to distinguish between equally good works made at different times in different places; and although the practice of associating art with the age in which it was produced can be of no service to art or artists, I am not sure that it can be of no service whatever. For if it be true that art is an index to the spiritual condition of an age, the historical consideration of art cannot fail to throw some light on the

history of civilisation. It is conceivable
therefore that a comparative study of artistic
periods might lead us to modify our con-
ception of human development, and to revise
a few of our social and political theories.
Be that as it may, this much is sure : should
anyone wish to infer from the art it pro-
duced the civility of an age, he must be
capable of distinguishing the work of that
age from the work of all other ages. He
must be familiar with the characteristics of
the movement. It is my intention to indi-
cate a few of the more obvious charac-
teristics of the contemporary movement.

But how comes it that the art of one
age differs from that of another? At first
sight it seems odd that art, which is the
expression of man's sense of the significance
of form, should vary even superficially
from age to age. Yet, deeply considered,
it is as certain that superficially art will
always be changing as that essentially it
cannot change. It seems that the ape-
instinct in man is so strong that unless he
were continually changing he would cease
to create and merely imitate. It is the
old question of the artistic problem. Only
by setting himself new problems can the
artist raise his powers to the white heat

of creation. The forms in which artists can express themselves are infinite, and their desire to express themselves keeps up a constant change and reaction in artistic form. Not only is there something of the ancestral ape in man, there is something of the ancestral sheep; there are fashions in forms and colours and the relations of forms and colours; or, to put the matter more pleasantly, and more justly, there is sufficient accord in the sensibilities of an age to induce a certain similarity of forms. It seems as though there were strange powers in the air from which no man can altogether escape; we call them by pet names— "Movements," "Forces," "Tendencies," "Influences," "The Spirit of the Age"—but we never understand them. They are neither to be frightened nor cajoled by our airs of familiarity, which impress the public only. They exist, however, and if they did not we should have to invent them; for how else are we to explain the fact that not only do the artists of a particular period affect particular kinds of form, but that even the spectators of each new generation seem to be born with sensibilities specially apt to be flattered by them. In this age it is pos-

sible to take refuge under the magic word
"Cézanne"; we can say that Cézanne has
imposed his forms on Georgian painters
and public, just as Wagner imposed his
on Edwardian musicians and concert-goers.
This explanation seems to me inadequate;
and in any case it will not account for
the predominance of formal fashions in
ages undominated by any masterful genius.
The spirit of an artistic age is, I suspect,
a composition that defies complete analysis;
the work of one great mind is generally
one part of it, the monuments of some
particular past age are often another.
Technical discoveries have sometimes led
to artistic changes. For instance, to men
who have been in the habit of painting on
wood, the invention of canvas would sug-
gest all sorts of fascinating novelties.
Lastly, there is a continual change in the
appearance of those familiar objects which
are the raw material of most visual artists.
So, though the essential quality—signifi-
cance—is constant, in the choice of forms
there is perpetual change; and these changes
seem to move in long flights or shorter
jumps, so that we are able, with some pre-
cision, to lay our fingers on two points
between which there is a certain amount

of art possessing certain common charac-
teristics. That which lies between two
such points historians call a period or
movement.

The period in which we find ourselves
in the year 1913 begins with the maturity
of Cézanne (about 1885). It therefore
overlaps the Impressionist movement, which
certainly had life in it till the end of the
nineteenth century. Whether Post-Impres-
sionism will peter out as Impressionism has
done, or whether it is the first flowering
of a new artistic vitality with centuries of
development before it, is, I have admitted,
a matter of conjecture. What seems to
me certain is that those who shall be able
to contemplate our age as something com-
plete, as a period in the history of art,
will not so much as know of the existence
of the artisans still amongst us who create
illusions and chaffer and quarrel in the
tradition of the Victorians. When they
think of the early twentieth-century painters
they will think only of the artists who
tried to create form—the artisans who tried
to create illusions will be forgotten. They
will think of the men who looked to the
present, not of those who looked to the
past; and, therefore, it is of them alone

that I shall think when I attempt to de-
scribe the contemporary movement.*

Already I have suggested two character-
istics of the movement; I have said that in
their choice of forms and colours most vital
contemporary artists are, more or less, in-
fluenced by Cézanne, and that Cézanne has
inspired them with the resolution to free
their art from literary and scientific irre-
levancies. Most people, asked to mention a
third, would promptly answer, I suspect—
Simplification. To instance simplification as
a peculiarity of the art of any particular age
seems queer, since simplification is essential
to all art. Without it art cannot exist; for
art is the creation of significant form, and
simplification is the liberating of what is signi-
ficant from what is not. Yet to such depths
had art sunk in the nineteenth century,
that in the eyes of the rabble the greatest
crime of Whistler and the Impressionists was
their by no means drastic simplification.

* Of course there are some good artists alive who owe
nothing to Cézanne. Fortunately two of Cézanne's con-
temporaries, Degas and Renoir, are still at work. Also
there are a few who belong to the older movement, *e.g.*
Mr. Walter Sickert, M. Simon Bussy, M. Vuillard, Mr.
J. W. Morrice. I should be as unwilling to omit these
names from a history of twentieth century art as to in-
clude them in a chapter devoted to the contemporary
movement.

SIMPLIFICATION AND DESIGN

And we are not yet clear of the Victorian slough. The spent dip stinks on into the dawn. You have only to look at almost any modern building to see masses of elaboration and detail that form no part of any real design and serve no useful purpose. Nothing stands in greater need of simplification than architecture, and nowhere is simplification more dreaded and detested than amongst architects. Walk the streets of London; everywhere you will see huge blocks of ready-made decoration, pilasters and porticoes, friezes and façades, hoisted on cranes to hang from ferro-concrete walls. Public buildings have become public laughing-stocks. They are as senseless as slag-heaps, and far less beautiful. Only where economy has banished the architect do we see masonry of any merit. The engineers, who have at least a scientific problem to solve, create, in factories and railway-bridges, our most creditable monuments. They at least are not ashamed of their construction, or, at any rate, they are not allowed to smother it in beauty at thirty shillings a foot. We shall have no more architecture in Europe till architects understand that all these tawdry excrescences have got to be simplified away, till they make up their minds to express

themselves in the materials of the age—steel, concrete, and glass—and to create in these admirable media vast, simple, and significant forms.

The contemporary movement has pushed simplification a great deal further than Manet and his friends pushed it, thereby distinguishing itself from anything we have seen since the twelfth century. Since the twelfth century, in sculpture and glass, the thirteenth, in painting and drawing, the drift has been towards realism and away from art. Now the essence of realism is detail. Since Zola, every novelist has known that nothing gives so imposing an air of reality as a mass of irrelevant facts, and very few have cared to give much else. Detail is the heart of realism, and the fatty degeneration of art. The tendency of the movement is to simplify away all this mess of detail which painters have introduced into pictures in order to state facts. But more than this was needed. There were irrelevancies introduced into pictures for other purposes than that of statement. There were the irrelevancies of technical swagger. Since the twelfth century there has been a steady elaboration of technical complexities. Writers with nothing to say soon come to regard the manipulation

of words as an end in itself. So cooks without eggs might come to regard the ritual of omelette-making, the mixing of condiments, the chopping of herbs, the stoking of fires, and the shaping of white caps, as a fine art. As for the eggs,—why that's God business: and who wants omelettes when he can have cooking? The movement has simplified the *batterie de cuisine*. Nothing is to be left in a work of art which merely shows that the craftsman knows how to put it there.

Alas! It generally turns out that Life and Art are rather more complicated than we could wish; to understand exactly what is meant by simplification we must go deeper into the mysteries. It is easy to say eliminate irrelevant details. What details are not irrelevant? In a work of art nothing is relevant but what contributes to formal significance. Therefore all informatory matter is irrelevant and should be eliminated. But what most painters have to express can only be expressed in designs so complex and subtle that without some clue they would be almost unintelligible. For instance, there are many designs that can only be grasped by a spectator who looks at them from a particular point of view. Not every picture

is as good seen upside down as upside up.
To be sure, very sensitive people can always
discover from the design itself how it should
be viewed, and, without much difficulty, will
place correctly a piece of lace or embroidery
in which there is no informatory clue to
guide them. Nevertheless, when an artist
makes an intricate design it is tempting and,
indeed, reasonable, for him to wish to pro-
vide a clue; and to do so he has only to
work into his design some familiar object, a
tree or a figure, and the business is done.
Having established a number of extremely
subtle relations between highly complex
forms, he may ask himself whether anyone
else will be able to appreciate them. Shall
he not give a hint as to the nature of his
organisation, and ease the way for our
aesthetic emotions? If he give to his forms
so much of the appearance of the forms of
ordinary life that we shall at once refer them
back to something we have already seen,
shall we not grasp more easily their aesthetic
relations in his design? Enter by the back-
door representation in the quality of a clue
to the nature of design. I have no objec-
tion to its presence. Only, if the represen-
tative element is not to ruin the picture
as a work of art, it must be fused into

the design. It must do double duty; as well as giving information, it must create aesthetic emotion. It must be simplified into significant form.

Let us make no mistake about this. To help the spectator to appreciate our design we have introduced into our picture a representative or cognitive element. This element has nothing whatever to do with art. The recognition of a correspondence between the forms of a work of art and the familiar forms of life cannot possibly provoke aesthetic emotion. Only significant form can do that. Of course realistic forms may be aesthetically significant, and out of them an artist may create a superb work of art, but it is with their aesthetic and not with their cognitive value that we shall then be concerned. We shall treat them as though they were not representative of anything. The cognitive or representative element in a work of art can be useful as a means to the perception of formal relations and in no other way. It is valuable to the spectator, but it is of no value to the work of art; or rather it is valuable to the work of art as an ear-trumpet is valuable to one who would converse with the deaf: the speaker could do as well without it, the

225

listener could not. The representative
element may help the spectator; it can
do the picture no good and it may do
harm. It may ruin the design; that is
to say, it may deprive the picture of its
value as a whole; and it is as a whole,
as an organisation of forms, that a work
of art provokes the most tremendous
emotions.

From the point of view of the spectator
the Post-Impressionists have been particu-
larly happy in their simplification. As we
know, a design can be composed just as
well of realistic forms as of invented; but a
fine design composed of realistic forms runs
a great risk of being aesthetically underrated.
We are so immediately struck by the re-
presentative element that the formal signi-
ficance passes us by. It is very hard at
first sight to appreciate the design of a
picture by a highly realistic artist—Ingres,
for instance; our aesthetic emotions are
overlaid by our human curiosity. We do
not see the figures as forms, because we
immediately think of them as people. On
the other hand, a design composed of
purely imaginary forms, without any cogni-
tive clue (say a Persian carpet), if it be at
all elaborate and intricate, is apt to non-

plus the less sensitive spectators. Post-Impressionists, by employing forms sufficiently distorted to disconcert and baffle human interest and curiosity yet sufficiently representative to call immediate attention to the nature of the design, have found a short way to our aesthetic emotions. This does not make Post-Impressionist pictures better or worse than others; it makes them more easily appreciable as works of art. Probably it will always be difficult for the mass of men to consider pictures as works of art, but it will be less difficult for them so to consider Post-Impressionist than realistic pictures; while, if they ceased to consider objects unprovided with representative clues (*e.g.* some oriental textiles) as historical monuments, they would find it very difficult to consider them at all.

To assure his design, the artist makes it his first care to simplify. But mere simplification, the elimination of detail, is not enough. The informatory forms that remain have got to be made significant. The representative element, if it is not to injure the design, must become a part of it; besides giving information it has got to provoke aesthetic emotion. That is where symbolism fails. The symbolist eliminates,

but does not assimilate. His symbols, as a rule, are not significant forms, but formal intelligencers. They are not integral parts of a plastic conception, but intellectual abbreviations. They are not informed by the artist's emotion, they are invented by his intellect. They are dead matter in a living organism. They are rigid and tight because they are not traversed by the rhythm of the design. The explanatory legends that illustrators used to produce from the mouths of their characters are not more foreign to visual art than the symbolic forms with which many able draughtsmen have ruined their designs. In the famous "Melancholia," and, to some extent, in a few other engravings—"St. Eustace," for instance, and "The Virgin and Child" (B. 34. British Museum),—Dürer[2] has managed to convert a mass of detail into tolerably significant form; but in the greater part of his work (*e.g.* "The Knight," "St. Jerome") fine conception is hopelessly ruined by a mass of undigested symbolism.

Every form in a work of art has, then, to be made aesthetically significant; also every form has to be made a part of a significant whole. For, as generally happens,

the value of the parts combined into a whole is far greater than the value of the sum of the parts. This organisation of forms into a significant whole is called Design; and an insistence—an exaggerated insistence some will say—on design is the fourth characteristic of the Contemporary Movement. This insistence, this conviction that a work should not be good on the whole, but as a whole, is, no doubt, in part a reaction from the rather too easy virtue of some of the Impressionists, who were content to cover their canvases with charming forms and colours, not caring overmuch whether or how they were co-ordinated. Certainly this was a weakness in Impressionism—though by no means in all the Impressionist masters —for it is certain that the profoundest emotions are provoked by significant combinations of significant forms. Also, it seems certain that only in these organised combinations can the artist express himself completely.

It seems that an artist creates a good design when, having been possessed by a real emotional conception, he is able to hold and translate it. We all agree, I think, that till the artist has had his moment of emotional vision there can be no very con-

siderable work of art; but, the vision seen and felt, it still remains uncertain whether he has the force to hold and the skill to translate it. Of course the vast majority of pictures fail in design because they correspond to no emotional vision; but the interesting failures are those in which the vision came but was incompletely grasped. The painters who have failed for want of technical skill to set down what they have felt and mastered could be counted on the fingers of one hand — if, indeed, there are any to be counted. But on all sides we see interesting pictures in which the holes in the artist's conception are obvious. The vision was once perfect, but it cannot be recaptured. The rapture will not return. The supreme creative power is wanting. There are holes, and they have to be filled with putty. Putty we all know when we see it—when we feel it. It is dead matter —literal transcriptions from nature, intellectual machinery, forms that correspond with nothing that was apprehended emotionally, forms unfired with the rhythm that thrilled through the first vision of a significant whole.

There is an absolute necessity about a good design arising, I imagine, from the

fact that the nature of each form and its relation to all the other forms is determined by the artist's need of expressing exactly what he felt. Of course, a perfect correspondence between expression and conception may not be established at the first or the second attempt. But if the work is to be a success there will come a moment in which the artist will be able to hold and express completely his hour or minute of inspiration. If that moment does not come the design will lack necessity. For though an artist's aesthetic sense enables him, as we shall see, to say whether a design is right or wrong, only this masterful power of seizing and holding his vision enables him to make it right. A bad design lacks cohesion; a good design possesses it; if I conjecture that the secret of cohesion is the complete realisation of that thrill which comes to an artist when he conceives his work as a whole, I shall not forget that it is a conjecture. But it is not conjecture to say that when we call a design good we mean that, as a whole, it provokes aesthetic emotion, and that a bad design is a congeries of lines and colours, individually satisfactory perhaps, but as a whole unmoving.

For, ultimately, the spectator can determine whether a design is good or bad only by discovering whether or no it moves him. Having made that discovery he can go on to criticise in detail; but the beginning of all aesthetic judgment and all criticism is emotion. It is after I have been left cold that I begin to notice that defective organisation of forms which I call bad design. And here, in my judgments about particular designs, I am still on pretty sure ground: it is only when I attempt to account for the moving power of certain combinations that I get into the world of conjecture. Nevertheless, I believe that mine are no bad guesses at truth, and that on the same hypothesis we can account for the difference between good and bad drawing.

Design is the organisation of forms: drawing is the shaping of the forms themselves. Clearly there is a point at which the two commingle, but that is a matter of no present importance. When I say that drawing is bad, I mean that I am not moved by the contours of the forms that make up the work of art. The causes of bad drawing and bad design I believe to be similar. A form is badly drawn when

it does not correspond with a part of an emotional conception. The shape of every form in a work of art should be imposed on the artist by his inspiration. The hand of the artist, I believe, must be guided by the necessity of expressing something he has felt not only intensely but definitely. The artist must know what he is about, and what he is about must be, if I am right, the translation into material form of something that he felt in a spasm of ecstasy. Therefore, shapes that merely fill gaps will be ill-drawn. Forms that are not dictated by any emotional necessity, forms that state facts, forms that are the consequences of a theory of draughtsmanship, imitations of natural objects or of the forms of other works of art, forms that exist merely to fill spaces—padding in fact,—all these are worthless. Good drawing must be inspired, it must be the natural manifestation of that thrill which accompanies the passionate apprehension of form.

One word more to close this discussion. No critic is so stupid as to mean by " bad drawing," drawing that does not represent the model correctly. The gods of the art schools, Michelangelo, Mantegna, Raffael, &c. played the oddest tricks with anatomy. Everyone

knows that Giotto's figures are less accurately drawn than those of Sir Edward Poynter ;[3] no one supposes that they are not drawn better. We do possess a criterion by which we can judge drawing, and that criterion can have nothing to do with truth to nature. We judge drawing by concentrating our aesthetic sensibility on a particular part of design. What we mean when we speak of "good drawing" and "bad drawing" is not doubtful; we mean "aesthetically moving" and "aesthetically insignificant." Why some drawing moves and some does not is a very different question. I have put forward an hypothesis of which I could write a pretty sharp criticism: that task, however, I leave to more willing hands. Only this I will say: just as a competent musician knows with certainty when an instrument is out of tune though the criterion resides nowhere but in his own sensibility; so a fine critic of visual art can detect lines and colours that are not alive. Whether he be looking at an embroidered pattern or at a careful anatomical study, the task is always the same, because the criterion is always the same. What he has to decide is whether the drawing is, or is not, aesthetically significant.

SIMPLIFICATION AND DESIGN

Insistence on design is perhaps the most obvious characteristic of the movement. To all are familiar those circumambient black lines that are intended to give definition to forms and to reveal the construction of the picture. For almost all the younger artists,—Bonnard[4] is an obvious exception—affect that architectural method of design which indeed has generally been preferred by European artists. The difference between "architectural design" and what I call "imposed design" will be obvious to anyone who compares a picture by Cézanne with a picture by Whistler. Better still, compare any first-rate Florentine of the fourteenth or fifteenth century with any Sung[5] picture. Here are two methods of achieving the same end, equally good, so far as I can judge, and as different as possible. We feel towards a picture by Cézanne or Masaccio or Giotto as we feel towards a Romanesque church; the design seems to spring upwards, mass piles itself on mass, forms balance each other masonrywise : there is a sense of strain, and of strength to meet it. Turn to a Chinese picture; the forms seem to be pinned to the silk or to be hung from above. There is no sense of thrust or strain; rather there is the feeling of some creeper, with roots we know not where, that

hangs itself in exquisite festoons along the wall. Though architectural design is a permanent characteristic of Western art, of four periods I think it would be fairly accurate to say that it is a characteristic so dominant as to be distinctive; and they are Byzantine VIth Century, Byzantine IX–XIIIth Century, Florentine XIVth and XVth Century, and the Contemporary Movement.

To say that the artists of the movement insist on design is not to deny that some of them are exceptionally fine colourists. Cézanne is one of the greatest colourists that ever lived; Henri-Matisse is a great colourist. Yet all, or nearly all, use colour as a mode of form. They design in colour, that is in coloured shapes. Very few fall into the error of regarding colour as an end in itself, and of trying to think of it as something different from form. Colour in itself has little or no significance. The mere juxtaposition of tones moves us hardly at all. As colourists themselves are fond of saying, "It is the quantities that count." It is not by his mixing and choosing, but by the shapes of his colours, and the combinations of those shapes, that we recognise the colourist. Colour becomes significant only when it

becomes form. It is a virtue in con-
temporary artists that they have set their
faces against the practice of juxtaposing
pretty patches of colour without much con-
sidering their formal relations, and that
they attempt so to organise tones as to
raise form to its highest significance. But
it is not surprising that a generation of
exceptionally sweet and attractive but rather
formless colourists should be shocked by
the obtrusion of those black lines that seem
to do violence to their darling. They are
irritated by pictures in which there is to
be no accidental charm of soft lapses and
lucky chiaroscuro. They do not admire
the austere determination of these young
men to make their work independent and
self-supporting and unbeholden to adventi-
tious dainties. They cannot understand
this passion for works that are admirable
as wholes, this fierce insistence on design,
this willingness to leave bare the construc-
tion if by so doing the spectator may be
helped to a conception of the plan. Critics
of the Impressionist age[6] are vexed by
the naked bones and muscles of Post-
Impressionist pictures. But, for my own
part, even though these young artists in-
sisted on a bareness and baldness exceeding

anything we have yet seen, I should be far from blaming a band of ascetics who in an age of unorganised prettiness insisted on the paramount importance of design.

III

THE PATHETIC FALLACY

MANY of those who are enthusiastic about the movement, were they asked what they considered its most important characteristic, would reply, I imagine, "The expression of a new and peculiar point of view." "Post-Impressionism," I have heard people say, "is an expression of the ideas and feelings of that spiritual renaissance which is now growing into a lusty revolution." With this I cannot, of course, agree. If art expresses anything, it expresses some profound and general emotion common, or at least possible, to all ages, and peculiar to none. But if these sympathetic people mean, as I believe they do, that the art of the new movement is a manifestation of something different from—they will say larger than—itself, of a spiritual revolution in fact, I will not oppose them. Art is as good an index to the spiritual state of this

age as of another; and in the effort of
artists to free painting from the clinging
conventions of the near past, and to use
it as a means only to the most sublime
emotions, we may read signs of an age
possessed of a new sense of values and
eager to turn that possession to account.
It is impossible to visit a good modern
exhibition without feeling that we are back
in a world not altogether unworthy to be
compared with that which produced primi-
tive art. Here are men who take art
seriously. Perhaps they take life seriously
too, but if so, that is only because there
are things in life (aesthetic ecstasy, for in-
stance) worth taking seriously. In life,
they can distinguish between the wood and
the few fine trees. As for art, they know
that it is something more important than
a criticism of life; they will not pretend
that it is a traffic in amenities; they know
that it is a spiritual necessity. They are
not making handsome furniture, nor pretty
knick-knacks, nor tasteful souvenirs; they
are creating forms that stir our most won-
derful emotions.

It is tempting to suppose that art such as
this implies an attitude towards society. It
seems to imply a belief that the future will

not be a mere repetition of the past, but that by dint of willing and acting men will conquer for themselves a life in which the claims of spirit and emotion will make some headway against the necessities of physical existence. It seems, I say : but it would be exceedingly rash to assume anything of the sort, and, for myself, I doubt whether the good artist bothers much more about the future than about the past. Why should artists bother about the fate of humanity? If art does not justify itself, aesthetic rapture does. Whether that rapture is to be felt by future generations of virtuous and contented artisans is a matter of purely speculative interest. Rapture suffices. The artist has no more call to look forward than the lover in the arms of his mistress. There are moments in life that are ends to which the whole history of humanity would not be an extravagant means ; of such are the moments of aesthetic ecstasy. It is as vain to imagine that the artist works with one eye on The Great State of the future, as to go to his art for an expression of political or social opinions. It is not their attitude towards the State or towards life, but the pure and serious attitude of these artists towards their art, that makes the movement significant of the age.

Here are men who refuse all compromise, who will hire no half-way house between what they believe and what the public likes; men who decline flatly, and over-stridently sometimes, to concern themselves at all with what seems to them unimportant. To call the art of the movement democratic—some people have done so—is silly. All artists are aristocrats in a sense, since no artist believes honestly in human equality; in any other sense to call an artist an aristocrat or a democrat is to call him something irrelevant or insulting. The man who creates art especially to move the poor or especially to please the rich prostitutes whatever of worth may be in him. A good many artists have maimed or ruined themselves by pretending that, besides the distinction between good art and bad, there is a distinction between aristocratic art and plebeian. In a sense all art is anarchical; to take art seriously is to be unable to take seriously the conventions and principles by which societies exist. It may be said with some justice that Post-Impressionism is peculiarly anarchical because it insists so emphatically on fundamentals and challenges so violently the conventional tradition of art and, by implication, I suppose, the conventional view of life. By

setting art so high, it sets industrial civilisation very low. Here, then, it may shake hands with the broader and vaguer spirit of the age; the effort to produce serious art may bear witness to a stir in the underworld, to a weariness of smug materialism and a more passionate and spiritual conception of life. The art of the movement, in so far as it is art, expresses nothing temporal or local; but it may be a manifestation of something that is happening here and now, something of which the majority of mankind seems hardly yet to be aware.

Men and women who have been thrilled by the pure aesthetic significance of a work of art go away into the outer world in a state of excitement and exaltation which makes them more sensitive to all that is going forward about them. Thus, they realise with a heightened intensity the significance and possibility of life. It is not surprising that they should read this new sense of life into that which gave it. Not in the least; and I shall not quarrel with them for doing so. It is far more important to be moved by art than to know precisely what it is that moves. I should just like to remind them, though, that if art were no more than they sometimes fancy it to be, art would not

move them as it does. If art were a mere matter of suggesting the emotions of life a work of art would give to each no more than what each brought with him. It is because art adds something new to our emotional experience, something that comes not from human life but from pure form, that it stirs us so deeply and so mysteriously. But that, for many, art not only adds something new, but seems to transmute and enrich the old, is certain and by no means deplorable.

The fact is, this passionate and austere art of the Contemporary Movement is not only an index to the general ferment, it is also the inspiration, and even the standard, of a young, violent, and fierce generation. It is the most visible and the most successful manifestation of their will, or they think it is. Political reform, social reform, literature even, move slowly, ankle-deep in the mud of materialism and deliquescent tradition. Though not without reason Socialists claim that Liberals ride their horses, the jockeys still wear blue and buff. Mr. Lloyd George stands unsteadily on the shoulders of Mr. Gladstone; the bulk of his colleagues cling on behind. If literature is to be made the test, we shall soon be wishing ourselves back

THE PATHETIC FALLACY

in the nineteenth century. Unless it be Thomas Hardy, there is no first-rate novelist in Europe; there is no first-rate poet; without disrespect to D'Annunzio, Shaw,[1] or Claudel, it may be said that Ibsen was their better. Since Mozart, music has just kept her nose above the slough of realism, romance, and melodrama. Music seems to be where painting was in the time of Courbet; she is drifting through complex intellectualism and a brilliant, exasperating realism, to arrive, I hope, at greater purity.* Contemporary painting is the one manifest triumph of the young age. Not even the oldest and wisest dare try to smile it away. Those who cannot love Cézanne and Matisse hate them; and they not only say it, they shriek it. It is not surprising, then, that visual art, which seems to many the mirror in which they see realised their own ideals, should have become for some a new religion. Not content with its aesthetic significance, these seek in art an inspiration for the whole of life. For some of us, to be sure, the aesthetic significance is a sufficient inspira-

* June 1913. *Ariadne in Naxos.* Is Strauss,[2] our one musician of genius, himself the pivot on which the wheel is beginning to swing? Having drained the cup of Wagnerism and turned it upside down, is he now going to school with Mozart?

tion; for the others I have no hard words.
To art they take their most profound and
subtle emotions, their most magnanimous
ideas, their dearest hopes; from art they
bring away enriched and purified emotion
and exaltation, and fresh sources of both. In
art they imagine that they find an expression
of their most intimate and mysterious feel-
ings; and, though they miss, not utterly but
to some extent, the best that art has to give,
if of art they make a religion I do not blame
them.

In the days of Alexander Severus[3] there
lived at Rome a Greek freed man.[4] As he
was a clever craftsman his lot was not hard.
His body was secure, his belly full, his hands
and brain pleasantly busy. He lived amongst
intelligent people and handsome objects, per-
mitting himself such reasonable emotions as
were recommended by his master, Epicurus[5]
He awoke each morning to a quiet day of
ordered satisfaction, the prescribed toll of
unexacting labour, a little sensual pleasure, a
little rational conversation, a cool argument,
a judicious appreciation of all that the in-
tellect can apprehend. Into this existence
burst suddenly a cranky fanatic, with a
religion. To the Greek it seemed that the
breath of life had blown through the grave,

imperial streets. Yet nothing in Rome was changed, save one immortal, or mortal, soul. The same waking eyes opened on the same objects; yet all was changed; all was charged with meaning. New things existed. Everything mattered. In the vast equality of religious emotion the Greek forgot his status and his nationality. His life became a miracle and an ecstasy. As a lover awakes, he awoke to a day full of consequence and delight. He had learnt to feel; and, because to feel a man must live, it was good to be alive. I know an erudite and intelligent man, a man whose arid life had been little better than one long cold in the head, for whom that madman, Van Gogh, did nothing less.

V

THE FUTURE

I

SOCIETY AND ART

To bother much about anything but the present is, we all agree, beneath the dignity of a healthy human animal. Yet how many of us can resist the malsane pleasure of puzzling over the past and speculating about the future? Once admit that the Contemporary Movement is something a little out of the common, that it has the air of a beginning, and you will catch yourself saying "Beginning of what?" instead of settling down quietly to enjoy the rare spectacle of a renaissance. Art, we hope, serious, alive, and independent is knocking at the door, and we are impelled to ask "What will come of it?" This is the general question, which, you will find, divides itself into two sufficiently precise queries—"What will Society do with Art?" and "What will Art do with Society?"

It is a mistake to suppose that because

251

Society cannot affect Art directly, it cannot affect it at all. Society can affect Art indirectly because it can affect artists directly. Clearly, if the creation of works of art were made a capital offence, the quantity, if not the quality, of artistic output would be affected. Proposals less barbarous, but far more terrible, are from time to time put forward by cultivated state-projectors who would make of artists, not criminals, but highly-paid officials. Though statesmanship can do no positive good to art, it can avoid doing a great deal of harm: its power for ill is considerable. The one good thing Society can do for the artist is to leave him alone. Give him liberty. The more completely the artist is freed from the pressure of public taste and opinion, from the hope of rewards and the menace of morals, from the fear of absolute starvation or punishment, and from the prospect of wealth or popular consideration, the better for him and the better for art, and therefore the better for everyone. Liberate the artist: here is something that those powerful and important people who are always assuring us that they would do anything for art can do.

They might begin the work of encourage-

ment by disestablishing and disendowing
art ; by withdrawing doles from art schools,
and confiscating the moneys misused by the
Royal Academy. The case of the schools
is urgent. Art schools do nothing but
harm, because they must do something. Art
is not to be learned ; at any rate it is not
to be taught. All that the drawing-master
can teach is the craft of imitation. In
schools there must be a criterion of excel-
lence and that criterion cannot be an artistic
one ; the drawing-master sets up the only
criterion he is capable of using—fidelity to
the model. No master can make a student
into an artist ; but all can, and most do,
turn into impostors, maniacs, criminals, or
just cretins, the unfortunate boys and girls
who had been made artists by nature. It
is not the master's fault and he ought not
to be blamed. He is there to bring all his
pupils to a certain standard of efficiency
appreciable by inspectors and by the general
public, and the only quality of which such
can judge is verisimilitude. The only re-
spects in which one work can be seen to
differ from another by an ordinarily insen-
sitive person (*e.g.* a Board of Education
inspector) are choice of subject and fidelity
to common vision. So, even if a drawing-

master could recognise artistic talent, he
would not be permitted to encourage it.
It is not that drawing-masters are wicked,
but that the system is vicious. Art schools
must go.

The money that the State at present
devotes to the discouragement of Art had
better, I dare say, be given to the rich.
It would be tempting to save it for the
purchase of works of art, but perhaps that
can lead to nothing but mischief. It is
unthinkable that any Government should
ever buy what is best in the work of its
own age; it is a question how far purchase
by the State even of fine old pictures is
a benefit to art. It is not a question that
need be discussed; for though a State may
have amongst its employés men who can
recognise a fine work of art, provided it
be sufficiently old, a modern State will be
careful to thwart and stultify their danger-
ously good taste. State-acquisition of fine
ancient art might or might not be a means
to good—I daresay it would be; but the
purchase of third-rate old masters and
objets d'art can benefit no one except the
dealers. As I shall hope to show, some-
thing might be said for supporting and en-
riching galleries and museums, if only the

public attitude towards, and the official conception of, these places could be changed. As for contemporary art, official patronage is the surest method of encouraging in it all that is most stupid and pernicious. Our public monuments, the statues and buildings that disgrace our streets, our postage-stamps, coins, and official portraits are mere bait to the worst instincts of the worst art-students and to the better a formidable temptation.

Some of those generous prophets who sit at home dreaming of pure communistic societies have been good enough to find a place in them for the artist. Demos[1] is to keep for his diversion a kennel of mountebanks. Artists will be chosen by the State and supported by the State. The people will pay the piper and call the tune. In the choice of politicians the method works well enough, but to art it would be fatal. The creation of soft artistic jobs is the most unlikely method of encouraging art. Already hundreds take to it, not because they have in them that which must be expressed, but because art seems to offer a pleasant and genteel career. When the income is assured the number of those who fancy art as a profession will not diminish. On the contrary, in the great State of the

future the competition will be appalling
I can imagine the squeezing and intriguing
between the friends of applicants and their
parliamentary deputies, between the deputies
and the Minister of Fine Arts; and I
can imagine the art produced to fulfil a
popular mandate in the days when private
jobbery will be the only check on public
taste. Can we not all imagine the sort of man
that would be chosen? Have we no experi-
ence of what the people love? Comrades,
dear democratic ladies and gentlemen, pursue,
by all means, your schemes for righting the
world, dream your dreams, conceive Utopias,
but leave the artists out. For, tell me
honestly, does any one of you believe that
during the last three hundred years a single
good artist would have been supported by
your system? And remember, unless it had
supported him it would not have allowed
him to exist. Remember, too, that you
will have to select or reject your artists
while yet they are students—you will not
be able to wait until a name has been im-
posed on you by years of reputation with
a few good judges. If Degas is now rever-
enced as a master that is because his pic-
tures fetch long prices, and his pictures fetch
long prices because a handful of people who

would soon have been put under the great civic pump have been for years proclaiming his mastery. And during those long years how has Degas lived? On the bounty of the people who love all things beautiful, or on the intelligence and discrimination of a few rich or richish patrons? In the great State you will not be able to take your masters ready-made with years of reputation behind them; you will have to pick them yourselves, and pick them young.

Here you are, then, at the door of your annual exhibition of students' work; you are come to choose two State pensioners, and pack the rest off to clean the drains of Melbourne. They will be chosen by popular vote—the only fair way of inducting a public entertainer to a snug billet. But, unknown to you, I have placed amongst the exhibits two drawings by Claude and one by Ingres; and at this exhibition there are no names on the catalogue. Do you think my men will get a single vote? Possibly; but dare one of you suggest that in competition with any rubbishy sensation-monger either of them will stand a chance? "Oh, but," you say, "in the great new State everyone will be well educated." "Let them," I reply, "be as well educated

257

as the M.A.s of Oxford and Cambridge who
have been educated from six to six-and-
twenty: and I suggest that to do even that
will come pretty dear. Well, then, submit
your anonymous collection of pictures to
people qualified to elect members of parlia-
ment for our two ancient universities, and
you know perfectly well that you will get
no better result. So, don't be silly: even
private patronage is less fatal to art than
public. Whatever else you may get, you
will never get an artist by popular election."

You say that the State will select through
two or three highly sensitive officials. In
the first place you have got to catch your
officials. And remember, these, too, in the
eyes of their fellow-workers, will be men
who have got hold of a soft thing. The
considerations that govern the selection of
State-paid artists will control the election
of State-paid experts. By what sign shall
the public recognise the man of sensibility,
always supposing that it is a man of sensi-
bility the public wants? John Jones, the
broker's man, thinks himself quite as good
a judge of art as Mr. Fry, and apparently
Mr. Asquith thinks the trustees of the
National Gallery better than either. Sup-
pose you have by some miracle laid hands

on a man of aesthetic sensibility and made him your officer, he will still have to answer for his purchases to a popularly elected parliament. Things are bad enough at present: the people will not tolerate a public monument that is a work of art, neither do their obedient servants wish to impose such a thing on them; but when no one can live as an artist without becoming a public servant, when all works of art are public monuments, do you seriously expect to have any art at all? When the appointment of artists becomes a piece of party patronage does anyone doubt that a score of qualifications will stand an applicant in better stead than that of being an artist? Imagine Mr. Lloyd George nominating Mr. Roger Fry Government selector of State-paid artists. Imagine — and here I am making no heavy demand on your powers — imagine Mr. Fry appointing some obscure and shocking student of unconventional talent. Imagine Mr. Lloyd George going down to Limehouse to defend the appointment before thousands of voters, most of whom have a son, a brother, a cousin, a friend, or a little dog who, they feel sure, is much better equipped for the job.

If the great communistic society is bent

on producing art—and the society that does not produce live art is damned—there is one thing, and one only, that it can do. Guarantee to every citizen, whether he works or whether he loafs, a bare minimum of existence—say sixpence a day and a bed in the common dosshouse. Let the artist be a beggar living on public charity. Give to the industrious practical workers the sort of things they like, big salaries, short hours, social consideration, expensive pleasures. Let the artist have just enough to eat, and the tools of his trade: ask nothing of him. Materially make the life of the artist sufficiently miserable to be unattractive, and no one will take to art save those in whom the divine daemon is absolute. For all let there be a choice between a life of dignified, highly-paid, and not over-exacting employment and the despicable life of a vagrant. There can be little doubt about the choice of most, and none about that of a real artist. Art and Religion are very much alike, and in the East, where they understand these things, there has always been a notion that religion should be an amateur affair. The pungis of India are beggars. Let artists all over the world be beggars too. Art and Religion are not professions: they

are not occupations for which men can be paid. The artist and the saint do what they have to do, not to make a living, but in obedience to some mysterious necessity. They do not produce to live—they live to produce. There is no place for them in a social system based on the theory that what men desire is prolonged and pleasant existence. You cannot fit them into the machine, you must make them extraneous to it. You must make pariahs of them, since they are not a part of society but the salt of the earth.

In saying that the mass of mankind will never be capable of making delicate aesthetic judgments, I have said no more than the obvious truth. A sure sensibility in visual art is at least as rare as a good ear for music. No one imagines that all are equally capable of judging music, or that a perfect ear can be acquired by study: only fools imagine that the power of nice discrimination in other arts is not a peculiar gift. Nevertheless there is no reason why the vast majority should not become very much more sensitive to art than it is; the ear can be trained to a point. But for the better appreciation, as for the freer creation, of art more liberty is needed. Ninety-nine out of every hundred

people who visit picture galleries need to be delivered from that "museum atmosphere" which envelops works of art and asphyxiates beholders. They, the ninety-nine, should be encouraged to approach works of art courageously and to judge them on their merits. Often they are more sensitive to form and colour than they suppose. I have seen people show a nice taste in cottons and calicoes, and things not recognised as "Art" by the custodians of museums, who would not hesitate to assert of any picture by Andrea del Sarto[2] that it must be more beautiful than any picture by a child or a savage. In dealing with objects that are not expected to imitate natural forms or to resemble standard masterpieces they give free rein to their native sensibility. It is only in the presence of a catalogue that complete inhibition sets in. Traditional reverence is what lies heaviest on spectators and creators, and museums are too apt to become conventicles of tradition.

Society can do something for itself and for art by blowing out of the museums and galleries the dust of erudition and the stale incense of hero-worship. Let us try to remember that art is not something to

be come at by dint of study; let us try to think of it as something to be enjoyed as one enjoys being in love. The first thing to be done is to free the aesthetic emotions from the tyranny of erudition. I was sitting once behind the driver of an old horse-omnibus when a string of sandwichmen crossed us carrying "The Empire" poster. The name of Genée[3] was on the bill. "Some call that art," said the driver, turning to me, "but we know better" (my longish hair, I surmise, discovered a fellow connoisseur): "if you want art you must go for it to the museums." How this pernicious nonsense is to be knocked out of people's heads I cannot guess. It has been knocked in so solemnly and for so long by the schoolmasters and the newspapers, by cheap text-books and profound historians, by district visitors and cabinet ministers, by clergymen and secularists, by labour leaders, teetotallers, antigamblers, and public benefactors of every sort, that I am sure it will need a brighter and braver word than mine to knock it out again. But out it has to be knocked before we can have any general sensibility to art; for, while it remains, to ninety-nine out of every hundred a work of art

will be dead the moment it enters a public gallery.

The museums and galleries terrify us. We are crushed by the tacit admonition frowned from every corner that these treasures are displayed for study and improvement, by no means to provoke emotion. Think of Italy—every town with its public collection; think of the religious sightseers! How are we to persuade these middle-class masses, so patient and so pathetic in their quest, that really they could get some pleasure from the pictures if only they did not know, and did not care to know, who painted them. They cannot all be insensitive to form and colour; and if only they were not in a flutter to know, or not to forget, who painted the pictures, when they were painted, and what they represent, they might find in them the key that unlocks a world in the existence of which they are, at present, unable to believe. And the millions who stay at home, how are they to be persuaded that the thrill provoked by a locomotive or a gasometer is the real thing?—when will they understand that the iron buildings put up by Mr. Humphrey[4] are far more likely to be works of art than anything they will see

at the summer exhibition of the Royal Academy?* Can we persuade the travelling classes that an ordinarily sensitive human being has a better chance of appreciating an Italian primitive than an expert hagiographer? Will they understand that, as a rule, the last to feel aesthetic emotion is the historian of art? Can we induce the multitude to seek in art, not edification, but exaltation? Can we make them unashamed of the emotion they feel for the fine lines of a warehouse or a railway bridge? If we can do this we shall have freed works of art from the museum atmosphere; and this is just what we have got to do. We must make people understand that forms can be significant without resembling Gothic cathedrals or Greek temples, and that art is the creation, not the imitation, of form. Then, but not till then, can they go with impunity to seek aesthetic emotion in museums and galleries.

It is argued with plausibility that a sensitive people would have no use for museums. It is said that to go in search of aesthetic

* An example of this was the temporary police-court set up recently in Francis Street, just off the Tottenham Court Road. I do not know whether it yet stands; if so, it is one of the few tolerable pieces of modern architecture in London.

emotion is wrong, that art should be a part of life—something like the evening papers or the shop windows that people enjoy as they go about their business. But, if the state of mind of one who enters a gallery in search of aesthetic emotion is necessarily unsatisfactory, so is the state of one who sits down to read poetry. The lover of poetry shuts the door of his chamber and takes down a volume of Milton with the deliberate intention of getting himself out of one world and into another. The poetry of Milton is not a part of daily life, though for some it makes daily life supportable. The value of the greatest art consists not in its power of becoming a part of common existence but in its power of taking us out of it. I think it was William Morris[5] who said that poetry should be something that a man could invent and sing to his fellows as he worked at the loom. Too much of what Morris wrote may well have been so invented. But to create and to appreciate the greatest art the most absolute abstraction from the affairs of life is essential. And as, throughout the ages, men and women have gone to temples and churches in search of an ecstasy incompatible with

and remote from the preoccupations and activities of laborious humanity, so they may go to the temples of art to experience, a little out of this world, emotions that are of another. It is not as sanctuaries from life—sanctuaries devoted to the cult of aesthetic emotion—but as class-rooms, laboratories, homes of research and warehouses of tradition, that museums and galleries become noxious.

Human sensibility must be freed from the dust of erudition and the weight of tradition; it must also be freed from the oppression of culture. For, of all the enemies of art, culture is perhaps the most dangerous, because the least obvious. By "culture" it is, of course, possible to mean something altogether blameless. It may mean an education that aims at nothing but sharpening sensibility and strengthening the power of self-expression. But culture of that sort is not for sale: to some it comes from solitary contemplation, to others from contact with life; in either case it comes only to those who are capable of using it. Common culture, on the other hand, is bought and sold in open market. Cultivated society, in the ordinary sense of the word, is a congeries of persons

who have been educated to appreciate *le beau et le bien*. A cultivated person is one on whom art has not impressed itself, but on whom it has been impressed—one who has not been overwhelmed by the significance of art, but who knows that the nicest people have a peculiar regard for it. The characteristic of this Society is that, though it takes an interest in art, it does not take art seriously. Art for it is not a necessity, but an amenity. Art is not something that one might meet and be overwhelmed by between the pages of *Bradshaw*,[6] but something to be sought and saluted at appropriate times in appointed places. Culture feels no imperative craving for art such as one feels for tobacco; rather it thinks of art as something to be taken in polite and pleasant doses, as one likes to take the society of one's less interesting acquaintances. Patronage of the Arts is to the cultivated classes what religious practice is to the lower-middle, the homage that matter pays to spirit, or, amongst the better sort, that intellect pays to emotion. Neither the cultivated nor the pious are genuinely sensitive to the tremendous emotions of art and religion; but both know what they are

expected to feel, and when they ought to feel it.

Now if culture did nothing worse than create a class of well-educated ladies and gentlemen who read books, attend concerts, travel in Italy, and talk a good deal about art without ever guessing what manner of thing it is, culture would be nothing to make a fuss about. Unfortunately, culture is an active disease which causes positive ill and baulks potential good. In the first place, cultivated people always wish to cultivate others. Cultivated parents cultivate their children; thousands of wretched little creatures are daily being taught to love the beautiful. If they happen to have been born insensitive this is of no great consequence, but it is misery to think of those who have had real sensibilities ruined by conscientious parents: it is so hard to feel a genuine personal emotion for what one has been brought up to admire. Yet if children are to grow up into acceptable members of the cultivated class they must be taught to hold the right opinions— they must recognise the standards. Standards of taste are the essence of culture. That is why the cultured have ever been defenders of the antique. There grows

up in the art of the past a traditional
classification under standard masterpieces by
means of which even those who have no
native sensibility can discriminate between
works of art. That is just what culture
wants; so it insists on the veneration of
standards and frowns on anything that can-
not be justified by reference to them. That
is the serious charge against culture. A
person familiar with the masterpieces of
Europe, but insensitive to that which makes
them masterpieces, will be utterly non-
plussed by a novel manifestation of the
mysterious "that." It is well that old
masters should be respected; it were better
that vital art should be welcome. Vital
art is a necessity, and vital art is stifled by
culture, which insists that artists shall re-
spect the standards, or, to put it bluntly,
shall imitate old masters.

The cultured, therefore, who expect in
every picture at least some reference
to a familiar masterpiece, create, uncon-
sciously enough, a thoroughly unwhole-
some atmosphere. For they are rich and
patronising and liberal. They are the very
innocent but natural enemies of originality,
for an original work is the touchstone that
exposes educated taste masquerading as

sensibility. Besides, it is reasonable that those who have been at such pains to sympathise with artists should expect artists to think and feel as they do. Originality, however, thinks and feels for itself; commonly the original artist does not live the refined, intellectual life that would befit the fancy-man of the cultured classes. He is not picturesque; perhaps he is positively inartistic; he is neither a gentleman nor a blackguard; culture is angry and incredulous. Here is one who spends his working hours creating something that seems strange and disquieting and ugly, and devotes his leisure to simple animalities; surely one so utterly unlike ourselves cannot be an artist? So culture attacks and sometimes ruins him. If he survives, culture has to adopt him. He becomes part of the tradition, a standard, a stick with which to beat the next original genius who dares to shove an unsponsored nose above water.

In the nineteenth century cultured people were amazed to find that such cads as Keats and Burns were also great poets. They had to be accepted, and their caddishness had to be explained away. The shocking intemperance of Burns was deplored in a paragraph, and passed over—as though Burns were not

as essentially a drunkard as a poet! The
vulgarity of Keats's letters to Fanny Brawne
did not escape the nice censure of Matthew
Arnold[7] who could not be expected to see
that a man incapable of writing such letters
would not have written "The Eve of St.
Agnes." In our day culture having failed
to suppress Mr. Augustus John[8] welcomes
him with undiscriminating enthusiasm some
ten years behind the times. Here and there,
a man of power may force the door, but
culture never loves originality until it has
lost the appearance of originality. The
original genius is ill to live with until he is
dead. Culture will not live with him; it
takes as lover the artificer of the *faux-bon*.
It adores the man who is clever enough to
imitate, not any particular work of art, but
art itself. It adores the man who gives in
an unexpected way just what it has been
taught to expect. It wants, not art, but
something so much like art that it can feel
the sort of emotions it would be nice to feel
for art. To be frank, cultivated people are
no fonder of art than the Philistines; but
they like to get thrills, and they like to see
old faces under new bonnets. They admire
Mr. Lavery's[9] seductive banalities and the
literary and erudite novelettes of M. Rostand.[10]

They go silly over Reinhardt and Bakst.[11] These confectioners seem to give the distinction of art to the natural thoughts and feelings of cultivated people. Culture is far more dangerous than Philistinism because it is more intelligent and more pliant. It has a specious air of being on the side of the artist. It has the charm of its acquired taste, and it can corrupt because it can speak with an authority unknown in Philistia. Because it pretends to care about art, artists are not indifferent to its judgments. Culture imposes on people who would snap their fingers at vulgarity. With culture itself, even in the low sense in which I have been using the word, we need not pick a quarrel, but we must try to free the artist and the public too from the influence of cultivated opinion. The liberation will not be complete until those who have already learned to despise the opinion of the lower middle-classes learn also to neglect the standards and the disapproval of people who are forced by their emotional limitations to regard art as an elegant amenity.

If you would have fine art and fine appreciation of art, you must have a fine free life for your artists and for yourselves. That is another thing that Society can do for art:

273

it can kill the middle-class ideal. Was ever
ideal so vulnerable? The industrious ap-
prentice who by slow pettifogging hardness
works his way to the dignity of material
prosperity, Dick Whittington, what a hero
for a high-spirited nation! What dreams
our old men dream, what visions float into
the minds of our seers! Eight hours of
intelligent production, eight hours of thought-
ful recreation, eight hours of refreshing sleep
for all! What a vision to dangle before the
eyes of a hungry people! If it is great art
and fine life that you want, you must renounce
this religion of safe mediocrity. Comfort is
the enemy; luxury is merely the bugbear of
the bourgeoisie. No soul was ever ruined by
extravagance or even by debauch; it is the
steady, punctual gnawing of comfort that
destroys. That is the triumph of matter over
mind; that is the last tyranny. For how
are they better than slaves who must stop
their work because it is time for luncheon,
must break up a conversation to dress for
dinner, must leave on the doorstep the friend
they have not seen for years so as not to
miss the customary train?

Society can do something for art, because
it can increase liberty, and in a liberal atmos-
phere art thrives. Even politicians can do

something. They can repeal censorious laws and abolish restrictions on freedom of thought and speech and conduct. They can protect minorities. They can defend originality from the hatred of the mediocre mob. They can make an end of the doctrine that the State has a right to crush unpopular opinions in the interests of public order. A mighty liberty to be allowed to speak acceptable words to the rabble! The least that the State can do is to protect people who have something to say that may cause a riot. What will not cause a riot is probably not worth saying. At present, to agitate for an increase of liberty is the best that any ordinary person can do for the advancement of art.

II

ART AND SOCIETY

WHAT might Art do for Society? Leaven
it; perhaps even redeem it: for Society
needs redemption. Towards the end of the
nineteenth century life seemed to be losing
its savour. The world had grown grey and
anæmic, lacking passion, it seemed. Sedate-
ness became fashionable; only dull people
cared to be thought spiritual. At its best
the late nineteenth century reminds one of a
sentimental farce, at its worst of a heartless
joke. But, as we have seen, before the turn,
first in France, then throughout Europe, a
new emotional movement began to manifest
itself. This movement if it was not to be
lost required a channel along which it might
flow to some purpose. In the Middle Ages
such a channel would have been ready to
hand; spiritual ferment used to express
itself through the Christian Church, gene-
rally in the teeth of official opposition. A

modern movement of any depth cannot so express itself. Whatever the reasons may be, the fact is certain. The principal reason, I believe, is that the minds of modern men and women can find no satisfaction in dogmatic religion; and Christianity, by a deplorable mischance, has been unwilling to relinquish dogmas that are utterly irrelevant to its essence. It is the entanglement of religion in dogma that still keeps the world superficially irreligious. Now, though no religion can escape the binding weeds of dogma, there is one that throws them off more easily and light-heartedly than any other. That religion is art; for art is a religion. It is an expression of and a means to states of mind as holy as any that men are capable of experiencing; and it is towards art that modern minds turn, not only for the most perfect expression of transcendent emotion, but for an inspiration by which to live.

From the beginning art has existed as a religion concurrent with all other religions. Obviously there can be no essential antagonism between it and them. Genuine art and genuine religion are different manifestations of one spirit, so are sham art and sham religion. For thousands of years men have expressed in art their ultra-human emotions,

and have found in it that food by which the
spirit lives. Art is the most universal and
the most permanent of all forms of religious
expression, because the significance of formal
combinations can be appreciated as well by
one race and one age as by another, and
because that significance is as independent
as mathematical truth of human vicissitudes.
On the whole, no other vehicle of emotion
and no other means to ecstasy has served
man so well. In art any flood of spiritual
exaltation finds a channel ready to nurse and
lead it: and when art fails it is for lack
of emotion, not for lack of formal adapta-
bility. There never was a religion so
adaptable and catholic as art. And now
that the young movement begins to cast
about for a home in which to preserve itself
and live, what more natural than that it
should turn to the one religion of unlimited
forms and frequent revolutions?

For art is the one religion that is always
shaping its form to fit the spirit, the one
religion that will never for long be fettered
in dogmas. It is a religion without a
priesthood; and it is well that the new
spirit should not be committed to the hands
of priests. The new spirit is in the hands of
the artists; that is well. Artists, as a rule,

are the last to organise themselves into official castes, and such castes, when organised, rarely impose on the choicer spirits. Rebellious painters are a good deal commoner than rebellious clergymen. On compromise which is the bane of all religion—since men cannot serve two masters—almost all the sects of Europe live and grow fat. Artists have been more willing to go lean. By compromise the priests have succeeded marvellously in keeping their vessel intact. The fine contempt for the vessel manifested by the original artists of each new movement is almost as salutary as their sublime belief in the spirit. To us, looking at the history of art, the periods of abjection and compromise may appear unconscionably long, but by comparison with those of other religions they are surprisingly short. Sooner or later a true artist arises, and often by his unaided strength succeeds in so reshaping the vessel that it shall contain perfectly the spirit.

Religion which is an affair of emotional conviction should have nothing to do with intellectual beliefs. We have an emotional conviction that some things are better than others, that some states of mind are good and that others are not; we have a strong

emotional conviction that a good world ought to be preferred to a bad; but there is no proving these things. Few things of importance can be proved; important things have to be felt and expressed. That is why people with things of importance to say tend to write poems rather than moral treatises. I make my critics a present of that stick. The original sin of dogmatists is that they are not content to feel and express but must needs invent an intellectual concept to stand target for their emotion. From the nature of their emotions they infer an object the existence of which they find themselves obliged to prove by an elaborately disingenuous metaphysic. The consequence is inevitable; religion comes to mean, not the feeling of an emotion, but adherence to a creed. Instead of being a matter of emotional conviction it becomes a matter of intellectual propositions. And here, very properly, the sceptic steps in and riddles the *ad hoc* metaphysic of the dogmatist with unanswerable objections. No Cambridge Rationalist can presume to deny that I feel a certain emotion, but the moment I attempt to prove the existence of its object I lay myself open to a bad four hours.

No one, however, wishes to deny the

existence of the immediate object of aesthetic emotion—combinations of lines and colours. For my suggestion that there may be a remote object I shall probably get into trouble. But if my metaphysical notions are demolished in a paragraph, that will not matter in the least. No metaphysical notions about art matter. All that matter are the aesthetic emotion and its immediate object. As to the existence of a remote object and its possible nature there have been innumerable theories, most, if not all, of which have been discredited. Though a few have been defended fiercely, they have never been allowed to squeeze out art completely: dogma has never succeeded in ousting religion. It has been realised always to some extent that the significance of art depends chiefly on the emotion it provokes, that works are more important than theories. Although attempts have been made to impose dogmas, to define the remote object and to direct the emotion, a single original artist has generally been strong enough to wreck the spurious orthodoxy. Dimly it has always been perceived that a picture which moves aesthetically cannot be wrong; and that the theory that condemns it as heretical condemns itself. Art remains an undogmatic religion. You are

invited to feel an emotion, not to acquiesce in a theory.

Art, then, may satisfy the religious need of an age grown too acute for dogmatic religion, but to do so art must enlarge its sphere of influence. There must be more popular art, more of that art which is unimportant to the universe but important to the individual: for art can be second-rate yet genuine. Also, art must become less exclusively professional. That will not be achieved by bribing the best artists to debase themselves, but by enabling everyone to create such art as he can. It is probable that most are capable of expressing themselves, to some extent, in form; it is certain that in so doing they can find an extraordinary happiness. Those who have absolutely nothing to express and absolutely no power of expression are God's failures; they should be kindly treated along with the hopelessly idiotic and the hydrocephalous. Of the majority it is certainly true that they have some vague but profound emotions, also it is certain that only in formal expression can they realise them. To caper and shout is to express oneself, yet is it comfortless; but introduce the idea of formality, and in dance and song you may

find satisfying delight. Form is the talisman. By form the vague, uneasy, and unearthly emotions are transmuted into something definite, logical, and above the earth. Making useful objects is dreary work, but making them according to the mysterious laws of formal expression is half way to happiness. If art is to do the work of religion, it must somehow be brought within reach of the people who need religion, and an obvious means of achieving this is to introduce into useful work the thrill of creation.

But, after all, useful work must remain, for the most part, mechanical; and if the useful workers want to express themselves as completely as possible, they must do so in their leisure. There are two kinds of formal expression open to all—dancing and singing. Certainly it is in dance and song that ordinary people come nearest to the joy of creation. In no age can there be more than a few first-rate artists, but in any there might be millions of genuine ones; and once it is understood that art which is unfit for public exhibition may yet be created for private pleasure no one will feel shame at being called an amateur. We shall not have to pretend that all our friends are

great artists, because they will make no such pretence themselves. In the great State they will not be of the company of divine beggars. They will be amateurs who consciously use art as a means to emotional beatitude ; they will not be artists who, consciously or unconsciously, use everything as a means to art. Let us dance and sing, then, for dancing and singing are true arts, useless materially, valuable only for their aesthetic significance. Above all, let us dance and devise dances—dancing is a very pure art, a creation of abstract form ; and if we are to find in art emotional satisfaction, it is essential that we shall become creators of form. We must not be content to contemplate merely ; we must create ; we must be active in our dealings with art.

It is here that I shall fall foul of certain excellent men and women who are attempting to "bring art into the lives of the people" by dragging parties of school children and factory girls through the National Gallery and the British Museum. Who is not familiar with those little flocks of victims clattering and shuffling through the galleries, inspissating the gloom of the museum atmosphere? What is being done to their native sensibilities by the earnest bear-leader with

his (or her) catalogue of dates and names and appropriate comments? What have all these tags of mythology and history, these pedagogic raptures and peripatetic ecstasies, to do with genuine emotion? In the guise of what grisly and incomprehensible charlatan is art being presented to the people? The only possible effect of personally conducted visits must be to confirm the victims in their suspicion that art is something infinitely remote, infinitely venerable, and infinitely dreary. They come away with a respectful but permanent horror of that old sphinx who sits in Trafalgar Square propounding riddles that are not worth answering, tended by the cultured and nourished by the rich.

First learn to walk, then try running. An artisan of exceptional sensibility may get something from the masterpieces of the National Gallery, provided there is no cultivated person at hand to tell him what to feel, or to prevent him feeling anything by telling him to think. An artisan of ordinary sensibility had far better keep away until, by trying to express himself in form, he has gained some glimmer of a notion of what artists are driving at. Surely there can be no reason why almost every man

and woman should not be a bit of an artist since almost every child is. In most children a sense of form is discernible. What becomes of it? It is the old story: the child is father to the man; and if you wish to preserve for the man the gift with which he was born, you must catch him young, or rather prevent his being caught. Can we by any means thwart the parents, the teachers, and the systems of education that turn children into modern men and women? Can we save the artist that is in almost every child? At least we can offer some practical advice. Do not tamper with that direct emotional reaction to things which is the genius of children. Do not destroy their sense of reality by teaching them to manipulate labels. Do not imagine that adults must be the best judges of what is good and what matters. Don't be such an ass as to suppose that what excites uncle is more exciting than what excites Tommy. Don't suppose that a ton of experience is worth a flash of insight, and don't forget that a knowledge of life can help no one to an understanding of art. Therefore do not educate children to be anything or to feel anything; put them in the way of finding out what they want

and what they are. So much in general. In particular I would say, do not take children to galleries and museums; still less, of course, send them to art schools to be taught high-toned commercialism. Do not encourage them to join guilds of art and crafts, where, though they may learn a craft, they will lose their sense of art. In those respectable institutions reigns a high conception of sound work and honest workmanship. Alas! why cannot people who set themselves to be sound and honest remember that there are other things in life? The honest craftsmen of the guilds have an ideal which is praiseworthy and practical, which is mediocre and unmagnanimous, which is moral and not artistic. Craftsmen are men of principle, and, like all men of principle, they abandon the habit of thinking and feeling because they find it easier to ask and answer the question, "Does this square with my principles?"—than to ask and answer the question, "Do I feel this to be good or true or beautiful?" Therefore, I say, do not encourage a child to take up with the Arts and Crafts. Art is not based on craft, but on sensibility; it does not live by honest labour, but by inspiration. It is not to be

taught in workshops and schoolrooms by craftsmen and pedants, though it may be ripened in studios by masters who are artists. A good craftsman the boy must become if he is to be a good artist; but let him teach himself the tricks of his trade by experiment, not in craft, but in art.

To those who busy themselves about bringing art into the lives of the people, I would also say—Do not dabble in revivals. The very word smacks of the vault. Revivals look back; art is concerned with the present. People will not be tempted to create by being taught to imitate. Except that they are charming, revivals of morris-dancing and folk-singing are little better than Arts and Crafts in the open. The dust of the museum is upon them. They may turn boys and girls into nimble virtuosi; they will not make them artists. Because no two ages express their sense of form in precisely the same way all attempts to recreate the forms of another age must sacrifice emotional expression to imitative address. Old-world merry-making can no more satisfy sharp spiritual hunger than careful craftsmanship or half hours with our "Art Treasures." Passionate creation and ecstatic contemplation, these alone will satisfy men in search of a religion.

ART AND SOCIETY

I believe it is possible, though extremely difficult, to give people both—if they really want them. Only, I am sure that, for most, creation must precede contemplation. In Monsieur Poiret's[1] *Ecole Martine** scores of young French girls, picked up from the gutter or thereabouts, are at this moment creating forms of surprising charm and originality. That they find delight in their work is not disputed. They copy no master, they follow no tradition ; what they owe to the past—and it is much—they have borrowed quite unconsciously with the quality of their bodies and their minds from the history and traditional culture of their race. Their art differs from savage art as a French *midinette*[2] differs from a squaw, but it is as original and vital as the work of savages. It is not great art, it is not profoundly significant, it is often frankly third-rate, but it is genuine ; and therefore I rate the artisans of the *Ecole Martine* with the best contemporary painters, not as artists, but as manifestations of the movement.

I am no devout lover of rag-time and

* We may hope much from the Omega Workshops[3] in London ; but at present they employ only trained artists. We have yet to see what effect they will have on the untrained.

turkey-trotting, but they too are manifesta-
tions. In those queer exasperated rhythms
I find greater promise of a popular art than
in revivals of folk-song and morris-dancing.
At least they bear some relationship to the
emotions of those who sing and dance them.
In so far as they are significant they are
good, but they are of no great significance.
It is not in the souls of bunny-huggers that
the new ferment is potent; they will not
dance and sing the world out of its lethargy;
not to them will the future owe that debt
which I trust it will be quick to forget.
There is nothing very wonderful or very
novel about rag-time or tango, but to over-
look any live form of expression is a mistake,
and to attack it is sheer silliness. Tango
and rag-time are kites sped by the breeze
that fills the great sails of visual art. Not
every man can keep a cutter, but every boy
can buy a kite. In an age that is seeking
new forms in which to express that emotion
which can be expressed satisfactorily in form
alone, the wise will look hopefully at any
kind of dancing or singing that is at once
unconventional and popular.

So, let the people try to create form for
themselves. Probably they will make a
mess of it; that will not matter. The im-

portant thing is to have live art and live sensibility; the copious production of bad art is a waste of time, but, so long as it is not encouraged to the detriment of good, nothing worse. Let everyone make himself an amateur, and lose the notion that art is something that lives in the museums understood by the learned alone. By practising an art it is possible that people will acquire sensibility; if they acquire the sensibility to appreciate, even to some extent, the greatest art they will have found the new religion for which they have been looking. I do not dream of anything that would burden or lighten the catalogues of ecclesiastical historians. But if it be true that modern men can find little comfort in dogmatic religion, and if it be true that this age, in reaction from the materialism of the nineteenth century, is becoming conscious of its spiritual need and longs for satisfaction, then it seems reasonable to advise them to seek in art what they want and art can give. Art will not fail them; but it may be that the majority must always lack the sensibility that can take from art what art offers.

That will be very sad for the majority; it will not matter much to art. For those

who can feel the significance of form, art can never be less than a religion. In art these find what other religious natures found and still find, I doubt not, in impassioned prayer and worship. They find that emotional confidence, that assurance of absolute good, which makes of life a momentous and harmonious whole. Because the aesthetic emotions are outside and above life, it is possible to take refuge in them from life. He who has once lost himself in an "O Altitudo" will not be tempted to over-estimate the fussy excitements of action. He who can withdraw into the world of ecstasy will know what to think of circumstance. He who goes daily into the world of aesthetic emotion returns to the world of human affairs equipped to face it courageously and even a little contemptuously. And if by comparason with aesthetic rapture he finds most human passion trivial, he need not on that account become unsympathetic or inhuman. For practical purposes, even, it is possible that the religion of art will serve a man better than the religion of humanity. He may learn in another world to doubt the extreme importance of this, but if that doubt dims his enthusiasm for some things that are truly excellent it will

dispel his illusions about many that are not. What he loses in philanthropy he may gain in magnanimity; and because his religion does not begin with an injunction to love all men, it will not end, perhaps, in persuading him to hate most of them.

THE END

EXPLANATORY NOTES

PREFACE

1 ... *contributed by me to that periodical*: i.e. 'Post-Impressionism and Aesthetics', *Burlington Magazine*, 22 (Jan. 1913), pp. 226–30.

2 P. Cézanne (1839–1906); P. Gauguin (1848–1903); H. Matisse (1869–1954).

3 Fry, 'An Essay in Aesthetics', *New Quarterly*, 2 (Apr. 1909), pp. 171–90: reprinted in *Vision and Design*, ed. J. B. Bullen (Oxford University Press, 1981), pp. 12–27.

4 The term 'Post-Impressionism' was devised to describe Roger Fry's exhibition 'Manet and the Post-Impressionists' at the Grafton Galleries, which opened on 8 November 1910. The first person to use the term in print was the critic Frank Rutter who in *Art News*, the journal of which he was editor, described the painter Othon Freisz as a 'post-impressionist leader' when he reviewed the French *Salon d'automne* on 15 October 1910 (p. 5). This was nearly one month before the opening of the exhibition in London.

EXPLANATORY NOTES

PREFACE TO THE 1949 EDITION

1 H. Tonks (1862–1937) was a teacher at the Slade School of which he became Professor in 1918. He had little sympathy with the Post-Impressionist movement: see Introduction, p. xli.

2 G. Seurat (1859–91), P. Signac (1863–1935), and H. E. Cross (1856–1910) were all neo-Impressionist painters mentioned by Bell on p. 187.

3 Bell wrote (quoting from James Joyce's *Ulysses*): 'He [i.e. Degas] was a Realist after the manner of Maupassant—*le mot juste*. He observed life as it came and recorded his observations with such strength and economy that, by sheer intensity, his impression became art. For all their unexpectedness, his drawings are, we say, "exactly like"; and they are like, not as photographs, but as brilliant similes—"the snot green sea".' *Landmarks in Nineteenth Century Painting* (London: Chatto and Windus, 1927), p. 192.

4 E. Degas (1834–1917), *Beach Scene* (1877), National Gallery, London, Lane Bequest (1917).

5 Sickert said in a lecture given at the first Post-Impressionist exhibition at the Grafton Galleries: 'History must needs describe Cézanne as *un grand raté*, an incomplete giant. But nothing can prevent his masterpieces from

taking rank.' 'Post-Impressionists', *Fortnightly Review*, NS 95 (Jan. 1911), pp. 79–89. See *Post-Impressionists in England: the Critical Reception*, ed. J. B. Bullen (London, Boston, Melbourne, and Henley: Routledge and Kegan Paul, in press), entry 29.

6　J. S. Sargent (1856–1925) expressed his dislike of Cézanne in a letter to the *Nation* of 7 Jan. 1911. See *Post-Impressionists in England*, entry 28.

7　The critic Robert Ross, for example, when reviewing the first Post-Impressionist exhibition said that Van Gogh was 'a typical matoid [*sic*] and degenerate of the modern sociologists' and that his work was 'the visualized ravings of an adult maniac'. 'The Post-Impressionists at the Grafton: The Twilight of the Idols', *Morning Post*, 7 Nov. 1910, p. 3. See *Post-Impressionists in England*, entry 11.

8　J. E. Blanche (1861–1942), portrait painter, writing to the *Morning Post*, 30 Nov. 1901, p. 5.

9　This is a reference to a lecture which Fry gave to the Art Workers' Guild in late January or early February 1911. In this he spoke in the defence of the Post-Impressionists when they were attacked for their 'insanity' by T. B. Hyslop, the Physician Superintendent to the Royal Hospitals of Bridewell and Bedlam. Hyslop's lecture was published as

EXPLANATORY NOTES

'post-Illusionism and the art of the insane', *Nineteenth Century*, Feb. 1911, pp. 270-81. See *Post-Impressionists in England*, entry 38.

10 Sickert, 'Post-Impressionists', *Fortnightly Review*, p. 82. See *Post-Impressionists in England*, entry 29.

The Aesthetic Hypothesis

1 Sir. E. Landseer (1802–73), a highly popular painter of animal subjects.

2 Giotto (*c*.1267–1337), an early Italian painter largely 'discovered' in the early part of the nineteenth century.

3 N. Poussin (1593/4–1666); Piero della Francesca (*c*.1420–92). Poussin who had been much revered in the eighteenth century fell out of favour with pietist critics in the nineteenth century for his studied artificiality. Piero was very much an early twentieth-century discovery and both painters appealed to Bell's generation for the appearance of a high level of design and structure in their work.

4 'Rhythm' became a prominent term in art criticism in 1911. It was used principally to describe the features of Fauve painting and seems to have derived in part from a work exhibited by the Scottish artist J. D. Fergusson at the *Salon d'automne* of 1910, with the

title *Rhythm*. In 1911 Michael Sadler and Middleton Murray started a journal of modern art entitled *Rhythm* with Fergusson as art editor and with his picture on the cover. Frank Rutter, looking back to this period, wrote: 'RHYTHM was the magic word of the moment. What it meant exactly nobody knew, and the numerous attempts made at defining it were not very convincing. But it sounded well, one accepted it; one "knew what it meant," and did not press the matter further. When we liked the design in a painting or drawing, we said it had Rhythm. The pictures of Matisse had lots of Rhythm' (*Art in My Time* (London: Rich and Cowan, 1933), pp. 132–3). The idea of rhythm was extended to drama and dance by Huntley Carter in his book *The New Spirit in Drama and Art* of 1912 and subsequently promulgated in articles like his 'Schönberg, Epstein, Chesterton, and Mass Rhythm', *Egoist*, 16 Feb. 1914, pp. 75–6.

5 W. P. Frith (1819–1909). His painting *The Railway Station* (1862), which Bell calls *Paddington Station*, had a huge popular success in the nineteenth century and is now owned by Royal Holloway College, London.

6 Sir L. Alma-Tadema (1836–1912) was at the height of his popularity when he died in 1912. Fry wrote a highly controversial obituary in the *Nation* of 18 Jan. 1910 where he described

EXPLANATORY NOTES

Alma-Tadema's 'products' as 'typical of the purely commercial ideals of the age in which he grew up'. 'He noticed,' Fry went on, 'that, in any proprietary article, it was of the first importance that the customer should be saved all trouble. He wisely adopted the plan, since exploited by the Kodak Company, "you press the button, and we do the rest". His art, therefore, demands nothing from the spectator beyond the almost unavoidable knowledge that there was such a thing as the Roman Empire, whose people were very rich, very luxurious, and, in retrospect at least, agreeably wicked' (p. 667). When Burne-Jones, Richmond, and Shaw attacked Fry for his irreverence, Bell wrote strongly in support of Fry. See THE METAPHYSICAL HYPOTHESIS, note 3.

7 *The Doctor* (1891) was one of Sir L. Fildes's (1844–1927) most popular, sentimental, and frequently reproduced pictures.

8 Bell had expressed similar sentiments in his review of the 'Post-Impressionist and Futurist Exhibition' organized by Frank Rutter at the Doré Galleries in 1913, where he described the Futurists as 'a negligible accident'. *Nation*, Oct. 1913, reproduced as 'English Post-Impressionists' in *Pot Boilers* (London: Chatto and Windus, 1918), p. 181.

9 G. Severini (1883–1966) was, before the First

World War, the most popular of the Futurist
painters. His work was first seen at the Sack-
ville Gallery in March 1912, and in April
1913 he had a one-man show at the Marlbor-
ough Galleries where his picture *Pan Pan
Dance at the Monico* (destroyed in the Second
World War) received much favourable com-
ment.

10 P. A. Besnard (1849–1934).

11 When the Japanese–British exhibition at
Shepherd's Bush, London, closed on 29 Oct.
1910 it had been visited by six million people.

12 Sir E. Poynter (1836–1919), President of the
Royal Academy in 1896, and Lord Leighton
(1830–96), President in 1878, both specialized
in a popular form of Victorian neo-classicism.

AESTHETICS AND POST-IMPRESSIONISM

1 Claude Lorraine (1600–82); El Greco
(1541–1614); J. B. S. Chardin (1699–1779);
J. A. D. Ingres (1780–1867); P. A. Renoir
(1841–1919); N. Poussin (1593/4–1666).

2 The *Salon d'automne* was founded in 1903 by
Bonnard, Rouault, Matisse, and Marquet.
The first show included a memorial exhibi-
tion of the work of Gauguin and the second a
one-man show of the works of Cézanne. The
Salon des indépendants was founded by an
earlier generation of painters in 1884 but at

the time that Clive Bell was writing it offered the largest show of avant-garde work in Paris.

3 The British public first saw Cubist pictures when two works, one by Picasso the other by Herbin, were published in the *New Age*, 23 Nov. 1911, where they caused an enormous *furore* (see *Post-Impressionists in England*, entry 47). But the first exhibition of original works took place at the second Post-Impressionist exhibition in October 1912.

4 S. Vitale, Ravenna (*c.* AD 530).

THE METAPHYSICAL HYPOTHESIS

1 'O imagination, which so steals us at times from outward things that we pay no need though a thousand trumpets sound about us, who moves thee if the senses offer thee nothing? A light moves thee which takes form in the heavens, either of itself or by a will which directs it downwards . . . and at this my mind was so withdrawn within itself that nothing came from without that was then received by it.' *The Divine Comedy of Dante Alighieri: Il Purgatorio*, ed. John D. Sinclair (Oxford: Oxford University Press, 1971), Canto 17, ll. 13–18 and 22–4.

2 See THE AESTHETIC HYPOTHESIS, note 4.

3 G. B. Shaw (1856–1950) attacked Roger Fry's

obituary of Lawrence Alma-Tadema (see
THE AESTHETIC HYPOTHESIS, note 6) in the
Nation, 15 Feb. 1913, saying that 'Alma-
Tadema did what he wanted to do, and did it
extremely well. . . . It was a merit in him that
he wanted not to draw or paint with a Parisian
touch, but quite simply to produce an illu-
sion, and that he did produce it very bril-
liantly. No doubt this simplicity bores Mr
Fry. He misses the design, the draughtsman-
ship, [and] the color [*sic*] orchestration of his
Post-Impressionists . . .' (p. 818). Shaw and
Bell then entered into a substantial corre-
spondence in the *Nation* under the heading
'Mr Roger Fry's Criticism'. See *Nation*, 22
Feb. 1913, pp. 853–4; 1 Mar. 1913, pp. 888–9;
8 Mar. 1918, p. 928.

4 J. Galsworthy (1867–1933).

ART AND RELIGION

1 'An Essay in Aesthetics' [Bell's note]. See
PREFACE, note 3.

2 J. McT. E. McTaggart, *Some Dogmas of Reli-
gion* (London: Edward Arnold, 1906), p. 105
[Bell's note].

3 Bell is referring to the second Post-Impres-
sionist exhibition which opened at the Graf-
ton Galleries in October 1912.

EXPLANATORY NOTES

4 Matisse, *Marguerite Matisse: jeune fille au chat* (1910: private collection, Paris).

5 *Boswell's Life of Johnson*, ed. G. B. Hill (Oxford: Clarendon Press, 1934), ii. 55.

6 Ibid. i. 471.

7 G. E. Moore, *Principia Ethica* (Cambridge: Cambridge University Press, 1903, repr. 1984).

8 Ibid., p. 119.

ART AND HISTORY

1 Sir E. Carson (1854–1935), Ulster leader and lord of appeal in ordinary.

ART AND ETHICS

1 G. E. Moore, *Principia Ethica*, p. 7.

2 Ibid., pp. 10–13.

3 J. S. Mill (1806–73).

4 Mill's 'Utilitarianism' was published in *Fraser's Magazine* in 1861 and republished in 1863.

5 G. E. Moore, op. cit., p. 7.

6 In his *What is Art?*, trans. Almer Maud (3rd edn. 1898), pp. 46–52.

7 The New English Art Club was founded in 1886 by Clausen, Wilson Steer, Stanhope

ART

Forbes, Sargent, La Thangue, Fred Brown, and others who had been influenced by contemporary French painting.

8　Suffolk Street Gallery: the gallery where the New English Art Club held many of its exhibitions.

The Rise of Christian Art

1　Wei (AD 220–65); Liang (AD 502–49); T'ang (AD 618–906).

2　Duccio di Buoninsegna (active 1278–1319); Giotto (*c*.1267–1337).

3　Lionardo or Leonardo da Vinci (1452–1519).

4　Basilian movement: named, presumably, after Basil II (*c*.958–1025), Roman Emperor of the East.

5　Palaeologi: a Byzantine family which first appeared in the middle of the eleventh century.

6　Corinth was sacked in 146 BC.

7　Alexander the Great died in 323 BC.

8　The 'Theseus' and the 'Illissus' are both figures in the Parthenon marbles.

9　Phidias was a sculptor of the mid fifth century BC.

10　Praxiteles was an Athenian sculptor of the mid fourth century BC.

EXPLANATORY NOTES

11 A. A. Correggio (*c*.1489–1534).

12 Marcus Aurelius died in AD 180.

13 Queen Victoria died in 1901.

14 Hadrian (AD 76–138).

15 This is probably a reference to Joseph Strzygowski's *Hellas in des Orients Umarmung ... Sonderabdruck aus der Beilage zur 'Allgemeinen Zeitung'* (Munich, 1902).

16 Sir G. G. Scott (1811–78) designed the Albert Memorial (1862–72).

17 Lord Melbourne (1779–1848).

18 Mr Finlay the historian: G. Finlay, *History of the Byzantine Empire from 716–1453* (1853–4), i. 42.

19 *dicunt enim ... esse*: 'truly they say that the art of painting is holy.'

20 The Chloudof Psalter is a ninth-century work with illustrations in the margin only. For centuries it was in the monastery of St Nicholas and is now in the Gosudarstvennyi Istoricheskii Muzei, Moscow.

GREATNESS AND DECLINE

1 Charlemagne (AD 742–814).

2 The Suermondt Museum in Aachen.

3 What Sig. Rivoira calls ...: in 'The Pre-Lombardic Style', G. T. Rivoira, *Lombardic*

Architecture: its Origin, Development and Derivatives, trans. G. McN. Rushworth (1910), ii. 112–50.

4 C. L. R. Fletcher, *The Making of Western Europe* (London: John Murray, 1912), i. 274 [Bell's note].

5 Bell has mistranscribed Parma for Pavia.

6 Cimabue (*c.*1240–*c.*1302).

7 Giotto's St Francis fresco cycle, the *Life of St Francis*, is in the upper Church of S. Francesco at Assisi and there are more illustrations of the life of St Francis in the Bardi Chapel, Sta Croce, Florence.

8 Bell is referring to Giotto's *Madonna di Ognissanti* and Cimabue's *Madonna in trono* formerly in the Accademia in Florence, now in the Uffizzi Gallery.

9 For Sta Croce see note 7.

10 The Arena or Scrovegni Chapel in Padua contains the *Lives of the Virgin and Christ* (1305–8) by Giotto.

11 extension lecturer: i.e. a lecturer in adult education.

12 Ugolino da Siena (active 1317–27); A. Lorenzetti (1319–48); Simone Martini (*c.*1285–1344).

13 Masaccio (1401–28); Masolino (*c.*1383–1447?); A. del Castagno (*c.*1423–57);

EXPLANATORY NOTES

Donatello (1386–1466); Fra Angelico (1387–1455); Piero della Francesca (c.1420–92).

14 P. Uccello (1397–1475); A. Mantegna (1431–1506).

15 Charles the Great: i.e. Charlemagne. See note 1.

16 Chrétien de Troyes (d. c.1183).

17 G. Boccaccio (1313–75).

18 Rinaldo d'Aquino (d. c.1279–81) was a thirteenth-century Sicilian poet whose *Lamento dell'amanti del crociato* was written for the Crusade of 1228.

19 Petrarch (1304–74).

20 Masolino (c.1383–1447?)

21 G. di Fabriano (1370–1427); G. Bellini (1430/40–1516).

THE CLASSICAL RENAISSANCE AND ITS DISEASES

1 Mr Finlay: see THE RISE OF CHRISTIAN ART, note 19.

2 T. Hobbes (1588–1679); T. Mommsen (1817–1903); C. A. de Sainte-Beuve (1804–69); Samuel Johnson (1709–84).

3 *The Taming of the Shrew*, II.i.

4 *The Tempest*, II.ii.

5 Jacques Coeur (d. 1456) was the minister of finance under Charles VII of France and became hugely rich.

6 Honorius (AD 384–423).

7 Tintoretto (1518–94).

8 Charles VIII (1470–98); Francis I (1494–1547); Cesare Borgia (1477–1507); Leo X (1475–1521); Raphael (1483–1520); Machiavelli (1469–1527); Erasmus (1466–1536).

9 Clement VII (1523–34); Rabelais (1494?–1553?); Titian (d. 1576); Palladio (1518–80); Vasari (1511–74).

10 Aurelian (*c*.AD 212–75).

11 Gregory I, the Great (*c*.540–604).

12 P. Veronese (1525–88).

13 A. A. Correggio (*c*.1489–1534).

14 Michelangelo Buonarrotti (1475–1564).

15 Velazquez (1599–1660).

16 His *Venus and Cupid*, known as the 'Rokeby Venus' (*c*.1658), hangs in the National Gallery, London. It was the object of suffragette attacks in the early years of this century.

17 J.-B. Martinez del Mazo (1612–61). In 1913 Herbert Cook wrote: 'Mazo or Velazquez is a question that has agitated the English critics ever since the Rokeby *Venus* [see note 16] entered the National Gallery. Far be it from me to reopen this astonishing discussion, now

happily at rest, but the problem of Mazo the mythical is always upon us in one form or another, and it is highly desirable to produce fresh evidence from which to construct the shadowy figure of Velasquez's *alter ego*' ('Further Light on Del Mazo', *Burlington Magazine*, 23 (Sept. 1913), p. 323).

18 Bell is probably referring to Frans Hals's (*c*.1580–1666) *A Family Group in a Landscape* which was purchased for the National Gallery with aid from the National Art-Collections fund in 1908, and a painting by Mabuse (Jan Gossaert; active 1503, died 1532) entitled *Magdalen* purchased out of the Lewis fund in 1907.

19 Sir C. Holroyd (1861–1917) was the director of the National Gallery between 1906 and 1916; Mr Maclagan, later Sir Eric Robert Dalrymple Maclagan (1879–1951), entered the Victoria and Albert Museum in 1905, becoming its director in 1924.

20 Jean Boldini (1842–1931) started his career as a *plein-airiste* but became a highly fashionable society artist.

21 Sir John Lavery (1856–1941).

22 E. Degas: (1834–1917).

23 El Greco (1541–1614); Rembrandt (1606–69); J. Vermeer (1628–91); P. P. Rubens (1577–1640); J. Jordaens (1593–1678); Claude

(1600–82); C. Wren (1632–1723); G. L. Bernini (1598–1680).

24 N. Poussin (1593/4–1666).

25 J. M. W. Turner (1775–1851).

26 J.-B.-S. Chardin (1699–1779).

27 J. A. Watteau (1684–1721); Canaletto (1697–1768); J. Crome (1768–1821); J. S. Cotman (1782–1842); F. Guardi (1712–93).

28 G. B. Tiepolo (1696–1770).

29 J. S. Sargent (1856–1925).

30 W. Hogarth (1697–1764).

31 John Collier (1850–1934) and his book *A Manual of Oil Painting* (1886) is mentioned disparagingly by Fry in 'An Essay in Aesthetics', *Vision and Design*, p. 12 n. 1.

32 Andrea del Sarto (1486–1531); Guido Reni (1575–1642), a Bolognese painter highly popular in the early nineteenth century; P. Veronese (1525–88); Trajan's column: a cylindrical marble column erected in the Roman Forum in AD 113 to celebrate Trajan's victories in Dacia.

33 Sir J. Reynolds (1723–92). Fry had edited the *Discourses* in 1905, which possibly accounts for the moderation in Bell's tone here.

34 J. A. D. Ingres (1780–1867); J. B. C. Corot (1796–1875); H. Daumier (1808–79).

EXPLANATORY NOTES

ALID EX ALIO

1 *Alid ex Alio*: i.e. 'One Thing from Another'.

2 the Newcastle programme: Gladstone (1809–98) made a speech in Newcastle on 7 October 1862 in which he expressed his opinion that, as the result of the American Civil War, reunion of north and south was impossible.

3 J. A. M. Whistler (1834–1903).

4 W. Sickert (1860–1942).

5 T. Carlyle (1795–1881); C. Dickens (1812–70); V. Hugo (1802–85).

6 G. Flaubert (1821–80).

7 H. Ibsen (1828–1906).

8 Count Leo Tolstoi or Tolstoy (1828–1910).

9 C. Darwin (1809–82).

10 R. Wagner (1813–83).

11 Giotto (*c.*1267–1337); Raphael (1483–1520).

12 P. A. Renoir (1841–1919); E. Manet (1832–83); E. Degas (1834–1917).

13 C. Monet (1840–1926).

14 G. Seurat (1859–91); P. Signac (1863–1935); and H. E. Cross (1856–1910). Bell's harsh judgement of Neo-Impressionism was characteristic of British writers at this time.

15 J. A. Watteau (1684–1721).

16 Whistler's *Ten o'Clock*: a lecture given in

London on 20 Feb. 1885 and published in Whistler's *The Gentle Art of Making Enemies* (1890). Whistler tried to establish the autonomy of art and nature and to defend himself from the critical abuse of Ruskin.

17 For *The Gentle Art* see note 16. *The Dissertation on the Letters of Phalaris*: Phalaris (6th cent. BC) was a Greek tyrant of Agrigentum in Sicily. The 148 letters bearing his name were proved by Bentley in 1697 and 1699 to be spurious. Gibbon's *Vindication*, published in 1779, is an *apologia* for the first part of his *Decline and Fall of the Roman Empire*.

18 F. M. A. de Voltaire (1694–1778).

19 *Nocturne in Blue and Silver: Cremorne Gardens* (1872: National Gallery, London) was one of Whistler's earliest nocturnes.

20 the Arena Chapel: see GREATNESS AND DECLINE, note 10.

21 O. Wilde (1854–1900); G. B. Shaw (1856–1950).

22 J. Ruskin (1819–1900).

23 'Arry: i.e. Harry Quilter (d. 1907) the prolific and philistine art reviewer for *The Times* and the *Spectator*.

24 in another place: i.e. p. 12.

25 C. Conder (1868–1909) specialized, among other things, in the decoration of fans.

26 that sagacious Roman: i.e. Lucretius (99–55 BC).

27 *haud ... aliena*: 'Not utterly then perish all things that are seen, since nature renews one thing from out another, nor suffers anything to be begotten unless she be requited by another's death.' Lucretius, *De Rerum Natura*, ed. Cyril Bailey (Oxford: Clarendon Press, 1947), Bk. 1, ll. 262–4.

THE DEBT TO CÉZANNE

1 P. Gauguin (1848–1903); V. van Gogh (1853–90); H. Matisse (1869–1954); H. Rousseau (1844–1910); P. Picasso (1881–1973); M. de Vlaminck (1876–1958); A. Derain (1880–1954); A. Herbin (1882–1960); J. H. Marchand (1883–1941); A. Marquet (1875–1947); P. Bonnard (1867–1947); D. Grant (1885–1978); A. Maillol (1861–1944); W. Lewis (1882–1957); W. Kandinsky (1866–1944); C. Brancuzi or Brancusi (1876–1957); B. von Anrep (1886–1969); R. Fry (1866–1934); O. Friesz (1879–1949); N. Goncharova (1881–1962); A. Lhote (1885–1962).

2 *Tu regere ... memento*: 'Do you, Roman, remember to rule over peoples with your empire.'

3 Lucian (*c.* AD 117–80), a Greek satirist best

known, perhaps, for his *Dialogues of the Dead*.

4 Frederick Nietszche (1844–1900). His work, and particularly his views on art, had been recently popularized in England by A. M. Ludovici, who, as art critic for the *New Age*, had used Nietszche's views to decry modern art.

5 Masaccio (1401–28); P. Uccello (1397–1475); A. del Castagno (1409–80).

6 E. Zola (1840–1902).

7 in another place: i.e. p. 59.

8 E. Waller (1606–87), author of a famous poem entitled 'Go Lovely Rose'.

SIMPLIFICATION AND DESIGN

1 W. Sickert (1860–1942); S. Bussy (1869–1954); J. E. Vuillard (1868–1940); J. W. Morrice (1865–1924).

2 A. Dürer (1471–1528).

3 Sir Edward Poynter (1836–1919).

4 P. Bonnard (1867–1947).

5 Sung: 960–1278.

6 Bell is probably thinking of writers such as D. S. McColl and Walter Sickert who were staunch champions of Impressionism, but found Post-Impressionist work much less comprehensible.

EXPLANATORY NOTES

The Pathetic Fallacy

1 G. D'Annunzio (1863–1938); P. Claudel (1868–1955).

2 R. Strauss (1864–1949).

3 Alexander Severus (AD 205–35).

4 a Greek freed Man: I have been unable to identify the source of this story.

5 Epicurus (c.341–270 BC).

Society and Art

1 Demos: i.e. common man.

2 Andrea del Sarto (1486–1531).

3 Adeline Genée (b. 1878) was a ballerina who performed at the Empire, Leicester Square, for ten years from 1897–1907.

4 Mr Humphrey: possibly A. G. Humphrey who was active in Roehampton in 1912.

5 William Morris (1834–96). Bell expressed similarly unfriendly views of William Morris's work in his review of A. Clutton Brock's *William Morris* (London: Williams and Norgate, 1914) in the *New Statesman*, 3 Oct. 1914, pp. 757–8. Reprinted in *Pot Boilers*.

6 *Bradshaw*: the railway timetable named after its designer and printer George Bradshaw.

7 Matthew Arnold (1822–8) said of one of Keats's letters: 'It has in its relaxed self-

abandonment something underbred and ignoble, as of a youth ill brought up ...' 'John Keats', in *The Complete Prose Works of Matthew Arnold*, ed. R. H. Super (Ann Arbor: University of Michigan Press, 1973), ix. 206.

8 A. John (1878–1961).

9 Sir J. Lavery (1856–1941).

10 E. Rostand (1868–1918).

11 M. Reinhardt (1873–1943) was an Austrian theatre manager whose most notable success was *The Miracle* (1911); L. Bakst (1866-1924) was a Russian painter who designed décor and costumes for the *Ballet Russe*.

ART AND SOCIETY

1 P. Poiret (1879–1944) was a dress designer and author of *En habillant l'époque* (Paris: 1930).

2 *midinette*: i.e. a dressmaker's apprentice or work-girl.

3 Omega Workshops: an organization set up by Roger Fry in 1912 for the production of furniture and fabric designs on Post-Impressionist lines.

SELECT BIBLIOGRAPHY

BIBLIOGRAPHY

Laing, Donald A., 'A Checklist of the Published Writings of Clive Bell' in William G. Bywater, Jr., *Clive Bell's Eye* (Detroit: Wayne State University, 1975), pp. 211–42.

CRITICAL WORKS

Bullen, J. B., (ed.), *Post-Impressionists in England: The Critical Reception* (London, Boston, Melbourne, and Henley: Routledge and Kegan Paul, in press).

Bywater, William G., Jr., *Clive Bell's Eye* (Detroit: Wayne State University, 1975).

Dickie, George T., 'Clive Bell and the Method of *Principia Ethica*', *British Journal of Aesthetics* 5 (1955), pp. 139–43.

Ekman, Rosalind, 'The Paradoxes of Formalism', ibid. 10 (1970), pp. 350–8.

Elliott, R. K., 'Bell's Aesthetic Theory and Critical Practice', ibid. 5 (1955), pp. 111–22.

ART

Fishman, Soloman, *The Interpretation of Art: essays on John Ruskin, Walter Pater, Clive Bell, Roger Fry and Herbert Read* (Berkeley and Los Angeles: University of California Press, 1963).

Fry, Roger, *Vision and Design*, ed. J. B. Bullen (Oxford: Oxford University Press, 1981).

Isenberg, Arnold, 'Critical Communication', in *Aesthetics and Language*, essays ed. by William Elton (Oxford: Basil Blackwell, 1954).

Lake, Beryl, 'Bell's Theory about Works of Art', in ibid.

Meager, R., 'Clive Bell and Aesthetic Emotion', *British Journal of Aesthetics* 5 (1955), pp. 123–31.

Osborne, Harold, 'Alison and Bell on Appreciation', ibid., pp. 132–8.

Weitz, Morris, 'Aesthetic Formalism', in *Philosophy of the Arts* (Cambridge, Mass.: Harvard University Press, 1950).